Old Enough

Old Enough

Southern Women Artists and Writers on Creativity and Aging

Edited by Jay Lamar and Jennifer Horne

with Katie Lamar Jackson and Wendy Reed

Photographs by Carolyn Sherer

NEWSOUTH BOOKS
AN IMPRINT OF THE
UNIVERSITY OF GEORGIA PRESS
ATHENS

Christmas 2024

Hi Terri

You are a wonderfully creative, dynamic yet empathetic, accomplished friend. I am glad to have known you for so long! — peace + love, Deborah

Publication of this work was made possible, in part, by a generous gift
from the University of Georgia Press Friends Fund.

NSB

Published by NewSouth Books,
an imprint of the University of Georgia Press
Athens, Georgia 30602
https://ugapress.org/imprints/newsouth-books/

Most NewSouth/University of Georgia Press titles are
available from popular e-book vendors.

Printed in the United States of America
28 27 26 25 24 C 5 4 3 2 1

Library of Congress Cataloging-in-Publication Data

Names: Lamar, Jay, 1956– editor. | Horne, Jennifer, editor. | Jackson, Katie Lamar,
 editor. | Reed, Wendy, 1966– editor. | Sherer, Carolyn, photographer.
Title: Old enough : Southern women artists and writers on creativity and aging
 / edited by Jay Lamar and Jennifer Horne ; with Katie Lamar Jackson and
 Wendy Reed ; photographs by Carolyn Sherer.
Description: Athens : NewSouth Books, [2024].
Identifiers: LCCN 2023049013 | ISBN 9781588385185 (hardback)
Subjects: LCSH: Creative ability in old age—Southern States. | Aging—
 Psychological aspects. | Older women—Southern States—Biography. |
 Women authors, American—Southern States—Biography. | Women artists—
 Southern States—Biography.
Classification: LCC BF724.85.C73 O53 2024 | DDC 305.26/20975—dc23/
 eng/20231229
LC record available at https://lccn.loc.gov/2023049013

CONTENTS

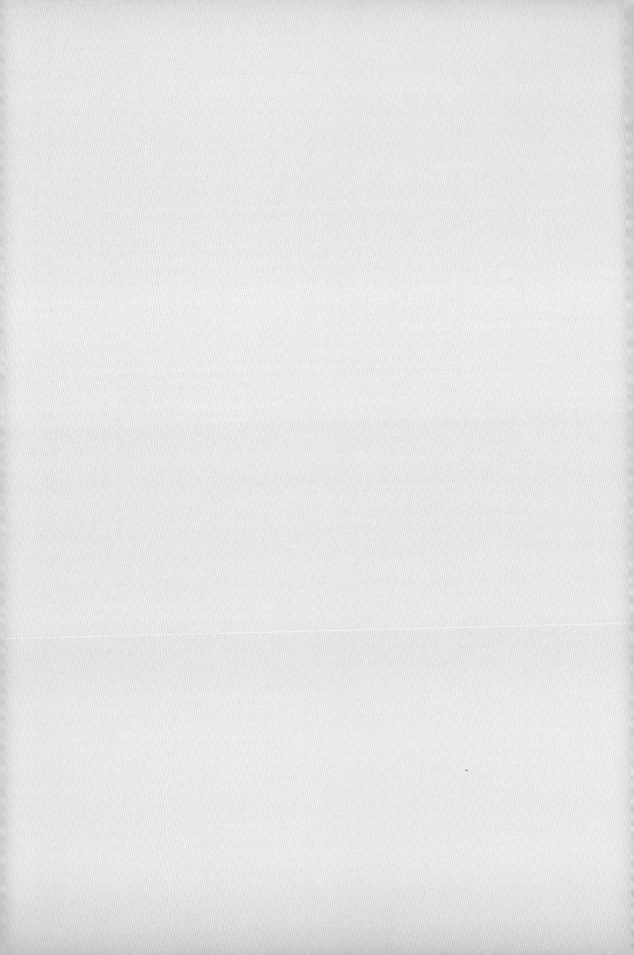

ACKNOWLEDGMENTS

As with most good projects, the making of this collection took the time, commitment, and effort of many, including our families and friends who listened to ideas and gave us the space, time, and support to pursue them. We love and thank them all. Thanks also to our esteemed contributors, who put flesh on those ideas and made them live and breathe beyond what we dared imagine. For generous grant support that enabled Carolyn Sherer to travel to make her beautiful portraits, we are grateful to the Alabama State Council on the Arts. For being our steadfast champion (always!) and for making it possible for us to be a part of Lifetime Arts' outstanding training on creative aging and the arts, we are especially grateful to ASCA's deputy director, Andrew Henley. Thanks also to Anne Kimzey, ASCA's literary arts program manager, who offered encouragement and invaluable expertise in recording and preserving Gail Andrews's conversation with Yvonne Wells. Our heartfelt thanks to Suzanne La Rosa, who as publisher of NewSouth Books enthusiastically accepted our proposal and shepherded it through the acquisition of NewSouth by the University of Georgia Press. Thank you to UGAP director Lisa Bayer for her faith in the project. It means everything. Thanks also to UGAP's Elizabeth Adams for her above-and-beyond work on permissions and the collection's title, to Jon Davies for his thorough and organized assistance, and to our copy editor Ann Marlowe for her eagle eye and sensitivity.

Jay Lamar and Jennifer Horne
with Katie Lamar Jackson and Wendy Reed

I deeply appreciate the love and support of Jean O'Neal and the rest of my family of choice during the process of image making for this book. Peggy Vandergrift provided especially helpful assistance on the road. I am also grateful to my mother, Doylene Sherer, for gifting me both a creative spirit and the work ethic necessary to bring a project like this to fruition. Thanks to my longtime friend and studio-mate Virginia Scruggs for generously crafting head shots of the team. Finally, I am indebted to each contributor for collaborating with me to create their portraits. Allowing me to share their physical and spiritual space for a moment was a treasured gift.

Carolyn Sherer

Permissions and Citations

Patti Callahan Henry's essay grew out of a "Friends & Fiction" column for *Parade* magazine, April 7, 2021.

Old Enough

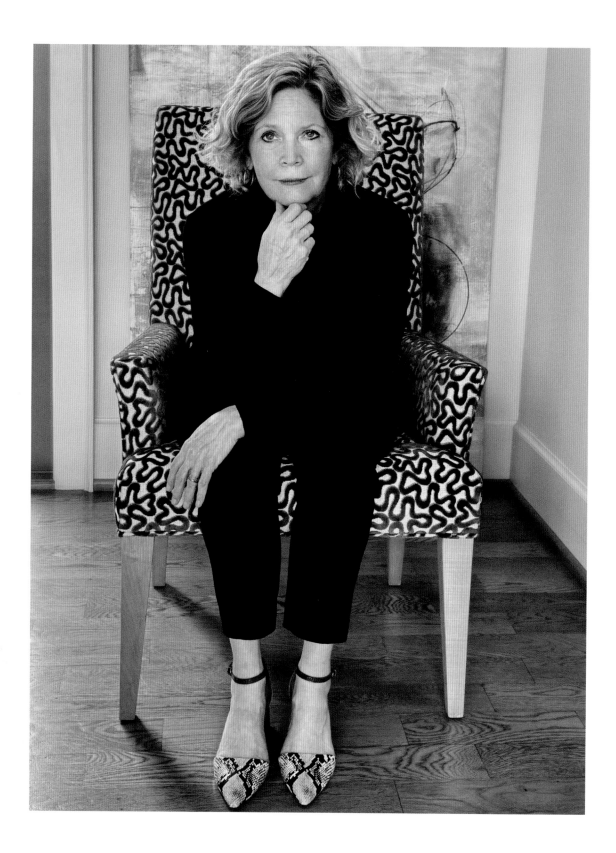

Old age was growing inside me. It kept catching my eye from the depths of the mirror. I was paralyzed sometimes as I saw it making its way toward me so steadily when nothing inside me was ready for it.
—Simone de Beauvoir, *Force of Circumstance*

Introduction

Jay Lamar

I was in my early sixties when I first read these words, and they made me sit back hard in my chair. I was feeling my age, and I recognized everything about them: the sense of dread, the approach of a fate that could not be escaped, the horror that it was carried inside me, growing not to be born but to take over my body.

It was not what I expected to feel. If when I was in my forties or early fifties someone had asked me what I thought about aging, I would have said not only do I not fear it, I intend to welcome it. I will be open to what it can teach me. I will be serene. I will do yoga. I will become my best self.

In short, I was not the least bit prepared, mentally or emotionally, for the reality of getting older. Crepey skin, bad feet, and hearing loss: I did my best to ignore the evidence, but a sideways glimpse in a passing store window or the full-on reflection in a well-lit mirror showed the visible truth. Something was happening, ready or not, and it wasn't pretty. I found myself thinking, *Who is this person and why is she crowding me out of my life?*

— In 1970, in her sixties, Beauvoir published *The Coming of Age*, a comprehensive study of aging across culture, race, and history. Her synthesis of disciplines and probing inquiry provoked discussion, calls to action, and a new field of study. The book is important in its content, but also perhaps in its very existence, for in it Beauvoir turns her dread to work. She uses a lifetime of knowledge and her powerful intellect to address fear and ignorance about age and aging and to instigate change. Her message to me: The face may fall, but the mind persists.

This matters, since one of the most disorienting aspects of female aging is that while we may feel ourselves to be alive, alert, ripe with experience and wisdom, the world can find us, well, barely there. The silence is painful and it is embarrassing: *Is it our fault somehow?* Then after shame comes anger, which is motivating in the short run. Once it burns off, though, you will want to know what to do with the rest of your life.

I was somewhere between hurt and furious when I turned to friends and fellow writers, my sister, Katie Jackson, Wendy Reed, and Jennifer Horne, coeditor of this collection. It had been reassuring to have Beauvoir's words, but it is even better to have flesh and blood companions. We began to meet, a few times in person and increasingly, as COVID spread, by Zoom, to talk about our experiences and ideas. The more we talked, the more clearly we saw that our issues with aging came down to concerns about identity, purpose, connectedness, the same concerns we'd always had, but with a few new questions: Had age changed us into different people? Had retirement rendered us brain dead? Why did our scope seem narrower? Why did we feel smaller? Isolated by COVID, we wondered: *Where are our people?*

As our questions multiplied, our conviction grew: we were not "done" and we were not going to be dismissed. Above all else we desired to make this time of life—our times of life, because in truth 60 is not 65 and 70 is not 80—meaningful, productive, and rewarding. And we wanted to hear from others, to know how other creative women of a certain age define themselves, how age challenges them, and what they do about it. How do they sustain their creativity, and what does it offer them as they age? We determined to write ourselves into discovery and understanding, or, as Lila Quintero Weaver writes in her essay "Wet Leaves," to "come to know ourselves" in these new times. Thus *Old Enough: Southern Women Artists and Writers on Creativity and Aging*, our Beauvoirian gesture.

Contributors to *Old Enough* are writers, painters and sculptors, a quilter, a photographer, and a singer-songwriter. In 2023, as I write this, they range in age from 57 to 87. If you add all their ages together, they have more than a thousand years of life experience, a collective number that actually seems kind of meaningful. Gay, straight, unmarried, partnered, widowed, Black, white, Latinx, retired, and working—they are artists and writers who are or have been educators, nurses, ministers, physical therapists and psychotherapists, restaurateurs, and nonprofit managers. They all come from or have spent significant periods of their life in the South. In their essays they show us, in Beauvoir's words, how "to go on pursuing ends that give our existence a meaning."

—— Pursuing those ends is not easy at any age. While many writers in this collection recall discovering the power and pull of words or paint or music in their girlhood, they acknowledge the demands of family and work, the lack of time, money, and good health, and fear of disapproval or failure that can keep us from creative work, sometimes for years. Clearly and without flinching, they also write about the experiences of age, the illness, caretaking, and loss that can ravage body and spirit and fray our connection to the very practices that help us, as Patricia Foster writes, find our "way through."

But whenever it happens that we know there is something in us that, in Yvonne Wells' words, needs "to be brought out," we try to pay attention. Each essayist in this collection has paid close attention and now generously shares what she has discovered.

—— We began this book maybe out of frustration but also with a sense of adventure, of being explorers entering a territory both new to us and generally undocumented, or at least not well represented by the place-names that usually mark our location in life: girlhood, young motherhood, menopause. We are for the most part beyond all three. On this side we look to our authentic selves, composed of the artists we may first have known ourselves to be in our youth and the people we have become through experience and time. We do not seek to name this age: to choose *crone, hag, elder, senior, mature adult* is to risk adopting a term that will define us without knowing us. In fact, this book is about the limitations of names, about defying prescribed identities and roles—capacities and relevance—based on others' ideas of who we are, what we can do, and what we have to offer. We are individual persons with vast experiences and unique perspectives. We are still driven to create, to be noisy, to investigate, to stay committed to the processes that work, to try to understand.

It may seem odd to begin this collection at the end, as it were, with "The Art of Dying," but there is something to be said for facing our worst fear first, and Carmen Agra Deedy's story is full of insight and wisdom, not least of which is that it takes time and life experience to be able to tell some stories. We hope this collection evokes and honors the limitless variety, depth, and scope of being old enough.

It is necessary to meditate early, and often, on the art of dying to succeed in doing it well, just once.
—Umberto Eco

On the Art of Dying

Carmen Agra Deedy

I was at a storytelling retreat in the mid-nineties when I first heard the strange and gripping tale "The Tiger and the Strawberry." It is an ancient koan from the Zen Buddhist tradition—a story meant to provoke more questions than answers.

It goes like this: A man was on a pleasant walk through a forest when he heard the snap of a twig, followed by a low growl. His heart quickened as he caught sight of a tiger, crouched beneath the underbrush, its muscles rippling as if ready to spring. The man rightly bolted through the trees and ran across a clearing, impelled by a fierce will to live. The tiger gave chase and might have caught the man—but for the cliff at the end of the meadow.

Without hesitation, the man grasped a nearby vine and leapt over the cliff edge. The tiger pounced.

Too late.

The enraged and hungry animal snapped and spat and pawed the ground, as the man below tightened his hold on the vine and tried to still his pounding heart.

But, what was this?

A second, equally terrible, roar rose from the bottom of the cliff. The man stared, paralyzed in both mind and body, as he observed a second tiger pacing impatiently below.

Fear gave way to a thin hope, as he willed his mind to devise a way to escape.

As he pondered, the vine began to quiver.

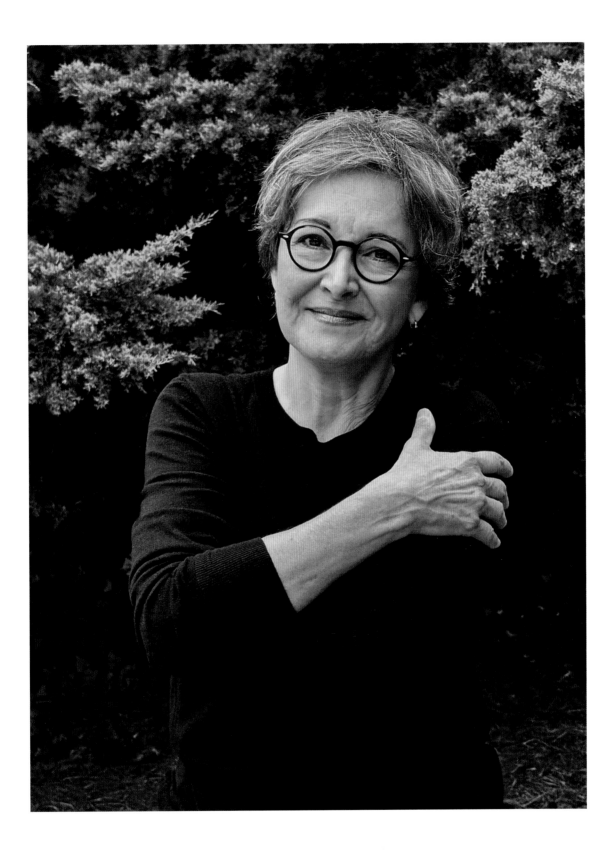

The man glanced up, up, up and saw a mouse gnawing away at his last fragile strand of salvation. The creature was maddeningly out of reach. In small increments, the man began to understand, then slowly accept, his fate. His frenzied mind calmed, as did his hammering heart.

Then—and only then—did he spy the ripe, summer-swollen strawberry growing on the side of the cliff.

Without hesitation, he plucked it and shoved it into his mouth, leaves and all.

It was the most delicious thing he had ever eaten, he thought, as the vine frayed and broke.

⸺ Like many Zen stories, a koan is not meant to appeal to the intellect, but rather to the heart. The meaning is often so elusive that you could ask a dozen people and receive a dozen different answers. This enigmatic story stayed with me for many years, but I never attempted to tell it.

Then, in my forties, I was asked to contribute a story to a literary anthology. The publisher was a fine one and I was jubilant. Giddy, even, in that way one often feels when an honor appears before it's been truly earned. It will surprise no reader to learn that within hours of accepting this writing assignment, panic took hold and shook me till my teeth rattled.

After countless dismal drafts, I called Papi, my Cuban father. He had a natural genius for storytelling and understood, better than anyone I knew, the proper *structure* of a good story, the way a medieval architect knew where to place a keystone or a flying buttress, or where to put diagonal tie timbers to keep a roof from collapsing. He was that kind of story builder. And I knew his help was essential if I was to untangle the mess I had made of the essay to which I'd committed myself.

We sat outside, near his garden. My mother brought out small cups of pungent Cuban coffee—something that she'd begun to ration as Papi grew older.

"Don't get used to it. The doctor says once a day is enough," warned Mami, then she added, "Supper is in twenty minutes. I'll set an extra place, *sí*?"

I nodded and she smiled as she disappeared into the house.

My father drank his *cafecito* in one practiced swig and said, "Well, *mija*, tell me this story you are having such trouble with. And pass me your cup, if you're not going to drink it, eh?"

I laughed, passed the coffee, and plunged right into the story. He listened without interrupting, eyes focused several yards away on his ripening muscadines. I knew he was listening *with intent*. This was also something I

learned from him. When you told my father something was important, he committed his every ion to the act of listening.

I finished the story and he responded with . . . silence. I wasn't immediately worried. I was familiar with this lull; it was a quiet soon to be followed by a tempest of questions, comments, and suggestions. He was thinking, sussing out the weak spots in the story. And I wasn't about to open my mouth and interfere.

At last he slapped the armrest on his lawn chair and turned to face me, as if to say, *¡Lo tengo!* I have it!

"I believe I have found your problem," he announced.

"Well—?" I prompted him with an eagerness known to any writer who's ever prayed somebody else would do the work for them.

"The problem is that *you haven't lived long enough to tell this story yet.*"

With a wry grin, I said, "I regret giving you that coffee." He was right, of course—cold comfort.

The following day I thanked the magazine and explained that, on further reflection, I didn't feel I could contribute anything meaningful on the subject. The whole business had been an excruciating exercise. It had also been a relief and a valuable lesson to simply admit I was the wrong girl for the job.

—— Years passed, as they will. And despite the limitations on time and space placed by the laws of quantum physics, the years seemed to actually *accelerate*. And another oddity of human aging that I noted: as I grew older, everyone in my life was growing older, too.

Children married, grandchildren arrived, anniversaries and birthdays appeared in an endless yearly rotation. Eventually, my parents moved in with us; this was both a cultural and practical decision that suited us all.

Then one day my father showed signs of a serious decline. He was ninety-three. He took to his bed and within days became eligible for in-home hospice care. Surrounded by his wife, daughters, sons-in-law, grandchildren, and great-grandchildren, our much-loved patriarch began his slow departure from this world. The journey would last a little more than seven weeks.

—— How does one even begin to describe this time?

I have a brilliant and wickedly funny friend, Geraldine, who is a most excellent hospice chaplain. She describes the period when we walk alongside a dying loved one as the "days of hyssop and honey."

The honey refers to the fact that every day is inestimable; each is understood to be one of an unknown, but finite, number. Everything around you

slows down. You feel you must be mentally present every moment, which is both exquisite and exhausting. Sitting beside him as he slept, I often found myself spellbound by the cumulus clouds outside Papi's bedroom window—was this the cerulean blue that Maxfield Parrish saw when he was painting? One morning a hummingbird, suspended in flight, appeared outside the kitchen window as I washed the morning's cups—I stood, unmoving, until it vanished. Had there always been hummingbirds in the garden? How could it be that I'd never seen one? There were many moments like this.

Ah, but the bitter hyssop. The jarring smells of ammonia and disinfectant. Oxygen and death kits filled with morphine and God knew what else—provided by kind hospice caregivers, but nonetheless harbingers of horrors yet to come.

The days—and even more so the nights—became endless.

My silent pleas, in conflict with one another, changed from day to day, sometimes hour to hour:

"Don't go! Your absence will be piercing and excruciating!"

"Go! I can't bear this another moment!"

You want—you *need*—it to be over, and you are overcome with the excruciating weight of such feelings.

Toward the end, Papi spoke less and less. He still sipped the rare spoonful of water, but he had stopped eating for nearly two days. I had much to learn about the dying, or I would have known how close he was to passing through that membrane of mystery that separates us from what lies beyond.

That particular morning, as I stepped into his room, I heard my mother in the shower. He moved his fingers slightly, as if to call me over. His eyes were half shut, and I had to lean in to hear him.

"Carmita"—he strained to whisper the words—"I would like a small piece of Cuban bread—*and coffee*."

I didn't move right away, and he jutted his chin, with some effort, toward the door. "*Ahora*. Now, please."

"Are you sure you can swallow it?"

What was I afraid of? That he might choke and die? This is only one of many absurdities that assault your common sense as you care for the dying.

He tried to laugh, but ended up surrendering to an alarming coughing fit instead.

When he quieted, I hurried along to the kitchen. It didn't take long to toast and butter the Cuban bread and brew his *cafecito*. When I returned, he

was restless and his eyes were bright. I lowered myself onto the edge of the bed and fed him the coffee from a spoon. I'd made it sweet and strong. He sighed and smiled at me.

"*Pan, por favor*. Bread, please."

I pinched a small corner. He opened his mouth like a hatchling, and I dropped it in. He closed his eyes and rolled his head back and forth, making the smallest of moans.

"Papi, what is it?" I asked.

He chewed for a few more moments before replying, "With the coffee still on my tongue, I found a par-ti-cu-lar-ly delicious corner of the bread, dripping with warm butter." He produced a smile that had no business on the face of a dying man, a smile that made the whole of his emaciated body surrender to a small shiver of delight.

I responded with a shiver of my own as, at long last, I believed I understood the story of the strawberry. The art of dying, it would seem, is to savor life to the last nanosecond of sentience. Then—without regret or hesitation—to let go.

The Mystery of Creativity and the Unmasking of Beauty

Patricia Ellisor Gaines

The two times when a woman is most free are when she is very young and when she is very old.

When I was very young, four to be exact, I decided after much consideration against becoming a movie star or a ballerina in favor of being a visual artist. The realization that led me to that choice was that art was something I could do when I was *old*, and I have been moving in the wake of my determination ever since.

Now having passed into the ninth decade of my life, I am comforted by the fact that had I become a ballerina or an actress, I certainly would not still be doing either of those things—but I am still making art. Undeniably old, after a long and varied career as a visual artist, my question now is: What should I do next? What is still possible? Where exactly am I going with my art, and do I have enough focused energy to get there? Looking back at my childhood career choice forces me to reflect on what I have learned, where I have been, what motivated me in the past, and to wonder if it is possible to keep growing at this "august" age into my earliest dreams for myself.

I am a big collector of quotations because I have been so often informed and inspired by the wisdom that can be found in them. One of my standbys is by my favorite artist, William Blake, who wrote: "If a fool persists in his folly, he will grow wise." A second favorite comes from the Great Houdini: "Magic is practice." These keen observations on life have been two of the arrows in my quiver, and they have served me well.

Years ago I read a memorable book by Eleanor Munro titled *Originals: American Women Artists*. Late in the book Munro writes how she was surprised to realize that, when asked to describe their earliest visual memory,

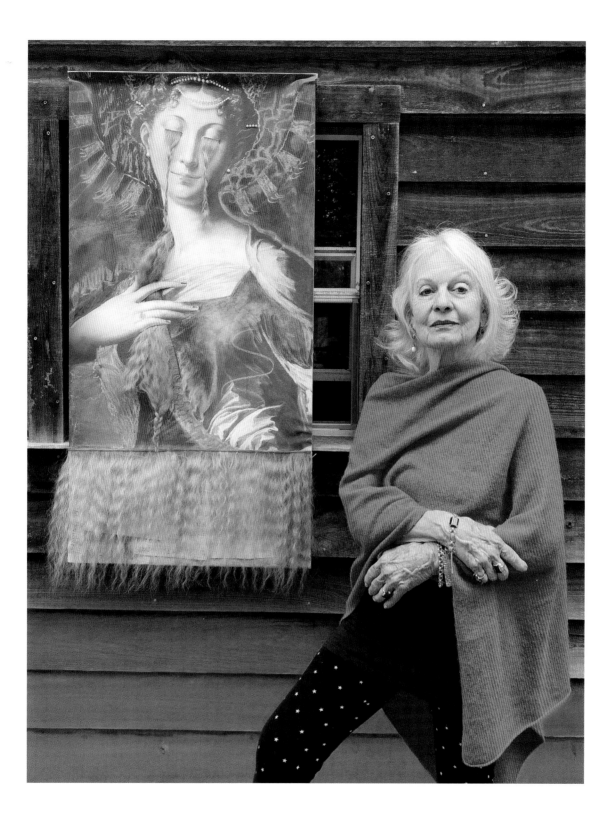

many of the visual artists she interviewed described the art they were at that time doing! In one interview, for example, Georgia O'Keeffe described sitting on a colorful quilt before being carried into her aunt's home where she saw a small painting of a moss rose whose petals spread out until they reached the edges of the canvas and overflowed into space. A Georgia O'Keeffe painting!

— I too remember being strongly affected by a flower. At about four years old, I had wandered outside in my little pink chenille robe where I was met by our family dog, Spotdog Ellisor. His face was on the same level as mine, and I adored him. He stood at a garden fence where a blue flower was opening. As I gazed, it bloomed right in front of my eyes, and the effect upon me was profound. I thought it was the most wondrous and beautiful thing I had ever seen. That afternoon the blossom closed and shriveled, and I was distraught, but my father consoled me with the assurance that it would open again at daybreak. So it did, and the morning glory became my favorite flower. I love its ability to self-generate, to follow the sun, to inspire and energize with its mystery and magical beauty, and with its astounding ability to move as if in a dance. I am still obsessed with the force that drives this flower through its green stem, to paraphrase Dylan Thomas.

In Arthur Koestler's book *The Act of Creation*, he suggests that the roots of art, humor, and scientific discovery have in common the bringing together of opposite or incongruous elements. He goes on to suggest that in all three of those areas accident can play a major part, in addition to skill, talent, inspiration, and preparation.

In my middle years, I experienced a "block" which I could not find my way through. When I turned forty, I took one of our family's best dining room chairs and covered the entire thing with undulating bands of blue and gray crochet. When I stepped back and took a look, I felt as if I was at sea. Shortly after that, I upholstered my third child's outgrown bike in black fabric. He was almost thirteen and about to go away to school.

"Well," I said. "Maybe I'll have time for my art now." I walked up to an empty canvas and began to weep and was unable to stop. I wept for lost time, for lost dreams, for my lost children who had entered that strange limbo land between childhood and adulthood, and I wept for my father who was dying, a man I had been so distant from for so long. He was a preacher-man from South Alabama. A man who rarely spoke unless he was behind a pulpit. A man who did a lot of good works and who loved his children but refused to protect them. Unable to paint, I picked up a hammer

and saw and began building strange shapes . . . leaping animal shapes, raised hands. I built things that looked like parts of houses. Maybe these had to do with all those parsonages I lived in as a child. I put plaster and paint around the shapes and stared at them with incomprehension. I felt dissatisfied with these constructions and cut the top third off each one. This part I leaned back like a roof and built a construct underneath. Seeking interpretation, I picked up Carl Jung's book of symbols and discovered that the leaping animal shape is one of the most archaic symbols for the self, and that my upraised hands represented the human search for spirituality. Thus did Carl Jung become my spiritual guide.

Next, I read his large autobiographical book, *Memories, Dreams, Reflections*, within which he describes himself as having a breakdown of sorts. He could no longer treat his patients or do his writings or research, so he went out to his land on Lake Zurich and began to work with rocks, at first just moving them around and finally building a stone tower. Through this physical activity Jung rebuilt his emotions, his mind, and his ability to heal himself. His famous quote "Only the wounded physician heals!" became, and remains, my mantra. Art, I have learned, is the ultimate healing, whether it be painting, sculpture, music, writing, dance, or drama. All the arts are capable of supporting, healing, and renewing us.

Which is why artist's block is such a serious concern. It seems to occur when we have put too much stress on ourselves. Here are a couple of hard-learned rules of the road for dealing with it:

- Do not get too hungry, too tired, or too lonely.
- Certain practices such as a brisk meditative walk are essential. We need enough energy to raise a strong vibration in order to channel creative energy. Another function of the walk is to get us out of our heads. Go outside to focus on the "other." Connect with whatever you encounter on this walk. This is not a time to focus on creative concerns, but rather a chance to balance your brain and spirit. We need this to pull us out of our self-absorption. At the same time, we fill the well with sights, sounds, and movement. And often our creative problems will solve themselves while we are otherwise occupied.

The making of art can be a tricky business. If you try too hard, it is easy to get blocked. Julia Cameron has written an excellent book, *The Artist's Way*, to help creative people get over being blocked. In it she argues that creation is play and that we are all "creatives" from childhood, but some of us are discouraged from carrying this inclination into our adult lives. In line with

this theory, reality therapists suggest that, after food and shelter, there are four basic human needs: love, work that feels valuable, freedom, and *play*. True creativity certainly encompasses all four.

Here are a few other things I have learned the hard way about the job of being an artist:

- Whenever possible, put your creativity first; if you don't, unless you are very disciplined, it will come last.
- Try not to be too critical of yourself or your work. Nurture both as you would a child.
- Do not be afraid to fail! Recognize any failure as painful growth. I am an artist who is fascinated by beauty and naturally would prefer that all my work be beautiful. The parts of me that want this I identify as perfectionism and pride. Both will mess you up. To be too critical is self-sabotage. I am reminded of a Picasso quote, "I am criticized for being too primitive in my technique. However, I am exploring uncharted territory. I slash and hack and cut. Leave it to the horticulturists who come behind me to neaten up my trail."
- Ultimately, I believe that art is a pathway to knowledge (self-knowledge and universal knowledge as well). It is a way to learn to know yourself in all your irrepressible variety. Follow your obsessions, but not too far. Keep your balance. Somerset Maugham called this walking the razor's edge. He said that all artists must seek this balance where opposites collide. This is where energy is created. I call it walking the tightrope.

I would be remiss if I did not include this next part.

After discovering the Jung symbols book, I was not done. I knew I was searching for the self and for spirituality, but I could not stop wondering about the deeper symbolism of the wooden pieces I had created when I was blocked on my painting. What are they? I asked myself. What am I trying to find? The top third of each piece was stucco, on which I had done paintings. I had cut off these tops, leaned them backwards, and built a construct of support behind each. Then I had placed each one against the studio wall. As I moved back from the pieces, I asked myself what *were* these strange sculptural shapes leaning backwards like solar panels? What did they mean? What were they struggling to tell me? Once again, I picked up the Jung book and approached the pieces. One had a piece of carved molding standing out below the painting, and I placed the open Jung book on it as if it were a lectern. I walked to the back of my studio, turned, and gasped! It was only then I saw that I had built a whole roomful of pulpits.

As Eleanor Munro discovered in her interviews, we artists are often powerfully and permanently imprinted by visual images from childhood. My father was a valiant, if mirthless, Methodist minister, and I was stunned to realize that a carved pulpit was the first sculptural shape I had seen as a young child while seated in the front row of his church in Eutaw, Alabama. I was trying to bridge that gap between father and daughter, between old and young, between life and death. In this attempt to reconcile opposites, I crossed over the line from my place of loss and fracture into a place of healing.

I will close with a final anecdote illustrating that intriguing fact. Years ago, at a friend's party, I had the good fortune to meet Louise Nevelson, one of my favorite and most admired artists. She built enormous wooden boxes, inside of which are rough-carved, abstract shapes that are both beautiful and mysterious. When I met her, she was wearing a long chinchilla coat lined with silk paisley, and her eyes were sporting the most abundant black false eyelashes I had ever seen. In conversation with her I learned that she had emigrated with her family from Russia. She was five then and remembered the dark wooden timbers that surrounded her in the hold of the ship. She also remembered running up wooden stairs to the deck, where she was not supposed to go, and seeing there lots of wooden barrels. On raising the lid to one of the barrels, she found it to be filled with large dolls' eyes, fringed with abundant fake black lashes!

Now, in addition to my painting, I too create wooden boxes filled with found objects and religious imagery. Creativity is a mystery, one that involves us from our impressionable, play-loving childhood onward. But the mind loves a mystery. Why? Because there is nothing more beautiful. ·

What Do You Want to Be When You Grow Up?

Patti Callahan Henry

My youngest child of three, my son, Rusk, walked across the stage at my alma mater, Auburn University, in his black robe. He threw his square cardboard hat in the air with the rest of the group, and he graduated with a business degree. Just like that. And I cried. I had expected to celebrate, but what I hadn't expected was what came over me in the following weeks—the swamping feeling of loss and the untethered quality of feeling at loose ends with myself and my life.

I'd done my job, right? I'd spent the last thirty years raising three little humans who are fiercely independent, smart, and an absolute pleasure to be near (although not every year was a pleasure, to be true).

What's next?

Each time I need to ask myself that question, I know I am in the middle, in the betwixt and between, and I don't like it. Not one little bit. I know I'm *supposed* to like it—psychically it is meant to give me space to sit still and find what is being called forth inside me. But I prefer knowing where I am and what I am doing and then going for it at a hundred miles an hour. I prefer getting up with my to-do list and my book in the works and my life in progress. To sit still in the in-between is uncomfortable.

Richard Rohr writes much about this part of our lives; so do Carl Jung and James Hollis. They say we have a chance to redefine, redo, and find purpose beyond the roles and structures we've used to keep ourselves safe. Rohr calls it "falling upward," and it's an apt metaphor. When I was home with three children under six years old, what I thought about my life was no longer working and I felt as if I might be in a free fall—but, says Rohr,

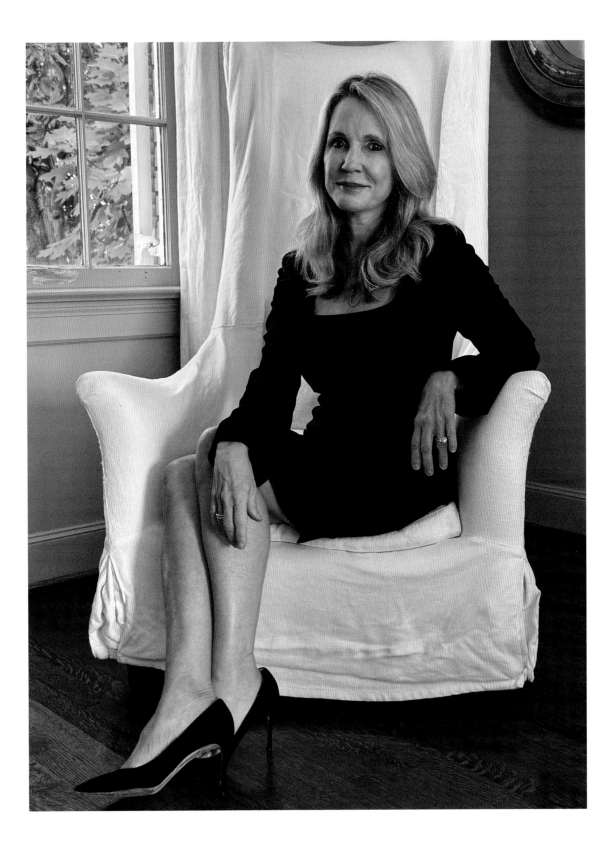

maybe, just maybe, I was falling upward to something new. It could even feel like surrender to my own soul's calling.

— "I want to be a writer of books."

Those words weren't mine. They came from the innocent and precocious mouth of my six-year-old daughter, Meagan, many years ago. But they might as well have come from me.

Back then, I was a nurse with a master's degree in pediatrics, but at that moment I was a stay-at-home mom with three kids under six years old. Meagan and I were playing with her plastic Fisher-Price dollhouse, the one with the pink roof and the helmet-hair three-inch family members, and I had just asked her, "What do you want to be when you grow up?"

It can be an important question or it can be a lazy question, one we are trained to ask, a fallback question passed down from generations of ancestors who want to know what we are going to do with our lives. It can feel final—tell me now and never waver. But there is never *one* answer, and we can change our answer whenever we please. No one ever told us that, did they?

That day, Meagan set down her doll, looked heavenward, and said she wanted to be a writer of books.

Part of me knew why. Books were at the heart of our special time together. With two little brothers, reading was *our* time. "One more book" was a constant refrain.

"Oh," I told her, "that's what I want to be when I grow up."

"You're already grown up," she said to me with incredulous certainty.

I was thirty-five years old and this was a pure moment, a liminal moment. Sitting there on her bedroom floor while her brothers napped and we played with a house made of molded plastic, something true had fallen from my lips and into my life. *That's what I want to be.*

Sometimes we're afraid to say who we want to grow into. Others around us might not want us to change, telling us we're fine just the way we are. But is *fine* what we want? No, definitely not. We want more than fine. We want to become who we were meant to be.

Who is that? How do we know? And by the way, we have responsibilities galore. We have families and jobs and bills and insurance and car payments and . . .

Yet, often, the hidden desires of who we want to become—because we are always becoming a different version of ourselves—are unspoken and tucked away in the things we loved as a child. Sometimes the very things

and activities that sustained us, or had us falling into the pure divinity of suspended time, are the callings of our life. As the poet Mary Oliver asks, "what is it you plan to do / with your one wild and precious life?"

For me, it was reading and writing. I carry a lot of beautiful memories from my early years. But I can say without a doubt that my favorite recollections, the ones that rise to the surface in a quiet moment, are the times I was alone with a novel or an empty notebook or a typewriter and a box of colored pencils to draw the cover of the story I just wrote.

But was it realistic to give in to that calling of my heart? To listen to the whispered answer inside "What do you want to be when you grow up?" Seriously, aren't we already grown up?

Yes, but we are always changing. Years passed from the moment I said "That's who I want to be" to the moment my first book was published. Saying it, admitting it, and putting the words to the hidden life wasn't a magical spell that changed my life in an instant. Nothing works that way but in the movies.

I began step by step, class by class, early morning by early morning. When I first started writing, I started with *The Artist's Way* by Julia Cameron. Through writing morning pages and completing some of her exercises, I slowly dismantled my resistance and fear brick by brick, unmaking a wall I had made for most of my life, a wall created of my "should do" and "must do." And I didn't build a new wall. Instead, I built a path to a different kind of life.

While I still worked part-time as a nurse and learned to be a mother to young children, I signed up for writing classes at Emory University, joined a local writing group, and entered contests that returned my work to me with some harsh criticism.

Even if the negative input—"Your writing is dull, dark, dreary and depressing"—hurt for the moment, it spurred me to learn more and refine my craft. I rose at 4:30 each morning and wrote for two hours before the kids woke up. I read books about writing; I attended lectures; I dove into the deep end of the publishing world without a life preserver. I keenly remember entering a room full of writers at a conference and feeling like my heart would burst out of my chest, my hands sweating.

It was four years later when an agent finally noticed the first pages of my book in a contest I had entered, and my publishing journey began. But even then, my first book didn't sell; it was the second book I wrote that finally sold to Penguin Publishing. That was eighteen years and sixteen books ago. My journey was far from an overnight success story—most lasting changes are far from an overnight story.

We can rarely just upturn our lives, change it all, and run from our jobs and responsibilities. And I didn't: I tried to make incremental changes that would allow writing to become an important piece of my life.

When I rounded into my fiftieth year, I was a multi-published author. Steady on, right?

Nope. Because if we aren't changing, we are stagnant, and if we are stagnant we are dying. Rohr says, "Transformation is more about unlearning than learning" in this part of our lives. And I agree.

One evening while talking to a dear friend at a Christmas party, I was lamenting how I felt my well was dry as a bone. I was uninspired. Uncreative. Unyielding. She asked, gently, the simplest question: "What would you write about if you could write about anything you want?"

"I would write about the astounding woman that was C. S. Lewis's wife," I said. "But I don't write historical fiction."

As soon as the words escaped from my thwarted unconscious, I knew they weren't true. I knew that I could write anything I wanted. That I could change again. And then again if I pleased.

And yet fear of change can have us denying the unguarded answer to "What do you want to be? *Who* do you want to be?"

The answer doesn't have to be about an instant revamping of our lives. It definitely doesn't have to be about a career change. And yet the answer can lead us to make small-step changes in our lives, from community involvement or joining a book club to enlarging our family or healing a relationship. Even the most seemingly insignificant changes can add up to mighty transformations in the course of our lives.

I knew all this and yet, when my youngest graduated from college, I was irritable and inattentive to the day's beauty—the hydrangea suddenly filling my yard like popcorn, the sweetness of my dog, Winnie, under my desk with her nose on my toes, the cool mornings that made me feel alive, and the children's voices as they walked to school outside my home office. When this preoccupation happens and my thoughts are grasshoppers in a tall field and won't settle, I turn to something I started more than twenty-five years ago: morning pages as taught by Julia Cameron in *The Artist's Way*. And long walks in nature alone.

Change brings me back to the basics.

It's not easy to understand that I am well past the middle of my life, and I don't particularly like to think about that. I'm in the last fourth, or the last third if I'm lucky. Regret creeps up, purposelessness inches toward me, and

society doesn't help with its damnable obsession with youth and its dismissiveness of aging women.

During this time, I wrote long pages in my journal-no-one-will-ever-read. I untangled the overwhelming emotions and tried to find a center in them. I like Rainer Maria Rilke and his poetry about "living into the questions." I could write unanswerable questions in my morning pages and not find the answers right away. Just the sheer act of scribbling them down, of unloading them, helped me find my way back to attentiveness and presence.

In this second half, or last days, or last hours of our life, I've come to see that what matters is this: purpose and meaning and connection. James Hollis said in his book *Living Between Worlds* that what we believe we want is happiness, but what we really want, deep down in our heart of hearts, is purpose and meaning. And where does that come from? It comes from what we do with our minutes, our hours, our days, and our lives. To move toward who we want to become while keeping our lives in balance with our responsibilities can be a herculean task. It's a journey of small steps toward a bigger self. But it's well worth it, a true hero's journey.

So is another change drawing near? My children are free in the world. I am now Mhamó (grandmother in Gaelic). I am betwixt and between again, but I can finally see that this is the place of growth. Of transformation. Of absolute possibility. This is the gift of age. I hope to accept it with gratitude and grace.

Will the words find me when I am old and gray? Will they spill from my mind into my pen with the same ease they did when I was young? I do not know the answer, but I go in search of those elusive words each and every day.

Finding the Words

WRITING PAST THE AGE OF FIFTY

Angela Jackson-Brown

When I was thirty and my son, Justin, was just shy of his ninth birthday, I made a decision that, to this day, I do not regret. I was going through a contentious divorce, and the more I tried to do everything—write, work, parent, pay bills, breathe—I realized it was too much. But more specifically, I realized that in order for me to properly mother my amazing, demanding, all-consuming boy child, it was not going to be possible for me to be the writer I wanted to be and the mother I had to be for Justin, all at the same time. I am and have always been a type A individual. Ambitious? Check. Workaholic? Check. Achievement oriented? Check. Go down the list of what it means to be type A, and I possess many of those traits. So I knew if I had to be a writer on the side or a part-time writer, I would not be satisfied. I also knew that if I couldn't approach motherhood with everything I had in me, I also would not be satisfied.

Of course I knew many women who were both mothers and writers, and many of them seemed to succeed at both, but I just couldn't figure out how I could keep all of the balls in the air at once. So I gave myself permission to delay my dream of being a published writer. I wasn't giving up on writing, but I wasn't going to give in to the feelings of guilt that I couldn't be the "every woman" Chaka Khan sang about. So I willingly relinquished the "S" on my chest and resigned myself to the fact that Superwoman probably couldn't do everything she wanted to do either, and it was okay to say, as much as I want to do it all, it's not in the cards for me. And I did not allow that inner voice to tell me that I was a failure because I couldn't do it all.

So I set aside my dreams of being the next Toni Morrison or Maya Angelou (two phenomenal authors who did find a way to be writers and

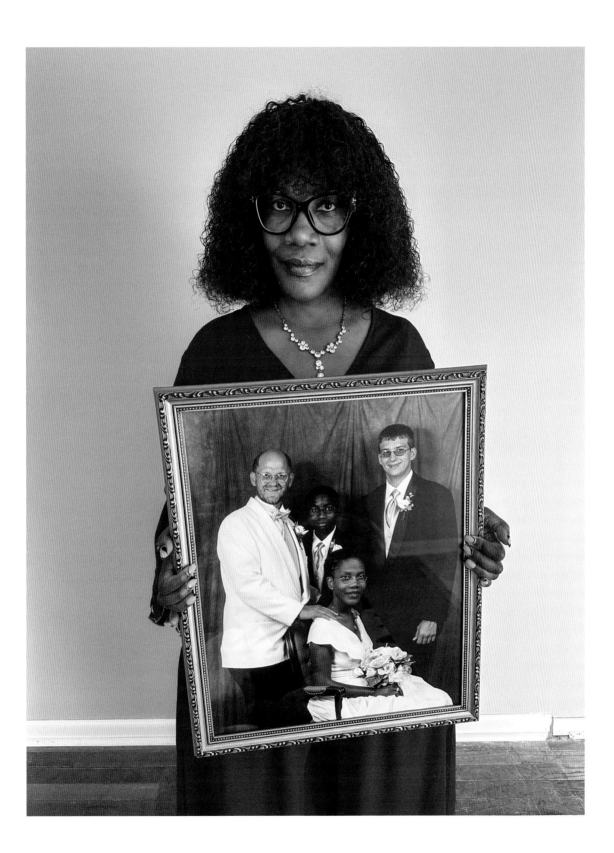

mothers at the same time) for actively being engaged with my son's Little League baseball, parent-teacher meetings, band competitions, and dance recitals. Don't get me wrong, I loved every single mommy moment that I got to experience, but as my son got older, I started wondering—*what if?* What if I put my mind to writing with the same single-mindedness I put into being Justin's mom? What if I showed up every single day to write just like I showed up for him?

I was hesitant at first because, by this time, I was moving toward forty and I just didn't know if I had it in me anymore. When I was a teenager, I had my life all mapped out. I was going to graduate from high school, move to Greenwich Village, and take classes at NYU. I was going to publish my first book with HarperCollins, and on the weekends I would hang out in the Village with my other *New York Times*–bestselling author friends. That was the life I planned on, but fate had something else in store for me.

Yes, I continued to write, but nothing like I did in my dreams. In my real life, there were no fancy lunches with my agent at Tavern on the Green. No quick shopping trips to find a dress for one of the many awards ceremonies where my books would be honored. Instead, I created poems for my family and friends to commemorate their birthdays, weddings, and anniversaries, and all the while time marched on with the rapidity of a hummingbird flapping its diminutive wings at what seemed like the speed of light. That tiny voice inside my head continued to whisper, "You will never be a published author. You will never live out your dream."

I allowed this ugly voice to whisper microaggressions at me until finally I decided I must honor the words of Andy Dufresne in the movie *The Shawshank Redemption*: "Get busy living or get busy dying." I recognized that if I truly wanted to be a writer, I couldn't use any more excuses. Not my son. Not my husband. Not my job or any of the myriad of other things that popped into my mind. So I did what I have always done when I felt overwhelmed—I sought out people who understood my plight. In this case, I sought out people who understood the business and craft of writing better than me. I went to Spalding University in Louisville, Kentucky, located just a few miles from my home at the time, and I enrolled in its MFA in Creative Writing program. It was a perfect scenario. The program was low residency, meaning I could keep my full-time job in marketing and PR and attend the residencies twice per year (using my vacation hours). My new husband was extremely supportive and wanted me to approach school just like I had approached everything else in life—with fire in my belly. So with his encouragement and the encouragement of the faculty and staff at Spalding, I did

it. I jumped off the symbolic cliff that represented safety to me, and I took a chance that my talent and my tenacity would serve me well.

For three solid years, I ate and slept writing. I soaked up everything my teachers and mentors said to me. I was like Hermione Granger from the *Harry Potter* series. My hand was constantly in the air with questions, and my notebooks were filling up with every word or thought my teachers and mentors uttered. If Kentucky's own Crystal Wilkinson or Silas House said it, I jotted it down and committed it to memory. They were where I wanted to be, and I knew if I just listened hard enough and asked the right questions, I would figure out the path. It also helped that they were generous with their time and talent.

One thing I did learn was that if I wanted to be a prolific writer I had to have a plan. Writing by the seat of my pants was not in the cards for me. I come from a business background, so I understand the importance of schedules and a detailed plan. I was not the type of writer who waited for some elusive muse to find me. I was the daughter of a World War II vet who scraped and scrapped for everything he ever got in life, and I modeled myself after Daddy. If I started a story, I was determined to finish it, and if I needed an agent to reach the level I wanted to reach, then I would devise a plan for that too. I planned everything. Every poem. Every short story. Every "chance" meeting with literary agents and editors. I was determined to treat being an author like a business, because I was approaching fifty and I did not know if I had another fifty years ahead of me to write all of the stories that danced in my head. I read about as many books on the business of writing as I did on the craft of writing, and from those books I developed an approach that worked for me. I knew I would have to keep working a full-time job—bills were not going to disappear just because I had a new goal in life—but the eighty-plus hours per week I was working were not going to cut it either. So after ten years in marketing and PR, I left the nonprofit sector and went back into education as a contract faculty member. I made a lot less money, but teaching afforded me the time I needed to focus on writing and publishing. On a regular basis I thought about Langston Hughes's poem "Harlem": "What happens to a dream deferred? Does it dry up like a raisin in the sun?" Had I put off my dream of being a published author for too long? Was all of my drive and tenacity for nothing? Would anyone want to publish an almost fifty-year-old woman when there were so many young ingenues ready and willing to paint the literary skies with their passion and power as writers? I didn't know, but I knew one thing: if I continued to write, if I continued to show up to the page every day, then there was hope.

I also was in the unique position of not needing the writing to define who I was. I had done that already. I had been the best mother I could be. I had accomplished great things in my career in marketing and PR, and I had successfully returned to teaching. I was happily married, and we had amazing pets who lived long lives and loved us. What more did I have to prove?

Realizing that helped me to calm down and just enjoy the process. I published my first novel with a small publishing house in Utah. It did okay. I didn't get recognized by the *New York Times*, and I didn't make enough money to retire, or even take a long, relaxing vacation, but I learned a lot about the publishing industry and what I wanted out of it. For my next book, I knew I needed an agent, and I found an amazing young woman who was as hungry as I was—Alice Speilburg.

Everything was looking up, but I still had to contend with writing at an older age. By the time Alice sold my second novel, I was well into my fifties. Not only did I have to contend with so-called writer's block, I also had to deal with chronic arthritis, brain farts, and hot flashes. At first glance, one would not think those three things are conducive to being a successful writer, but in some ways they really have been. All three conditions, along with birthdays that are happening at warp speed, remind me that my time here on this planet is growing shorter, not longer. So I can dedicate the next however many years I have left to feeling melancholy and sad, or I can tell every story I ever imagined telling with the type of tenacity one usually attributes to the young. The author of *Eat, Pray, Love*, Elizabeth Gilbert, said, "Writing is not like dancing or modeling; it's not something where—if you missed it by age 19—you're finished. . . . Your writing will only get better as you get older and wiser. . . . At least try." I love her advice, especially the part where she says, "At least try." That is what I have dedicated the rest of my life to doing—just trying. If I don't make it to the *New York Times* bestseller list, but my mind stays fresh well into my sixties, seventies, and eighties, allowing me to write with a wild abandonment until I close my eyes for the last time, I would count the latter the true win in my life. So I am spending a lot of time just thinking about my journey to this point of my career. I have now published three novels, one book of poetry, a whole host of plays, and I feel like I am just getting my feet wet. I always credit my daddy, M. C. Jackson, for my love of writing. Daddy wasn't an educated man, he was a World War II vet who had to quit school during his tenth year to work on the family farm where they were sharecroppers in a small, rural town in Alabama called Ariton. Daddy was just shy of fifty years old when he adopted me, and one thing he was adamant about was that I get a good

education, and I knew that whatever I was able to dream of becoming, he would move heaven and earth to help make it happen for me.

Somehow, before I was able to actually write words, Daddy figured out that reading and writing were going to be my pathway to success someday. When I was no older than five or six, my daddy started the practice of bringing me a new book every time he went to the store. *Amelia Bedelia. The Poky Little Puppy. Little House in the Big Woods. The Cat in the Hat.* At a very young age, I learned the importance and magic of words. It wasn't long before I started writing my own stories, and Daddy poured into me the belief that (1) my stories mattered and (2) those stories would matter to other people someday. Repeatedly he would say, "Baby girl, one day you are going to be a writer." Even as the years went on and I didn't pursue publishing, I always believed I was a writer whose words mattered because M. C. Jackson said they did.

Now, here I am, in my mid-fifties, and I am living the life he prophesied all of those years ago. I find myself experiencing the same joy I felt when I rewrote the fairy-tale stories he would read to me. I did not like the fact that there were no Black girls like me in those stories, so I would change them to make them fit with the world I knew underneath those pecan trees in rural Alabama. And here I am, working on a novel set underneath those same pecan trees, finding the same happiness I felt way back then. I know he would wonder how that little girl became a fifty-something-year-old woman, but he wouldn't wonder over the fact that I did live out his dreams for me.

One thing I do hope for, more than awards and accolades, is a legacy that I can leave behind that will inspire other young children who might have rural upbringings and can't imagine that anyone would ever want to read their words about their life and times. As a Black girl from the South, I didn't get many opportunities to read books by Black writers. They weren't in my school or public library, so it wasn't until I was a third grader and my first Black teacher, Mrs. Kennedy, introduced me to Maya Angelou. She gave me the book *I Know Why the Caged Bird Sings.* She said, "This book is probably too old for you, but you have read everything else on the bookshelf, so see what you can do with Maya Angelou's work. I'll help you with any words you can't figure out." Well, figuring out words was the least of my worries, but what did stump me was the Black woman on the book cover. I had not seen a Black author on a book cover before. So I hesitantly asked Mrs. Kennedy, "Who is that woman?" She said, "That's Maya Angelou, the author of the book." I looked at Mrs. Kennedy with wide eyes and asked, "You mean Black people can write books?" Mrs. Kennedy threw back her

head and laughed with a joy I had not heard in her laugh before. She pulled me into a hug, and whispered in my ear, "Oh my dear girl. Black people not only can write books. Black people can do ANYTHING." From that moment on, I believed my daddy and Mrs. Kennedy. They planted the seed that would eventually grow into the person I am today. I hope I can give that same belief to another writer.

Writing at an older age requires the same amount of hard work as writing at a younger age does, but there is something special about the knowledge that every story could be my last. As a young writer, we don't normally think along those lines. We tend to think, because we anticipate long, productive writing lives, that a story is always just around the bend. We don't feel pressed when we go days or weeks or even months or years without writing. We have time, or so we think.

I no longer live with that certainty of unlimited time on my hands. I have some very scary illnesses that I deal with on a daily basis, and cancer and dementia run in my family. Every day I wake up is a bonus, and every day a story creeps into my mind is a cause for celebration. I can't get caught up in the drama of competitiveness or any of the other pettiness that sometimes exists within the writing community. I have too much writing to do to enter into the games people sometimes play as they compare their reviews and their accolades. Those things are great, and I am always thankful when someone honors me with an award or a nice review, but I don't allow it to slow down my forward movement. I write first thing in the morning, and I write just before I go to bed at night. I am grateful for each and every word that comes into my mind, and I always thank God for giving me one more chance to tell a story, write a poem, or pen an essay. Every day a story shows up, I greet it like it is a long-lost old friend, and I say to it, "*Welcome. I am so happy you decided to visit me today.*"

Más sabe el diablo por viejo que por diablo.

The devil knows more from being old than from being the devil.

—Spanish proverb

Here's Looking at You

FRAGMENTS FROM AN OLDER SOUTHERN LATINX WOMAN

Cecilia Rodríguez Milanés

It is impossible for me to coherently address what it is being an older Latinx woman,[1] one who's lived in the South for most of her life, without affirming how much the pressure culture and gender expectations put on Latinx women matter, especially for those of us who have long lived in freaking Florida.[2] (My northernness wants to say "fucking Florida," but every so often a measure of southernness requests gentility.)

My youth was formed in the North, and I came into womanhood and motherhood in the South. I used to say I had both northern and southern sensibilities, but truth be told, the South I'm from isn't Alice Walker's or Flannery O'Connor's. Or Zora Neale Hurston's. It's not even Judith Ortiz Cofer's.

Miami, Cuba

To address the elefante in this essay: Miami, where I lived out my late teens and twenties, isn't a southern city; it isn't even American. South Florida isn't

1 I use the term "Latinx" because I'm comfortable with it and support its nonbinary inclusion. I sometimes interchange it with "Latina/s" to indicate women, specifically, of Hispanic descent— although very few South Florida Spanish-speaking folks use the term "Hispanic," tending instead to identify themselves by nationality as Cubanas, Dominicanas, and so on (female endings intended here).

2 Ah, fun in the sun, stupid Florida, home of Pulse and Parkland, sanctuary of QAnon and Confederate devotees and sycophant politicians hell-bent on eliminating women's rights to their own bodies, erasing LGBTQ+ folk, eroding voting rights, whitewashing educational curriculum, and more such tyrannical moves, whose only agenda is more power for themselves. I could go on, but that would veer me way off my intended purpose here.

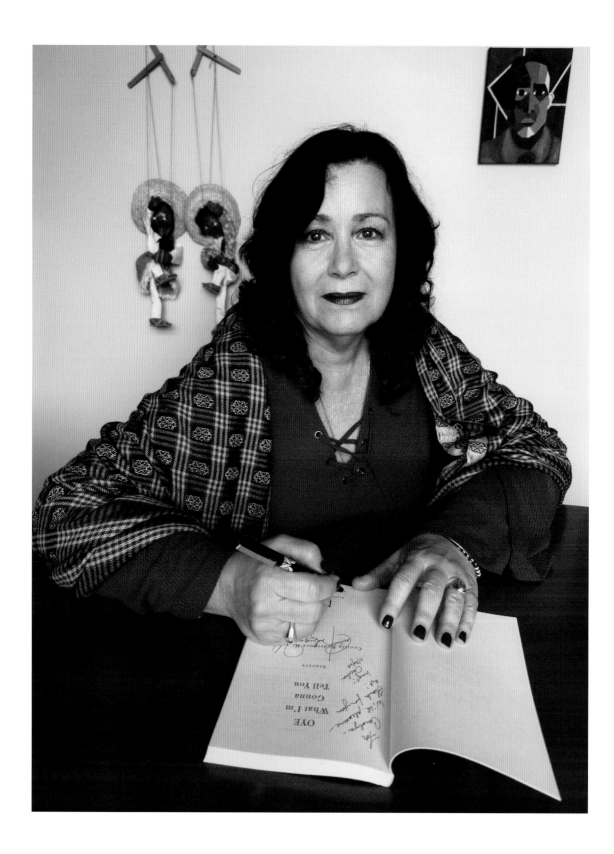

southern either. People, mostly academics, might refer to it as the "global South," and I get it—a place where compromised people from throughout the Americas have voluntarily migrated, or been forced to, due to failed or failing countries thanks to imperialism and U.S. intervention. There are so many Caribbeans (from French, English, and Spanish former colonies) and Central and Latin Americans who make South Florida their home. But trust me when I tell you that none of them would call themselves southerners. They—the Spanish-speaking ones—call themselves Colombianos, Venezolanos, Nicaragüenses, Argentinos, Dominicanos, Puertorriqueños, and so on. In Miami the majority of "them" are Cubanos. Because, collectively, more Cubans have arrived in South Florida since 2000 than in all previous migrations,[3] Miami remains culturally Cuban-dominated (politically too). As in, Miami, Cuba.

Of course, no city, state, or region is a monolith. Miami is no exception. It is made up of many enclaves where just about anyone from anywhere in the world has found a home and feels at home. It's not my home anymore, but I still recognize it as an important "once home" when I visit; it is an effervescent setting I return to over and over in my work. There is a lot of cultural fusion, flux, and mixing among the children, grandchildren, and great-grandchildren of their immigrant elders. A lovely hybridity is emerging—you know, a white supremacist's nightmare where no one unified race or ethnicity can be determined. And I'm here for it.

Orlando, Mickeytown

Central Florida, where I've lived for over twenty years now, isn't and hasn't been very southern for a while—at least since the mouse set up house here fifty-plus years ago. It's an in-between, liminal place for real Florida crackers (a few are indeed left in the rural parts),[4] Puerto Ricans from both the island and the Northeast (they make up the vast majority of the Latinx folks inhabiting the region), and an array of transplants: besides the Brazilians, Vietnamese, South Asians, and others, there are transplanted South Floridians who left Miami-Dade and Broward Counties after Hurricane Andrew in 1992 and who have continued to move here for cheaper home

3 For more, see Jorge Duany's "Cuban Migration: A Postrevolution Exodus Ebbs and Flows" on the Migration Policy Institute's site, www.migrationpolicy.org/article/cuban-migration-postrevolution -exodus-ebbs-and-flows.

4 Don't be shocked; the early white settlers to the region were ranchers called "crackers" because of their use of whips. The term is historical and not pejorative in Central Florida.

prices and less traffic. Then there are the other folks from out of state, lots of northerners. And of course, lots of cultural fusion, mixing, and intercultural mating going on here too.

Many Central Floridians work directly or indirectly for the largest employer in the region. Yup, Mickey! It is not a retiree-rich region; more young people reside here. It thrives because of tourists who adore Harry Potter, Legos, Shamu, or the latest Disney princess and leave lots of money in their wake. And even though the region has a lot of "natural beauty," let's face it and forgive the redundancy, most tourists come for the theme parks.

Orlando, where I live, is called the City Beautiful. Proud of its LGBTQ+ forward attitude (we say gay), many Orlando area businesses are targeted for the younger crowd—boutiques, vegan bakeries and bistros, coffee shops, microbreweries, sports venues, bars, clubs, vintage clothing stores, New Age everything, and all sorts of specialty shops like ax-throwing joints and, oh, yeah, lots of cannabis dispensaries too. When I lived in Miami, I used to say—in my totally unselfconscious and biased view—that Orlando was like the Midwest, devoid of color or culture. Clearly, I had no understanding of Florida (or American) history.

I am on Zora Neale Hurston turf. Eatonville is mecca for Hurston admirers and scholars; there are festivals, conferences, and exhibits that celebrate that "genius of the South." Hurston would probably get a kick out of the assortment of cultures and folks making their lives near her old stomping grounds.

My first university job took me to rural, white Western Pennsylvania—I'm talking coal-mining country. Stupid me, I thought Pennsylvania was a Middle Atlantic state like New Jersey. I learned soon enough that it was "Philadelphia and Pittsburgh with Alabama in between."[5] Warned not to rent or buy in the towns just north or south of the college town where I worked because there were KKK chapters there, I got quite the education. By the time my young daughter was school age, she was the only Latinx child in her classes, just as I was the only Latinx professor at my university. I went on the job market right after my first year, trying mightily to return to Florida. We—my family and my characters—yearned for our culture, language, foods. My partner and I didn't want our young daughter to always be the minority. When the offer came and I asked her if she would like to live in Orlando, where Mickey lives (I know, low blow), she responded immediately with a big smile and bigger yes.

5 Obviously, I had never heard James Carville's quote before moving to Indiana, Pennsylvania.

CECILIA RODRÍGUEZ MILANÉS

Central Florida is just right. It took eight long (dog) years to return to Florida. We were thrilled to be only four hours from our Miami families (instead of an interminable two-day drive), less than an hour to the beach, and, yes, close to all the theme parks. Houses were cheaper than in South Florida, and there was far less traffic. Twenty years ago Orlando felt like a young Miami. It was lovely to be among such a diverse demographic, even more so than Miami. It was not without sacrifice: I took a BIG hit on salary (jobs "up North" always seem to pay a lot more than in the South). But it was so worth it. I almost cried the first time I went to the grocery store and a random woman asked me, "¿Dónde está el arroz?" It took me a beat to comprehend that I had been addressed and recognized as a Spanish speaker. A Caribeña at that, since there was a decidedly informal tone in the phrasing. That encounter crystalized for me that I/we had come to the right place.

I have settled into my middle age here—a slippery claim, since many sources halt the "middle age" years at sixty, so maybe I am already in my old age. As they say, getting older is not for the faint of heart, but it is better than the alternative. There are little aches and pains I never felt before, but I can deal with them. After all, I survived breast cancer and the premature death of my only sibling—the latter being the harder challenge. And very recently, I had a total hip replacement, securing my membership in the "old enough" club.

Muñequitas and princesas

Little Latinx girls, especially Cuban girls, are groomed to be well groomed. From the time they arrive, we call them muñequitas, little baby dolls, and I do not jest when I say that well into their elder years they are accustomed to and expect to be celebrated and flirted with as in their youth. But let me be clear: while the male gaze is implied, women, young and old, also judge and celebrate each other. (Though elders don't talk about "los gay," there might be one or two en la familia. Generally, gay family members are accepted, even loved, but not publicly acknowledged as gay.)

Little Cuban and other Latinx girls' clothes are nothing if not frilly, ruf-fled, pastel-colored, lace, and sometimes hand-painted affairs. They are not made for running, jumping, climbing, or playing. They are dresses to be photographed in, celebrated in, and they encourage/compel girls to observe gender and cultural expectations. Later, young Latinx girls may have coming-of-age celebrations called quinceañeras, akin to southerners'

debutante balls or cotillions. These are geared to highlight a sole birthday girl, decked out like a princess in ball gown and rhinestones, including a tiara. Part of the celebration inevitably features her family, culture, and tributes to mark her un/official transition into young womanhood, preferably as a virgin (in the old days, it publicly declared her readiness for marriage). Quinceañeras may be big, lavish affairs or small and informal house parties. The point is, it's another event where young Latinx women are paraded, shown off to family and the community.[6]

Quinceañeras can be like pre-wedding celebrations, with similar symbols and gestures—big white dress, father-daughter dance, many-tiered cakes, a court of friends to party with. The popularity of quinceañeras in South and Central Florida ebbs from generation to generation, but the attention focused on young Latinx girls and women does not. They are aware of always being on display, observed, and judged by their beloveds and many unknown others.

I had a big quinceañera celebration, and so did my daughter. We must have yearned for the spotlight, if only for one night, but it was more likely that we just wanted the party and to party. We both had white ball gowns, tiaras, our hair and makeup and nails done, and a full court of fourteen identically dressed couples to accompany us in the choreographed presentation of bolero, waltz, merengue, and Cuban salsa. Thirty years apart, we both had a blast and have the pictures to prove it. Not surprisingly, a big quinceañera celebration figures in my novel in progress.

The expectation that a Latinx girl/woman will be looked at remains in place whether she lives in el Norte, where I grew up, or in South Florida.[7] Climate, however, determines whether or not frilly, girly dresses may be worn year-round. Little northern Latinas endure several months of coats or jackets. Not so for Miami muñequitas. My Cuban parents were poor and alone—no extended family Stateside to assist or support them, though they did have Spanish-speaking gente, neighbors, friends, and fellow parishioners. That community was based in an oral tradition, so stories were shared after church, on the stoop, steps, or porch, in the adjoining backyards, or

6 I am obsessed with quinceañeras, having attended dozens throughout my years. The MTV series *My Super Sweet 16*, which ran from 2005 to 2017, included crazy big quinceañeras and may have been the first time non-Latinx folks were introduced to them. There is a lot of scholarship on the practice among Latinx communities throughout the United States and the Americas. One of my favorites is Julia Alvarez's 2007 book *Once Upon a Quinceañera*, part memoir and part exposé.

7 Ironically, for Miamians, anything north of Orlando is el Norte, and for us in Central Florida, anything north of Orlando is the South—the "real" one, which is populated by "scary white folks."

out of windows. They served as surrogate family for me, and I soaked up their storytelling and became a storyteller myself.

Blood relations didn't arrive in this country until much later. There were no aunts or abuelas, no cousins from whom to receive hand-me-downs. Fortunately, my mother was an expert seamstress, so she made most of my clothes, including practical, warm jumpers worn with plain tights and turtlenecks in winter. My birthday falls in the spring, so she always made me an Easter suit in bright colors—either matching dress and jacket or dress and coat—to go with new shoes, a hat, gloves, and if there was money, a little white patent leather pocketbook. She made sure my brother and I had one nice outfit for our spring birthdays and annual formal studio portraits. She obsessively photographed us throughout our childhoods, amassing boxes and boxes of photographs and Super 8 footage that will come to me soon, since she's well into her nineties and purging. I've already inherited her sofa, area rugs, china, flowerpots, and frozen computer. Mami is trying to offload her bright blouses and scarves. She doesn't think it appropriate for young girls or women to wear dark clothes. Never black. That is for old ladies or widows. I had a stage when I liked black, especially long skirts and dresses. Mami scolded me for dressing like a vieja.

Oye, vieja—home (Latinx) girls

Grown-ass Latinas often call each other vieja. Just think of it as the women's equivalent of "dude." My Miami women friends and I bandy the moniker about, no matter how old we were/are. It is a familiar name, like cariño, cielo, mama, china,[8] or even negrita.[9] Vieja, literally "old woman," is a term of endearment, one that only close women friends call each other.

I am vieja now, though most polite beholders might dispute it. If Black don't crack, Brown don't frown. Blessed with always having looked about a decade younger than my age, I started my sixties at the beginning of the pandemic. I was going to embrace it, imagining a big party for my

8 "China" (or "chino" to designate a male) is a term of endearment that reflects the close proximity many Caribbeans had to Chinese immigrants to the Americas in the nineteenth century. The shape of one's eyes has only some bearing on whether one is referred to as Chinita or China.

9 Another term of endearment (see my "Negrita" in the *Americas Review*, Fall–Winter 1994, reprinted in *A Language and Power Reader: Representations of Race in a Post-Racist Era*, edited by Robert Eddy and Victor Villanueva, 2014). Skin color has little to no bearing on who says or answers this; it is an endearment that is historically based on chattel slavery in the Americas—wrap your head around that.

sixtieth—a quadruple quinceañera celebration. But there were no parties or celebrations that year, even though my youngest graduated from high school and my first granddaughter was born. No memorials for our dead, either—relations or friends—all of color, the demographic most affected. COVID robbed us of vital communal ceremonies.

Not a few times over the COVID years have I considered cosmetic surgery—it would have been perfect timing, since most sensible people were wearing masks and no one would have noticed until the big reveal. And what, pray tell, was I fantasizing about? A little nip or maybe a big tuck to correct my sagging jowls and my no longer slender, firm, lovely neck. Some treatment to diminish the dark half-moons under my eyes. After fifty-four, I started using concealer and foundation big time, evening out the sunspots caused by my sun-worshipping teens and twenties. I never used to be vain, but witnessing my face falling has been very, very disappointing, to say the least.

I used to be called cute. Back in the day—in my twenties and thirties—this was a compliment. But I hated it. Cute felt infantilizing; it made me feel not grown, not a young woman but a girl. Don't get me wrong, I was a pretty child and, like most people, had those awful awkward preteen and early teen years where everything was wrong. But once I learned how to pluck and shave and wax, once I learned how to paint my face, got my hair under control (and I do mean control, requiring often extreme methods), and finally understood how to attractively embody my body (for myself), I was pretty enough again. My mother would yell "¡Pintate!" before I left the house, to make sure I was wearing lipstick, even though she never wore very much makeup herself. She was reminding me that the presentation (and performance) of my femininity was going to be looked at.

As a little girl in the late 1960s, I loved and craved all the sparkly and bright-colored makeup, neon nail polish, tiny halters, hot pants, and big plastic bangles and jewelry my upstairs babysitters wore. Me and my girls,[10] as teens, wore dungarees and body-hugging shirts with platform shoes or wedgies. (It was before the advent of sneakers as fashion statements. See how old I am?)

10 The first time I read Toni Morrison's *Sula*, I understood and viscerally felt what she meant when Nel says of her friend "we was girls together." Though my crew consisted of an Afrocubana and Polish and Italian Americans, ethnicity wasn't a factor in our bond. Another sidenote, as a specialist in African American literature and writers of color, I learned a great deal about the South from Morrison's work.

Once I was transplanted to Miami, my new teen crew (all working-class Latinx) required me to share their fashionista ideology. I was expected to wear all my "Cuban" gold jewelry every day, not just for special occasions: cadena (literally chain) strung with saints' medals, azabaches (black stones to ward off the evil eye) and sometimes menturina (goldstone), manilla (name or ID bracelet), earrings (these might be small hoops, birthstone earrings, or dormilonas—literally, female sleepyheads—which were small gold spheres that babies often wore), and, as if that were not enough, an initial or birthstone ring or two. Cuban girls in South Florida didn't model their looks after their mothers; instead they pined after the looks of models in high-fashion magazines. Impossible standards, of course, but that didn't deter the desire. We wanted to look good to each other, show off. Even if stupid boys didn't notice, we noticed whether the purse was a Fendi, Dior, or Louis Vuitton.

I was expected to have my eyebrows impeccably over-tweezed, so thin they required a pencil to fill them in. The makeup had to be thick and on point: foundation, blush, bronzer, liner, eye shadow, and mascara. (I know that's nothing compared to what is being pushed on kids these days.) I'm talking a no-pore look. In other words, plastic. We straightened our curly hair, no matter how much the submission damaged it. Extreme label-consciousness reigned, and any Latina worth her salt, no matter how poor, bought only designer everything. Department store makeup that had to be handed to you across gleaming counters. No five-and-dime nail polish or lip gloss (though they were easier to shoplift). Boutique buys. To shop elsewhere was picúo. (God forbid we should be accused of wearing anything we considered tacky in our snobbish, wannabe way, like clothes from Sears or Penney's.) All of these things cost money, so of course we all had part-time jobs. There was just so much a teenager could earn after school, but I am not ashamed to tell you that with my very first paycheck I bought a beautiful pair of black snakeskin T-strap heels I had lusted after for weeks. Fessing up here: I still have a thing for shoes.

Señora—hecha y derecha

If "señorita" is the equivalent of "miss," an unmarried woman, it also connotes a young woman; una señora is a full-fledged, grown woman, a mature woman, a don't-mess-with-her kind of woman, a ma'am, as southerners might say. I left the señorita status when I married at twenty-four, an older bride for the time—my friends married right out of high school. Then I was

an older mom—my firstborn and I are thirty years apart, and my son was born when I was forty-one. They say having children keeps you young, but what if you're already old?

I was old when my first book was published. You should have seen me at that famous writers' retreat telling all the young folks I was going to be fifty the following year. It was *not* too late to be an author; after all, Toni Morrison's first novel was published when she was nearly forty. In fact, Morrison had read many of the stories in my collection when I was her graduate student at the State University of New York in Albany. It took twenty years to see my name on a book cover, an experience that was nothing short of transformative. To pay the bills, I had become a professor, but my heart was always in storytelling. For years I produced the academic writing expected of me while dedicating predawn hours to fiction. Like Ortiz Cofer, Morrison, and so many women writers, I wrote at five a.m. when no child, spouse, or pet would bother me. But it wasn't until I had my first sabbatical and had complete freedom from "school" for a year that I could compile a collection—stories about Cubans and Cuban Americans in South Florida. Now, as then, my subjects center on the lives of immigrants from the Caribbean and the Americas, how they and their offspring navigate acculturation. Many of the stories in my second book are narrated by or tell about Latinas dealing with oppressive gender and cultural expectations. All my work, poetry or prose, has drawn from the wellspring of culture as foundation and continues to do so.

I am an abuela now, and not to be cheesy or predictable, but I never knew how much love these grandbabies could bring. My new name is Yeya—I just realized this rhymes with "vieja"—proud grandmother to precious pedacitos who live in the North. They will visit me here in this liminal place, the "new" South, and I will visit them every chance I get, joyfully striving to keep up with them in this ole body, one I'm grateful for, despite the inconvenience of aged, aging, or replacement parts. Yet, not gonna lie, as the young folks say, I am so grateful not to have to care for little ones 24/7 now, especially not to have to homeschool anyone while also teaching remotely full-time during the pandemic. What a blessing and privilege it is that I can read and write for pleasure without interruptions, can garden for hours without listening to a baby monitor or picking up anyone from school. Good lord, what a tremendous relief it is not to worry about getting pregnant. And I am pleased that from some angles I'm still attractive to myself and others. If complimented, I often reply, "Smoke and mirrors, baby; smoke and mirrors."

When I tell students (they are impossibly younger every year) that I'm older than dirt and that I went to school a hundred years ago, they humor me. I don't withhold my age. On the contrary, I want them to see what "old" is and can be. To know that someone my age still has stories to tell and is a working writer besides being an actively engaged teacher and mentor. To understand that vitality is cultivated, not given. And most of all, I want to assure them that while age does not guarantee wisdom, I know some stuff because, like the devil, I'm old, and I might just be a wise Latina.

A Movement of Time

Sara Garden Armstrong

Recently I celebrated my seventy-ninth birthday. I do not consider myself old. Aging for me is a passage of time—a movement of time.

I don't have time to be old; I have too much to do. Work defines me. Three years ago a retrospective monograph about my work was published, accompanied by a traveling exhibition. I am showing in galleries and museums across the Southeast. I own and manage a building in Birmingham that is dedicated to art, housing studios and galleries. I am around artists and the artistic process 24/7. I am busier now than at most times during my career, though not with the intensity of my thirties. It is a quieter, more thoughtful, steady determination with which I approach a day, approach time. I understand that my time is limited. Do I have a few years? Ten, fifteen, twenty?

My work as a visual artist examines organic processes of transformation. Breathing and life systems of the body are recurrent themes, as are water and time, with elements of decay and chance, plus shifts of reality. The result is lyrical, nature-based biomorphic abstraction.

We artists spend our lives struggling with the creative process. Within each piece of art there are problems to be solved. My own work may involve extensive research, exploration, and/or experimentation. Chance and change are important factors, as are accidental discoveries. Unexpected doors open—you have to walk through in order to move forward. You don't know where it might lead, but you know that it will lead to something.

An example of this was an atrium artwork commissioned by the National Multiple Sclerosis Society, Alabama-Mississippi Chapter. First, I had to understand the disease. My studio felt like a lab with images and text all over

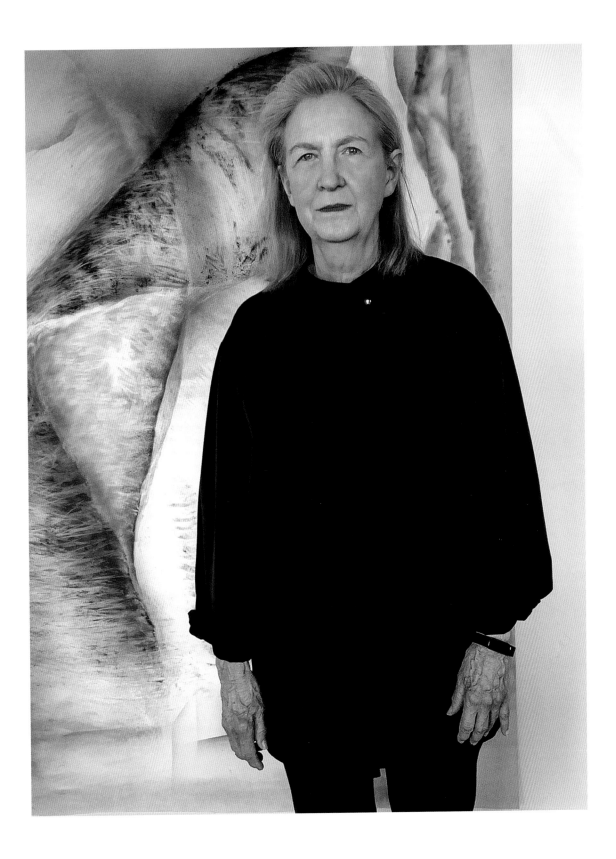

the walls. Finally recognizing that my goal was to know MS (not to discover a cure), I began translating my research of the issues into a work of art. This led to a model of the space where the sculpture would hang. I needed to understand how the sculpture would relate to the space. My model was approved—but how was I going to build the sculpture? What type of materials would I use? I was going to have light move through it representing the movement of a neuron. How would I accomplish that? How would I represent the myelinating glial cells? What would be my cost? I understood the concept—how an abstraction of the central nervous system, a translation of scientific information into art, could become a study of form and space. I knew what I wanted the sculpture to look like. I knew I could make this happen. The door had opened.

Recently I was talking to a close friend from the business world about how I might receive additional income from my real estate as I age. He quickly perceived that I did not have a plan, should I become incapacitated or die suddenly. What would happen to my art? Did I have the income to cover a severe illness? I had already been working on my estate plan, mainly concerned with the art, but to me this was a matter for the distant future, not today or tomorrow. I realized I had to face where I was, at this moment in time. Fortunately, he offered assistance to help me plan for the immediate future.

So which of my works of art do I consider significant, and where might they go? Producing artwork has been a constant in my life and still is. What does one do with artwork that one has spent a lifetime making? This question particularly confronts visual artists who work on a large scale not suited to hang on the walls of a home. Once control has passed from one's hands, how can one be sure that the Dumpster will not be outside waiting?

Presently I am doing new work for an upcoming exhibition, which will include a catalogue. In preparation, I laid out my studio with a combination of old and new pieces, so that a visiting writer could experience the work. Next it occurred to me that this would also be a good setting in which I could talk with curators and collectors about their thoughts on where some of the work might be placed. Having a large body of artwork can be a problem, though just a problem to be solved step by step, finding not one solution but multiple solutions. The gift is that everything feeds into everything else one is doing, opening doors and enabling possibilities.

Retirement is not a goal for me. I plan to remain an active, creative artist. It is a given that both mental and physical activity help deter the effects of the aging process. Nothing makes one feel old like physical problems.

On the other hand, physical problems can lead to a change in thinking and open other options. A stay in the hospital was a factor both in my decision to move to New York City in 1981 and to move back to Birmingham in 2017. In each case there was retrospection and introspection, looking back at my life and looking forward to new possibilities.

My return to the South actually began in 2014 when I decided to move a large trailer of artwork stored in upstate New York back to my Birmingham building, where I had left work prior to my move: canvas-covered forms, wooden-frame sound sculpture, sound drawings on handmade paper. Now I was bringing to Birmingham work from the 1980s through the early 2000s: biomorphic sculptural forms, drawings, prints, artist books, and more. Seeing this diverse body of work together for the first time had a strong effect on me, leading me to ask: "Who am I as an artist, what is all this work about? What are the concepts that run through the work?" I now had a large studio in Birmingham, so I started putting images of work up on the wall in columns by decades—a visual CV, in essence a movement of time. I felt a need to look at the work, study it, understand and verbalize what I had done in the past, compare it to what I was doing in the present, and envision where it could lead in the future.

The creation of the visual CV proved to be serendipitous. Shortly afterwards, I was asked by Space One Eleven, a Birmingham nonprofit gallery, to be part of the Joan Mitchell Creating a Living Legacy (CALL) project. I was given assistants and a detailed plan, the objective being to archive my work history. When we began, I was still living in NYC, so I made frequent trips back to Birmingham. The CALL project was a tremendous asset. My assistants and I were going through my body of work—cataloguing, photographing, and recording. It was an organized way to look at my oeuvre.

Out of this grew the traveling exhibition and monograph. A curator friend was visiting my studio. When he saw how much work I had done through the years—work he did not know about—he suggested a traveling exhibition, combining my new art with the old, dating back over four decades. Each exhibition would be site specific. A partial title emerged: "Threads and Layers." A catalogue was envisioned to coincide with the exhibition.

The catalogue became the monograph, continuing the work begun with the CALL project. Writers familiar with my work were asked to contribute essays. Some visited me in Birmingham, some I traveled to visit. Each visit led to a discovery as the big picture continued to change and evolve. At first the focus of the book was sculpture. However, the largest part of my body of work is flatwork. Why wasn't this included? Again, I made a chart of all

the pieces of sculpture and flatwork that were connected. Most of this flatwork had grown out of research for the sculpture, or from an exploration of the sculptural space. This process became an important part of the book—questioning, trying to understand, problem solving, forcing and embracing change.

The COVID pandemic broke out while I was in the midst of the book project. Sheltering in place was not all negative. It allowed me isolated, quiet time in which to think about many issues. Being on my own schedule with limited public activity became a positive. I laid out the book on my studio walls, visually, where I could play with its structure. I was groping to understand the multiple concepts that shape my work, and how the book would explore them. I was looking back, verbalizing thoughts, confirming dates, and making charts about concepts.

One of the essays in the monograph was about my connection to the South and my complicated history with it, which I have written about for years, striving for understanding. Upon reading the first draft, I felt something was missing. How did living for more than thirty-five years in New York City affect me? To me, the South is a rich, steaming, sensual, very earthy, organic place. I had to leave it to realize that I was so driven by it. I think it would have been impossible for my work to evolve as much as it did if I had remained. When I moved north to NYC, I thought I had escaped the South, not understanding how affected my work was and is by it. The South is embedded in my artwork. There are many layers, which to me is very southern. What's true? What's real? What's under the next layer? As you peel them off, you reveal something else. Reality changes, and the layers add to that change of reality.

My return to the South has been a positive experience. I understand this changing organic place. I am part of it, and it is part of me. It is part of my growth, and I am concerned with contributing to its growth. I feel that I can make a difference here. I have more space, time, and ability to work. The last neighborhood in NYC in which I lived was Queens, one of the most diverse places in the country. I was concerned that I would not find this diversity upon my return to Alabama, but the opposite has proved to be the case. I have found that communicating with a diverse group of people is easier in Birmingham than in NYC. We are a smaller community, interested in having real discussions, supporting one another, listening to each other, and being "real" people.

A positive aspect of the aging process is that you have more history, more experiences—you have met challenges and come out the other side. Aging

is a passage of time, with different focuses at different periods. Problems, explorations, and study are part of the process, as are successes and failures. As I go about my daily life, I try to keep in mind two quotes. Twyla Tharp, while working on her dance *As Time Goes By*, said: "I feel an artist is defined to a great extent by the range that they can control. It's not just what you can do well, it is also what is very difficult for you. That sort of diet is something that is a real concern for me." And Erica Jong in *How to Save Your Own Life* wrote: "Always do the things you fear the most. Courage is an acquired taste."

Ask questions; don't be afraid of problems. Forcing and embracing change is a positive, even if it doesn't feel good. This perspective guides me as I move through time.

The Generous Becoming

Jeanie Thompson

The Target

For the first time in my seventy years, I am on a Greek island in the Aegean Sea. It is at the onset of summer, and I am taking part in a three-week creative writing workshop on the Cycladic island of Serifos. At a point in my life when I really should not be spending thousands to run away, I have decided to perch on this rocky island and write like my life depends on it. It feels that imperative.

⏤ Day six on the island. Outside, the early summer wind on Serifos is howling, knocking the wooden shutters of our little white and blue apartments, whipping the tall bamboo behind my back porch so that it leans and sways with abandon, surrounding us like Aeolis himself, god of the wind, who wants attention, dammit! When I open the computer to look for notes, I find a poem called "The Target," written and abandoned—one of those poems that did not fit in anywhere, or so I thought.

I read it and remember who I was then, why it happened. Poetry often takes me back in time within the present moment: I am two places at once. I see flaws in line breaks, stanza composition. I start adjusting. After fifteen minutes of that, I feel a little freer. Our workshop leaders on this trip stress, as all writing teachers do, that revision is the soul of writing. But how does it make us free?

When I revise a poem, I can forget where I am in time as I take the lines from one place to another—toward a better piece of writing, I hope. I feel sure that other artists experience this absence of time passing, of being

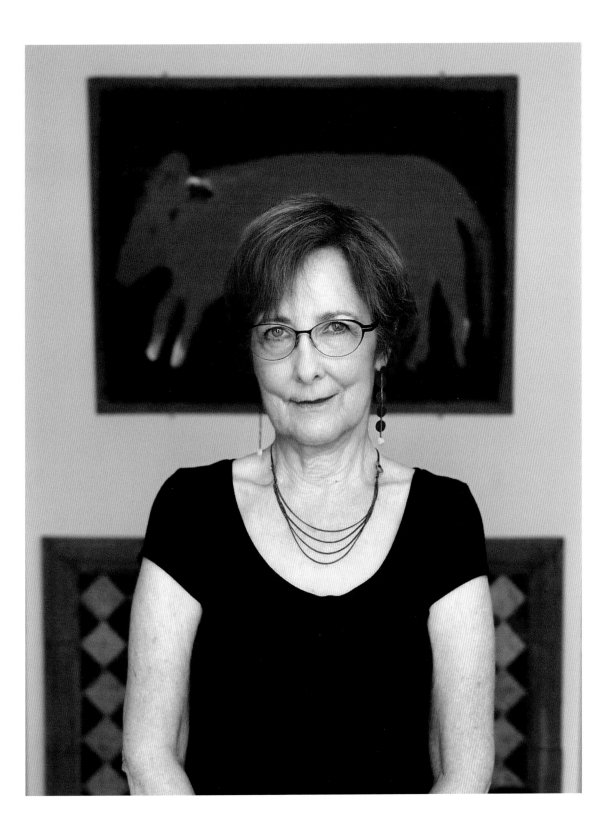

fully present in the moment, which may be the ideal state for creative work. Sadly, it can be as fleeting as a wisp of smoke. If I achieve this, I am not only briefly freed from time, but also from age. Not an older woman or a younger woman, simply a woman writing, searching for the most accurate expression of what she has to say.

"The Target," written in Italy in 2018, about a young man who was exceptionally talented at trumpet but also liked the sport of archery and who had sent me a little random video of himself practicing, had been dashed off, then misplaced. When I had visited his hometown, Pietrasanta, a town I had come to love when I worked on an art project there several years before, he did what young Italian men often do when asked—he was accommodating to an older woman; he was respectful. When I arrived in town, I texted him and he showed me around a little. I was like an auntie. I knew this as he showed me his apartment at his parents' house (they were at home in another part of the house), his trumpet collection, his cat Raja. There was nothing untoward here. He was mourning a lost girlfriend, I discerned, and was my son's age. My Italian and his English were so-so, and we talked mostly through Google Translate.

There was another poem that came out of this time—one I worked hard on because it satisfied something emotionally unresolved for me—but it was convoluted and refused to commit. I believe this about the poem because I worked and worked on it, taking it from prose to poetic lines and back, even submitting it to a themed competition for poems about the moon, because the moon figured largely in it. The editor said it was not "moony" enough. I withdrew it. It was not about the moon, no. It was about how love is fickle but can be witnessed, experienced through others. I experienced the trumpet player's pain over his girlfriend, which reminded me of my own pain, in a way, and there it was. But that was another poem.

Here's "The Target."

> *The Target*
>
> The young man takes up his bow,
> plants his feet
> as he might center himself
> to blow his trumpet.
> But this is not an orchestra.
> He conducts
> himself, maestro to a private rhythm.
> Beyond him, bull's-eye targets are spaced
> in gradations of depth, from left to right.

He pulls the metal arrow from
its quiver, sets. Sights. Fingers lace through
the arrow's fletching. His face in shadow,
his youth coolly lit under the pavilion.
The targets, trees, and hill
bathed in sunlight.
He draws.
The mechanical whine of the arrow's
taut release surprises me
each time I hit *replay*.
I do not see the arrow hit the target.

He walks calmly
out of the frame.

In reading this poem again, and immediately starting to revise it, I was taken back in time on several levels—memory, a sense of myself then versus now, and an awareness of moving through time at a different pace brought on by the act of revision. I know this process from years of writing—as far back as age fourteen, when I knew nothing about craft but still had an instinct to revise, to change a few words or cross something out.

Once someone who was not a poet asked me, "What would happen to you if you didn't write poetry?"

"I would die," I blurted.

Then revised: "I cannot imagine not writing poetry."

Poetry is part of who I am, whether I am actively publishing or not, and although I have had long dry spells, I am beginning to understand that a "fallow period" is a misnomer, and that poetry—that life blood—will always be available to me, but I must seek it, be alert and alive to it.

It is well known that the arts improve health; writing classes are proliferating everywhere, especially in settings such as trauma units, cancer wards for children, veterans' rehabilitation programs, memory care centers, and most vitally in institutions where humans are confined by courts. I think poetry's innate power to heal—to revise, to reconstruct—has barely been explored, though recently it has gotten some media attention as our world has grown more violent and incomprehensible. Someone asked, what if everyone in the world stopped for one hour a day, at the same time, to write a poem about themselves *in* the world, what might this do for our politics? It could change the world.

As a woman living in the southeastern United States, does my art, my poetry, help me consider my life, my aging process, my community? I don't

think about it that analytically. I just know that every day that I write and reaffirm my being, I feel better, more youthful. It is primarily about stronger mental health: being less self-focused, more expansive and happier. When I go for long stretches without writing—just thinking about writing—I begin to feel less healthy and, perhaps, older. I mentally stoop. But "revision" is the word I would use to describe what poetry does most for me. It allows me *to revise my life* in an objective way that frees me from the expectations of the social universe (an older woman should or should not do this or that) and lets me exist in a place that is ruled only by how often I pick up a pen or sit down to a keyboard. It is completely up to me how often I write, revise, and continue to become a poet.

Is writing poetry an elixir of life? Maybe. A mind game? Perhaps. It doesn't matter; I feel its necessity in my life. I trust what I know as a writer, poet, and citizen of the world, and hope not to run from it. In some ways, writing poetry is an act of generosity: distilling those moments of pure joy, agony, or exploration into poems that others can experience, and I can relive, is a generous becoming. And the first soul who experiences the gift is me.

As a young writer in a graduate creative writing program, I ran with cohorts who quoted lines by our favorite poets, many of whom we had been able to meet. The American literary world was smaller in the 1970s—no internet to clog up our interactions. We loved these lines from Jon Anderson's poem "In Autumn" from his early collection *In Sepia*.

> I understand by the body's knowledge
> I will not begin again.
> But it was October: leaves
> In the yellowed light were altered & familiar.
> We who have changed, & have
> No hope of change, must now love
> The passage of time.

Looking back, I do not think we understood very deeply what Anderson was saying, although it sounded wonderful. It was those last five words—"love the passage of time"—that hooked me and spurred what I would call a twentieth-century Romantic impulse. Certainly, he was thinking of Keats's ode "To Autumn" when he wrote the poem. Anderson's lines read like *truth* to me now, as they did then, but I hope I bring a little more wisdom to them after nearly forty years. When words lift one up to a higher plane of truth, no matter when it happens, there is no other response than to give an

internal *yes!* to the universe and be thankful for the freedom of the poetic experience.

Freedom is a necessary element of any poet's, any artist's life. Freedom from the exterior world of work, family, politics, and economics that is always pushing us in a "productive direction," pushing us away from our desire to discover through words who we are, what the world is, and to experience freedom and release from time. Not that writing is not productive; of course it is. But in our culture and economy, few poets earn a living by writing poems. They find safe haven somewhere—a college, a school, an arts organization. Some people get through life without the burden of creativity (being impelled to write, to create art), and they are blessedly unhindered for that. But the older I get, the longer I am in this world, that tug of war tears my heart every day. I know that a woman who is an artist will always have to choose *freedom* to be available for her work, and then turn back to the corporeal world in between those moments when a poem, a photograph, an aria seems possible, when there is hope of change.

The Decisive Moment

Photographer Wayne Sides helped me understand how to see photographic images as he does, and to comprehend "the decisive moment," a phrase coined by French photographer Henri Cartier-Bresson in 1952. One day in the spring during our undergraduate days at the University of Alabama, in the mid-1970s, Wayne and I were racing along in my green VW bug to Montevallo, Alabama, about an hour from the UA campus in Tuscaloosa. We were joining some other dance students for a performance, and I grabbed a moment to interview him about his current photography exhibit for a news article in the *Crimson White*, the campus newspaper. I let him drive while I wrote, or tried to, as the car jostled along with Wayne grinding through the gears. I took notes, listening as he explained how he had tried to capture a subject's decisive moment—that moment when a character or a scene reveals the essence of itself or creates a visual joke or comment without any artificial or interruptive framing, or when someone decides to take an action or make a gesture that stops us, makes us watch, momentarily holds us still, when the photographer *decides* to snap. It will only happen in that brief moment of time and is similar to the method I tried to use in the early 1970s to capture a powerful emotional moment of insight or understanding. As with many poets writing at that time, I wanted to move the poem toward a point of epiphany

when the reader experiences an elation or uplift, an "aha moment" that informs or moves her.

James Wright's poem "A Blessing" contains a decisive moment for me when the speaker concludes, after an encounter with two ponies,

> That if I stepped out of my body I would break
> Into blossom.

Once I read and *heard* that poem, I returned to it, and still do, to experience the transport from the immediate present ("my body") to a timeless space of realization ("I would break into blossom"). The poem always affirms the transport of freedom I felt the first time I read it, and also the love. In these times, to be able to leave the confines of this corporeal, war-wracked world and break into blossom is a gift beyond measure. Poet James Seay (who had taught for a time at the University of Alabama, and who then visited our graduate poetry workshop around 1975 or 1976) voiced a similar assessment, stating that "what makes Wright's poetry special is not that he has any new philosophical insights into the problems of existence but that he has the gift of using language in a way that the human spirit is awakened and alerted to its own possibilities." With Wright's poem, making art and resisting enslavement to the passage of time merged for me for the first time. I experienced a decisive moment of language. This became my paradigm for poetry as a young poet, and it still is.

To Abide

As I grew in my own writing, I discovered a mode that intrigued me and lured me back repeatedly: the persona poem, or writing in character. To learn and then speak through the voice of someone with whom I have found affinity is very akin to being in love. I suppose it has the lure of acting, too. There is a union with the subject matter and an encouragement to strive for the best creation possible. Taking on the mask of another or "the other" frees us. This mode has come to be one of the most popular in contemporary poetry, and for good reason: it is satisfying for the poet and pleasing to the reader to experience narrative and story.

To speak in the voice of another was liberating for me, and in my early life as a poet in graduate school, I began a series of persona poems. A section in my MFA thesis features a varied cast from Sappho to Jeanne Duval to Marilyn Monroe. Seeing the world through these women's lives, illuminating their decisive moments, was a warm-up for what was to come when

I found my own impelling subject matter (referred to by some teachers as "obsessions"). I found that writing in persona prepared me for telling my own story, especially when harder ones emerged to be told. Thinking of the method of persona, but imagining myself as the lead, I wrote my way out of several painful scenes in my life that would have been less compelling as autobiographical narrative poems. Whether or not these poems were my best work at the time, they were watersheds for me as I learned to distance myself and capture a decisive moment that came from the persona poem practice of my earlier years. I moved ahead as a writer by drawing on earlier discoveries.

In the late 1990s I encountered the persona subject matter that delivered me to a series of poems that became my seventh book, and that to this day is still offering me a chance to write in extended persona. This subject matter was not one but two characters, two individuals: Helen Keller and her teacher Anne Sullivan Macy.

In thinking about how writing mitigates aging, I credit the Helen Keller project as a primary agent of that for me. For more than ten years I studied, researched, false-started, agonized over, and finally turned into historical persona poetry the material that culminated in *The Myth of Water: Poems from the Life of Helen Keller*. Six years after the book's publication, to modest acclaim and recognition, I find myself not able to move fully away from the subject matter. In fact, I believe that the urge to return to that subject matter is life-giving. Through the creation of poems, my art gives life to me. And now I have another chapter in development.

I am not unique in this, of course. People of all genders and ages experience the life-restoring properties of the creative process. In my case, there just happens to be a renewing subject to which I can return. I think about fiction writers who "write the same story" over and over, or painters who work variations on a theme in canvas after canvas—think of Van Gogh's olive trees. It is a universal human experience in the creative process. We keep going back to the well to dip in for understanding. Keller's and Macy's stories still intrigue me and offer subject matter for poems. And this is not about quantity. It is the search for an essence that resonates with my life. My encounters with Helen Keller and Anne Sullivan Macy keep opening doors to an understanding of their lives, to insights into the unique nature of their relationship, and their impact on the world for those with the double disability of deafness and blindness, for those who experience injustice and discrimination economically and societally. I hear new things I want to explore. I want the poetry I write to serve a universal movement in some way,

to acknowledge the lives and contributions of a person—like Helen—by portraying her in a way that a reader can appreciate and be moved to action by. That action may be a change of mind that affects the way a reader sees the world, and therefore ripples out into life choices. In short, Helen and Anne encourage me to write poetry of witness that may result in change, no matter how small.

The first poem I drafted after the publication of *The Myth of Water* was called "Hinge of Doubt." I wanted to know more about the apprehension Anne Sullivan (not yet Macy) felt as she boarded a train for Alabama in March 1887, leaving Boston at age twenty-one and traveling into what must have been a confusing and confining place for her, not to mention the challenge of a lifetime as a young teacher. I also wondered if she had more doubts when she realized that the northern Alabama landscape was circumscribed by the centuries-long economy based on enslavement, the society and norms built around identities of "owners" and "slaves," and preserved by those who had fought in and lost a civil war. Helen's father, Captain Arthur H. Keller, served as a private, quartermaster, and paymaster in the Confederate Army until the end of the Civil War, and it is reported that he and Anne Sullivan argued about politics frequently. This is also alluded to in the play *The Miracle Worker*. But how did this landscape affect her personally?

I wanted to think about Anne physically in the Alabama landscape, in a cotton field, or a cornfield, as she wondered how she got there. She must see it, feel it, smell it, taste it as she moves toward a point of commitment, as if a door has opened that might close behind her at any time. There is doubt, certainly. But also, the hinge of escape, or widening to an unknown world.

So I began to imagine Anne in a physical space more directly and specifically than I had before, the first time in a sunset photo I shot with a camera phone, seeing the way Wayne had taught me: the red dirt road disappearing into the distance, the arching trees laced above it, the liquid setting sun. Everything close to southern cliché, yes, but real.

I heard Anne Sullivan in a cotton field, at sundown, thinking about why she was in Alabama. The portrait in the cotton field brings to life Anne's doubt about Alabama. I might not have gotten there before without the visual pulling me through—my simple photograph captured at the precise moment the sun was setting in Montgomery County, Alabama, in early fall. And as this happened, I could feel my own hinge opening, the possibility of new poems to be discovered, the breath of life continuing.

It had taken several years to get to this point, but I was there. And time collapsed and I was myself again, a poet finding her way, age an illusion.

Hinge of Doubt

an edge of dirt road
a dirt road bounding a field of cinquefoil
that tumbles, red dirt powdering
feet moving west
the cage of limbs against
late sun pouring gold
makes me want to flee, Helen,
why not?
the silent field, the ripple of road
like a stripped-off ribbon
a field of tossing yellow cinquefoil
a heart that
longs for silence.
where am I
in this moment without a cricket
or bird to name it, "Summer,
Alabama"?
caught in sunlight dropping to dusk.
turn to the field, turn back?

A Little White Boat in Serifos

Harry Mattison, husband of Carolyn Forché, our workshop leader, is a world-renowned photographer of war and conflict. But here on Serifos, he has spotted a favorite boat in the marina. He says he must get down to the Livadi port to photograph it "because the light is just right." Later I realize it is the same boat I have looked at longingly for a week, hoping to see the fisherperson (man/woman) who uses it. Harry's photograph, which he graciously shares with me later, is perfect. He captures every detail of the little craft's position on the water in the flawless afternoon light.

On one of the last nights, two poets and I walk to the waterfront restaurant for supper. The water is about ten feet from a small seawall protecting our chairs and wooden table, on top of which a paper tablecloth is secured by a giant rubber band. While we sit and watch the gentle movement of wind across the water—no whitecaps, just lapping—a yellow cat discovers a hermit crab in the shallowest wave on the sand.

The cat's ears tip forward in a hunter's crouch. It will not put a paw into the water but seems to know the hermit crab will move because it is out of its previous home, a large shell that had been tangled in some netting earlier in the day. The cat is almost ready to pounce, and we three women watch and comment on it as we talk and eat. Suddenly a boy, nine or ten years old, runs down to the cat, picks up the crab in his nimble fingers, then tosses it a little way out into the water. Having interrupted the order of the universe, this small man heads back to his table. The cat, still crouched, looks at us over its left shoulder, as if asking, "What? Why did you let him . . . ?" And then it looks again at the ripple where the crab landed. It stands up, looks at us again, and walks away.

The little boat, which has become an emblem for me since it never seems to move, has a dirty white hull but casts a mirror shadow into the flat water of the harbor. I wonder if it is put there as a tourist photo shot, as a water decoration, by the community of Serifos. Everyone in our group loves it, yet no one ever sees anyone pull up the anchor and take it out. If I turn my head sideways, I see the boat's prow and the mirrored prow on the water make a thin white moustache. There is a small cabin, not big enough for more than one person, I think, with a window on the side and two on the front. When will I ever see someone in there? There is a drum roller on the prow for pulling in or letting out nets. But now that I have snapped my own photo, I have just noticed that there was a seagull on top of the boat's cabin when I shot it. The gull is a large, healthy, white and gray bird. Later I try to sketch it, and the boat, in my notebook. I try to draw the gull as it bends down, looking intently at something.

For this trip I wanted to have a touchstone, so I brought along James Wright's *The Shape of Light*, a modest little book from White Pine Press about the poet's travels in Italy and France in the late 1970s. He is very much in love with his wife, Annie, and every sentence and paragraph is infused with this love, and his love of language. For our next workshop, Carolyn has asked us to write a haibun (a paragraph of prose that ends with a haiku) based on our journal entries about Serifos, so I try, thinking of James Wright traveling in Italy and in love.

> The shape of light holds
> my longing to travel far
> in the little white boat.

This form, the haiku—which every schoolchild has written—daunted me, and yet by starting with the first four words from Wright's book, I am

able to try. Here is poetry circling back to my beginnings. I was introduced to Wright early in my college career by a new poetry friend at the time, who later became a dear friend, and I fell under the spell of Wright's midwestern cadences. Now, more than forty years later, the cadence of his prose in a little book about Italy and happiness, history, and language strikes the note that rings a poem for me. What trust I have for the sound of this poet's language! It makes me feel real, feel alive, ageless.

What trust I feel for the sound of poetry from so many poets, some newer, some older friends. There is no sense of time passing or sadness in this. There is only the realization that poetry carries me forward, steadies me, a dependable buoy in whichever sea is moving me. Turbulent or serene, poetry grounds me and eventually tells me who I am, at least for that moment. I believe it will eventually take me another step on the path to the generous becoming of who I can be as a poet, and as a human being. Today I am happy and thankful that the path traced here, to an island six thousand miles from my home, among white steps and blue shutters. The salt-scented breeze lifts to me over the Aegean.

Sheltering in Place

Carolyn Sherer

I am the second child of a soldier and a teenaged mother from the foot-hills of the Appalachian Mountains. The men on both sides of the family worked in the coal mines, and my paternal grandfather was part of the Great Migration to both Chicago and Detroit. My father, Wild Bill, joined the U.S. Army on his seventeenth birthday—with his mother's permission and her signature on the enlistment papers.

We lived in military base apartments in Germany, trailer parks in the Deep South, a multifamily home in a transitional neighborhood in Chicago, and a fine private villa with servants' quarters in Thailand. My fun-loving parents spent weekends exploring new cultures, embracing opportunities to expose their daughters to local customs, sights, and food. By example they taught us to value all human beings and to embrace the unique at-tributes of those who are different. By the time I was twelve years old I knew that the schoolbooks that we had in Chicago with pages and pages of names of prior students were out of date, and that my education in the International School of Bangkok was what all children deserved. It was one of many lessons about privilege that a traveling childhood taught me. My identity formed as I was dropped into the reality of wildly diverse cultures. It was shared humanity that I clung to. My mother, and our circumstances, created my understanding of family; we celebrated weekends and holidays with a family of choice, wherever in the world we were living. I was always aware that family might be blood, or it might be the person sitting next to you, navigating the same life path. I became expert at walking into a cafete-ria and scanning the room for a suitable friend. Not much time, so choose

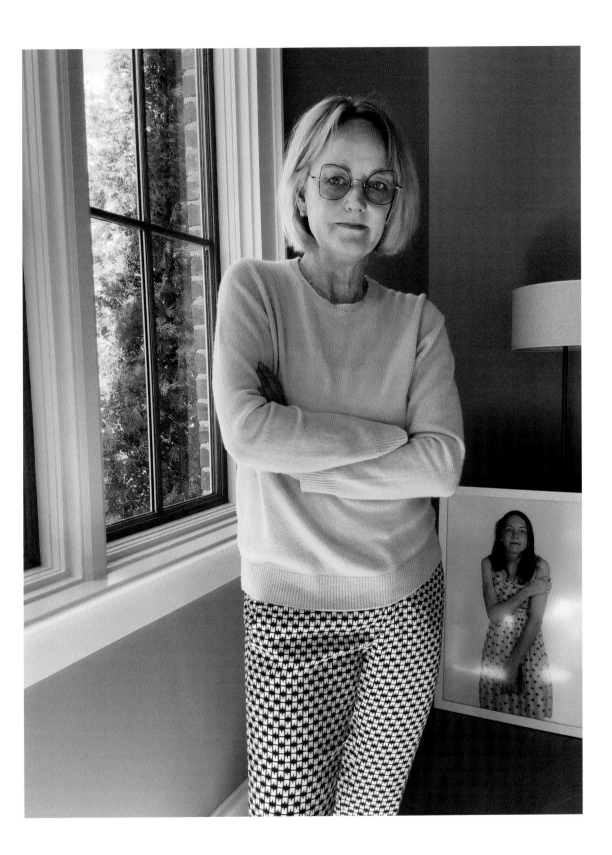

wisely. Not that one, maybe that one, yes—for sure that one would become my ally. I learned to fit in, though I never truly belonged.

I was twelve years old in 1969 when I sat on a beloved white French provincial poster bed with a hot pink ruffled comforter in my bedroom with variegated pink shag carpet and considered my love life. My friends had boy crushes that I couldn't grasp. Meanwhile, I stared at my beautiful Spanish teacher as she rolled her r's, and blushed when she looked at me. I wondered if I might be gay but decided that I didn't look like a lesbian. Not sporty at all!

In 1979 I moved in with my now wife, Jean, and we lived in the closet all of our young adult lives. Everyone knows that bad things happened to gay people in the past. And yes, Jean and I know people who were sent by families to receive shock treatments, lost custody of their children from previous heterosexual relationships, were fired, were thrown out of their homes, ostracized by their families of origin, and even arrested for sexual perversion after being caught kissing in a car at night on campus grounds. Some of us had a fictitious boyfriend, or a gay male friend who might be our date to public events. And many of us told people we were simply too busy working to date. Our lives as imposters were often painful, and plenty of our tribe used alcohol to cope or lived with depression. I am sure that my childhood experiences as an outsider kept me sane.

But what most people don't know is that in spite of those things, or perhaps as a result of them, many of us who did not leave Alabama in the seventies, eighties, and nineties were part of a delicious secret society. My dear friends were educated and fortunate to come of age when women were finally allowed in the workforce. We became overachievers. To be better than others provided a degree of job protection. We were invaluable caregivers to our parents, siblings, nieces, and nephews, even as we guarded our secret out of fear that we might be shunned by the family we were born to. We sustained each other socially via a fiercely loyal underground support network.

As closeted lesbians, we put as much space as possible between hurtful establishments and ourselves on the weekends as we "sheltered in place" together. We were drawn to our friends' rambling old Victorian homes in the city where everyone danced the night away, and to lake houses, situated ironically in conservative counties where everything fun was illegal, including liquor. Frequent, intense parties were meticulously planned and executed. Pent-up energy resulted in giddy social discourse and enchanted evenings.

When many did not feel welcome elsewhere, large groups of lesbians from many faiths came together to celebrate High Holidays, and we did so with a twist. On these occasions, we were intentionally irreverent—creating joyous celebrations and our own traditions. A Jewish woman organized a Seder murder mystery dinner, assigning each of us period regalia to wear that night. We celebrated Easter in the country. Lesbian clergy gave non-denominational, gender-neutral sermons, and we sang hymns—translated as "hyrs"—just before the Big Ass Fishing Contest and the Easter egg hunt began. But Halloween shindigs were the best. In 1990 a hundred masterfully disguised lesbians crammed into a barn party in the country. A mistress of ceremonies managed a parade of entertainers, including Elvis and a very skinny woman who lip-synced "Proud Mary" and danced as Tina Turner.

Out-of-state escapades gave us the opportunity to travel in same-sex pairs without worry about consequences. Horseback riding, kayaking, and bicycling trips abounded. In the early 1980s lesbians from Birmingham filled every single slot in a weeklong Vermont bike tour. The first night, a friend delighted the large dining hall crowd with vivid tales of once riding on the back of Martina Navratilova's motorcycle in Atlanta. The tour leaders quickly realized that, unbeknownst to them, a gay trip had been booked. They were perplexed: they had no idea there were that many lesbians in Alabama. And certainly not that many professional women. Yes indeed, doctors, lawyers, educators, dentists, business owners, and community leaders. We valued education and achievement, and we pushed each other to excel.

And like any good secret society, when we came home, we were there for each other. Need a doctor in the night? Done! Toothache? Don't hesitate to call anytime. Someone is really, really ill? We will put together a care team pronto. We were a chosen family in every sense of the word. The steep dues for membership to this exclusive social club were complete confidentiality. To be invisible was the key to survival. We understood each other without saying a word, and the things we survived together forever bond us.

My lifelong experience as an outsider seeking common humanity informs my work as a photographer. Working in series, I create images of individuals within an often marginalized group, compiling a mosaic that represents both diversity and shared humanity. In my childhood, Mom used treasured family photos to tell us the story of our absent family of origin. Now I create images to put a face on underrepresented communities.

In 2011 I had a series of coffee shop meetings with friends I had worked with on previous projects related to people with disabilities and those living

with HIV. We discussed collaborating on another social justice project and tossed ideas around. At some point my friend Ann A. said, "What about us? What about lesbians?" I immediately dismissed the idea, saying no one wants to look at pictures of old lesbians. Private conversations about it usually ended with "not in Alabama." Coffee chatter continued, though, and we came back to the notion repeatedly. We were all in the closet to varying degrees. Isie, Ann A., and I took turns saying we would consent to be photographed, only to decide against it by the next week. The idea haunted me.

When Jean and I discussed the notion, we agreed it was important and, though bold, timely. At our ages the risk seemed manageable because, through privilege and hard work, we had funded our retirement and were debt free. She still had a high-profile job that she loved, but decided to support my efforts because they were critical to our community. None of our friends had ever seen a portrait of a lesbian family like ours on a museum wall. Not a single image.

This is not New York City. The risks were real. At the time Alabama lacked a single legal ordinance to protect Lesbian, Gay, Bisexual, Trans, and Queer (LGBTQ) families. After much deliberation I developed a concept to keep my participants safe and willing to be included in the project. I would invite lesbian families for studio portraits with a blank background to protect them from evidence of place. Further, they would be in complete control of their environment, choosing what to wear, whether to face the camera, touch each other, and include children if they had them. I emailed a project description and invitation for participants. Most of my friends completely ignored it, though a few called and explained why they wouldn't take the risk.

I knew strong community endorsement was essential to pull this off. I had a previous working relationship with the curator and director at the Birmingham Civil Rights Institute (BCRI), who endorsed the concept as a human and civil rights issue and agreed to exhibit the new work. The director of the Birmingham Museum of Art boldly signed a letter of endorsement, without consulting her board of directors. Southern Poverty Law Center, another yes. Slowly more people agreed to participate, and momentum built. In the end we had more volunteers than we really needed, including two Birmingham power couples that now wanted to be included. They also wanted to use their connections to promote the exhibition and engage the corporate world. Ann H. and her now wife, Carol, organized an event where they invited the most powerful business and community leaders in town to come together to support the project. Ann H. successfully pitched

the idea that this exhibition that put a face on a previously invisible community would inspire the social change needed to retain and recruit talent. She also visited her friends in corporate management, came out to them as gay, encouraged them to consider same-sex couple benefits for their employees, and requested both personal and business donations of significant amounts. She believed such individual and institutional contributions were as much about public commitment to equality for everyone as they were about funding.

At this point Jean and I operated on a "don't ask, don't tell" basis, particularly with family. We were having drinks in a bar with my mother when a friend walked up and asked how the new exhibition was coming. "What exhibit?" asked my mom with arched eyebrows. Not how I intended to come out to my mother. I shared the topic, adding that it had been a struggle planning because people were fearful of likely controversy. My dear mother took several sips of her margarita. And then, "If anyone protests your show, I'll be on the opposite side of the street with my own picket sign."

There was resistance. The sympathetic printer scheduled reproduction of the exhibition poster during the night shift when the man who typically used that press was gone, since he refused to do the job because of religious objections. The day before that poster was printed, the Office of Diversity at the University of Alabama at Birmingham pulled their logo, reportedly because the project was too controversial. We persisted.

In 2012 our gay community, along with some great allies, got solidly behind my *Living in Limbo: Lesbian Families in the Deep South* photography exhibition at the BCRI. The collection of forty images of diverse lesbian families with Birmingham roots included many families who chose to turn their backs to the camera, making a powerful statement about the fear that dominated their lives. The epic opening reception stretched the building capacity limit with visitors, including politicians, religious leaders of all faiths, people from all socioeconomic groups and races, and business leaders. Older lesbians cried when they saw what had previously been unimaginable: a public celebration of diversity with their image represented on the walls. Although a few women never went to see it because they were afraid someone would spot them there, many of us came out that opening night publicly, en masse. Age set me free to create the most intimate and impactful work in my career, and I am grateful.

This groundbreaking exhibition already graced the walls of the BCRI when President Obama and the NAACP first announced their support for gay families in 2012. The fact that *Living in Limbo* existed in conservative

Alabama, the heart of the civil rights movement, attracted the national press. When the Associated Press photographer arrived, he said that he had ruminated about how he could photograph images of lesbians in a way that he could publish them in the newspaper, "but these are just families."

There was further pushback. A politician told the press that she was appalled that the BCRI would host such an exhibit, stating it co-opted the civil rights movement. The president of the board of directors at the BCRI, and daughter of an esteemed civil rights leader, publicly challenged that stance with her belief that civil and human rights were for everyone. A Facebook group organized a protest to tear down a large exhibition banner from the exterior of the building that featured an image of two women, one in uniform, with arms wrapped around each other, the face of the soldier hidden. BCRI management successfully networked churches and community leaders to shut that effort down.

Yes, there is still work to do in this state. And while many of us are retirement age and no longer in vulnerable positions at work, we still worry for those who are. However, for my friends and me, being able to honor decades-long relationships with marriage allowed us to feel our families were finally protected. Several communities of faith now have active LGBTQ outreach programs. But some of our Methodist friends recently abandoned longtime memberships to join new churches that would support them. Alabama now has an LGBTQ-affirming charter school, but recently a politician publicly ranted about shutting it down, airing provocative television ads including photos of vulnerable children. The culture hasn't quite caught up, and people still assume we are straight, forcing us to decide daily whether and to whom to come out. "What is your relationship to the woman named on your insurance card? What is your husband's name?" Notably, we have moved on socially. In recent years we have been included as couples in social events within the community at large, and it is not uncommon for Jean and me to be the only gay couple at a dinner party. I still frequently feel like an interloper, not quite trusting that I am truly safe.

There has clearly been a generational shift in what my friends and I still refer to as the gay community. LGBTQ youth now consider gender and sexual identity in nonbinary terms, and they plan future families and careers with full expectations of equality. Some choose an evolving set of pronouns. Their engagements and weddings are detailed on Facebook, and they introduce their husbands and wives socially as such without fear of homophobic repercussions. No one knows for sure if this progressive behavior will be dangerous in the long run. Likely raised by heterosexual

parents, and certainly not taught the history of the gay rights movement in Alabama public schools, many in this next generation seem to have few clues about what came before them. I am happy for the lives these young people lead, yet I worry. I want to ask, "Do y'all know where we have been?" I fear that, given the current Trump-era political climate, a lack of historical perspective may be at their peril.

So where are we now, mature women who lived a lifetime loving other women? When I see my old friends, the conversations frequently begin, "Did you ever think we could live out of the closet? Get married?" "No, not in my lifetime. Not in the Deep South."

We were at the forefront of LGBTQ advocacy in Alabama, working within the system and spending our hard-earned fiscal and political currency to move the needle. Our goals were brought to fruition, exceeding our modest dreams. Most of my friends have lengthy stable relationships and are married. We do not take that for granted. Now we can hold hands in public—though we struggle to overcome historical fear of that simple act of love and rarely do. In some ways we are still invisible. In the past it was because of alarm about being found out, and now we simply are not part of the dominant youthful culture of the self-identified gender-fluid, nonbinary LGBTQ community. Recently a youthful organization—a young group led by young leaders—proudly presented an exhibition featuring a timeline of historical milestones of the Alabama LGBTQ community. There was no reference to the groundbreaking work that the mature lesbian community and allies did using the arts as advocacy, or mention of the pioneering creation of the LGBTQ fund that provided fiscal support to make the timeline exhibition possible.

I will always cherish the family of choice that nourished and sheltered me when we lived in fear. As we continue to assimilate, I do wonder how to sustain and honor those relationships, and our shared unconventional culture. These women are lifetime members of an extraordinary sisterhood. Is it time for another party? Hmmm . . . it might be fun to see that Elvis impersonator again. She was amazing!

I Have Seen the Promised Land and It Is Me

Jacqueline Allen Trimble

About two months before my first book was to come out, I was filled with trepidation, for it occurred to me, perhaps for the first time, that people would *read* it. Strangers, out there, in the world, would hold my words in their hands, appraise them, disagree with them, hate them, love them, or even translate them into something I had not meant at all. And they would do all of this without me. I would have absolutely no say in their reception of or reaction to my words. I had had much the same feeling right before my first baby was born when I realized that my daughter was about to come out, would be in my hands a fully realized human being I would have to teach, care for, and keep alive. How could I possibly be up to such a task? All the feelings—joy, trepidation, anticipation, complete panic—had overwhelmed me then as I thought about having a new baby, just as they overwhelmed me when I considered the ramifications of having a new book. I was particularly worried because I had taken a workshop a few months before with a poet of note who had read part of my manuscript and whose comments had led me to mutilate a few poems. What if none of the poems were any good? What if I was no good? What in the world made me believe that, at fifty-five, I could begin writing poems again that anyone would want to read? My brain was too old and too tired for creativity. I called my friend and fellow Alabamian Randall Horton, a writer I admired who had blurbed my book. All of my fears tumbled out. What had I done? What was I going to do? So and so had said I needed to consider this and stop considering that. So and so had said, "You shouldn't write this way." So and so had communicated telepathically that I was an irrelevant crone who was too old to enter the Promised Land of poetry. Randall, who is one of the

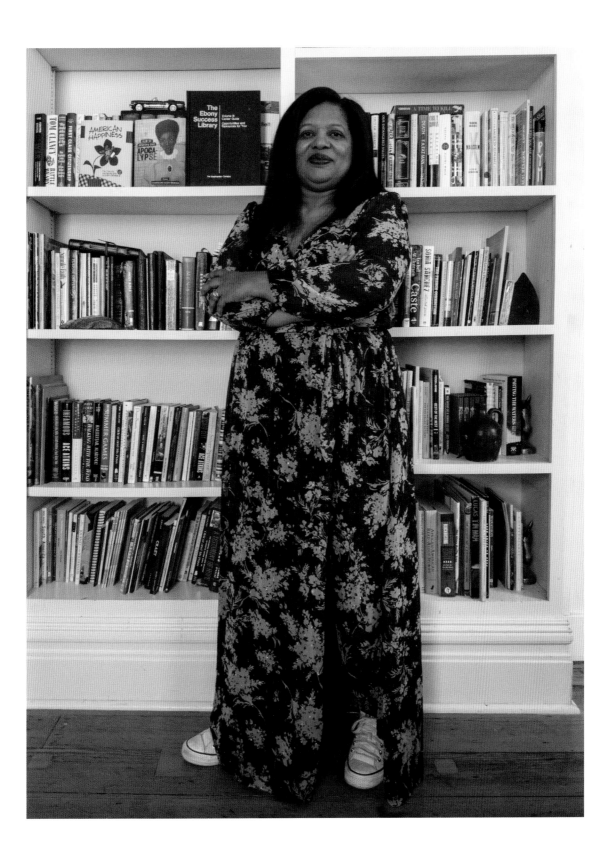

most wonderfully bottom-line folks I know, allowed me to ramble on like a crazy woman and then simply said, "Jackie, do you. Please." Those simple words stopped me. *Do you.* It was an invitation to be who I was, where I was, at the age I was.

I have been a writer all my life. Or perhaps saying I have been a creative all my life is more accurate. My mother made a vow to herself, and maybe even to God, that I would learn something of everything beautiful and artistic. She equated such exposure to sophistication, and if I were to grow beyond the confines of my Alabama town and, more importantly, the confines of what she saw as a constricting Alabama mentality, I would need the creative arts. She was always taking me to the orchestra, dance performances, plays, and the more esoteric movies (some of which I probably should not have seen when I saw them). I never minded these excursions into the wide, extraordinary creative world, where imagination was allowed to run amok and boundaries of mind and spirit were frowned upon, though they made me a child who lived in her head. I was more interested in twirling about the living room to *The Sound of Music* than going to the Thanksgiving Day parade with friends, who were often confused by my priorities. I was dubbed the "artsy one," or the "creative one." These were not necessarily good labels. I was strange. Dreamy. Internal. While many of my friends were swooning over the latest pop star or boy band, I was chilling to the mellow sounds of George Benson. Simply put, I fell in love with all forms of creative expression, much to my mother's delight.

This love affair led me to ask my mother for lessons. Lots and lots of lessons. When I saw a performance of the Bolshoi at Wolf Trap Farm, I just had to be one of those girls in the tutus pirouetting their way into eternity, and when I listened to the Brandenburg Concertos on an album given me by my cousin, I wanted, no, *needed*, to play Bach in an orchestra. My mother was only too happy to feed my desires. I did it all—ballet, tap, voice, piano, clarinet, and bassoon. I acted in plays, sang in the choir, and recited on program after program. I even painted, watching episode after episode of Bob Ross shows (not exactly Rembrandt, but it's what I had), emulating his every move, and then taking private drawing lessons when I was in college. My creativity was not confined to the traditional fine art forms. My mother taught me to sew, crochet, and cook (by which I mean entertain as a proper hostess with a beautifully set table, lovely flowers, and well-prepared meal). There were years of making clothes, granny square blankets for my bed, and even costumes for productions, a skill I would later need in my role as a mother when my five-year-old son volunteered me to

make eight elf costumes for the Christmas play at his school (a task I didn't learn of until his teacher thanked me for agreeing to do so the day before the play was to take place). Was I good at all these artistic pursuits? Not exactly. I was not a prodigy. I mastered no artistic endeavor. My body type was not suited to ballet. I found practicing musical instruments repetitive and boring. I felt discouraged having to pull out stitches—must seams really be that straight?—or when my mother made me crochet the same doily three times to ensure all of the loops were the same precise size.

Yet I regret none of it, this childhood spent inventing the world through the work of my imagination and hands. I learned to be a good audience member, to listen and gawk with appreciation at what dedication it takes to be perfect, to be an expert. I can still make my own pattern out of newspaper, and, if pressed, I can lurch my way through most songs on the piano. I was like Moses. I appreciated the Promised Land of artistic expression though I knew I would probably only know it secondhand. Plus, while I found joy in all forms of art, none of these creative outlets drew me, lifted me, enchanted me, or comforted me like reading. This was my mother's other gift. She introduced me to a world of books, and she let me read everything, ready or not. By the time I was eight, I was absorbing the rhythms and rhymes of Poe and Eliot and Whitman with all the gusto of one who starves for milk and honey. Did I understand what they were writing about, or their historic context, or their references? No. I didn't care what they meant. I made up my own meanings, the emotion of their words speaking directly to my soul. They might have been writing spells, for all I knew or cared. In fact, they *were* writing spells, incantations that took me to some place I wanted to go even if I did not know where it was. Yet there were no lessons, at least not yet, for books. There were only the intense pleasure of reading and my own ignited imagination writing itself on the page. Words drew me in and comforted me. Words protected me in a way that dance or music or even a well-made frock with straight seams never could. Words were a refuge where I could escape my own strangeness and the loneliness of being a child of imagination in a mass-produced, generic world.

My father died the year I learned to read, to really read, not just call words or mimic memorized stories, but go anywhere a book was willing to take me. And the year after that, I began making what seemed to me at eight the long trek to the library that was four or five blocks from my house. This was a magic place, a sanctuary. I loved to spend the day there, exploring the stacks, reading at will, inhaling that deep library smell that only libraries have. I already knew poetry, a form I had first read in my mother's

old set of Harvard Classics, but in that library I discovered contemporary poets like Carolyn Rodgers and David Ignatow and Denise Levertov. An odd assortment, I know, but I had no guide. I was just a kid reading through random bookshelves with neither map nor compass. Through their poems, my companions taught me to do as they did, to write, showing me daily what language could do. Each time I entered the small library, just one large square room really, with high shelves along the wall and low shelves spread throughout, I was in a place where I was never a stranger or strange. The hours flew by in this oasis. One summer I gave myself the task of reading through all the books beginning in the A's of adult fiction and working around the shelves. Did I make it? Hardly. Too many pleasures. Too much to read. Too many distractions. Some days I would just plunk down on the floor next to a low shelf and remove whatever book caught my eye. I read and absorbed. Though fiction was fun, poetry was my favorite. Poems allowed me to make sense of whatever did not make sense to me. Here is how I learned to navigate the treacherous world. The poets know it all, and they tell it. So for years I wrote poems about everything—joy, sorrow, rain, and soup—just as they had taught me. Poems helped me think through the death of my father, the frustrating transition from childhood to adulthood, the nature of love, the death of my mother.

Teachers and other adults cooed and clucked and told me I had "promise." Such a young people's word, this idea of potential being a precursor of the good to come with time, practice, and maturity. In some ways it is a dangerous word, at least it was for me, because it portended some external reward, some hope that with time and effort I would become an "expert" and that that was the goal. Why is expertise so important? Why is mastery the goal? Isn't art always expanding and changing as it responds to the volatile context in which it was created? Isn't art always about inventing skills we have yet to discover we need? Even the sonnet was once a new thing. What if there had been no lyrical ballads, bebop, golden shovels? If everyone had settled for the mastery of the old forms, none of these would exist. I did not know at the time that the desire for expert status is a desire for the death of creativity. But the word bred in me discontent, and I was filled with the need to hold a title, to reach a destination that no one can name, to avail myself of the riches of the fabled Promised Land. So I kept writing, and dreaming, kept being in love with writing, with writers, with words. Until, one day, I didn't write anymore.

Why I stopped making poems consistently has to do with my misunderstanding of how creativity and writing functioned in my life. My mother

JACQUELINE ALLEN TRIMBLE

died, and I dropped out of graduate school and had to get a practical job teaching developmental English to make money. I had just gotten married, and all my plans of being a writer began to fade. I thought of myself as a failure and an imposter. But why? Somehow I had spent my life in creative pursuits but did not understand at all what it means to be an artist. I lived in a transactional world where value, at least in my estimation, was determined by measurable goals and money. Even my own mother, the impetus for my love of creativity, had insisted I minor in business when I declared a major in English and my desire to write books. "You're going to starve," she said. And though I hated business with as much passion as I loved literature and theatre, I did it, the little voice in the back of my head agreeing with her. *Art is decoration. It is not a solid thing*, I thought. *Artists starve and live in drafty garrets where they die of mysterious dead artist disease.* My friends' derisive label of "artsy" rang in my ears. Plus, despite years of writing, I had no professional publications and no prospects for publication. I still had not become an expert. And so I became an adult, went back to graduate school to get a PhD, and settled into being a wife, a mother, and teaching other people how to write or about the writing of those who had made it to the Promised Land. Those who can't write teach others to write, or something like that.

After decades of lessons, reading, writing, and appreciating I still did not understand something my son Joseph David II understood very early in his life: creativity is an essential part of life and can be its own endgame. When he was a child, I would often sweep signs of external validation from under his bed: certificates, plaques, even trophies. He had hidden them there.

"Joe David, when did you get this?" I would ask.

"Oh, that? I dunno. Sometime this year," he would answer nonchalantly.

"Why didn't you invite us to the honors program when you received this?" I would ask, holding a newly discovered certificate or plaque.

"I forgot," he would say, and then walk away unbothered and unconcerned.

We repeated this little ritual, the hiding and the discovery, the questioning and the dismissal, many times throughout his childhood and into his adulthood. I was baffled. Why had he never once burst through the door waving the symbols of his successes in triumph? My daughter, Jasmine, finally explained it by recounting what he told her when he was eleven and she was thirteen. My daughter was stressing about a school project, and my son said to her, "You're doing too much. Keep expectations low, and then whatever you do will seem awesome. Just have some fun. Like me." Though his advice explained a great deal about the way he lived his life, I was astonished by this attitude and, frankly, worried. Had we put too much pressure

on him? Had we stressed achievement over all else? Had he given up on his dreams? Stopped believing in himself because we were too hard to please? Not at all. I had missed the point of his message, a point I would not fully understand until he was a grown man. Joe David was a gifted photographer even as a child. He had an eye, but no matter how much we encouraged him or nudged him with camera equipment, when I said, "Hey, why not let us set up an exhibition of your work?" he would say, "Oh, that sounds good," meaning "I'll see," meaning "No, I'm good." When I suggested he might want to distribute some business cards or flyers and do side work taking pictures at weddings or for graduations, he would say, "Cool," meaning "That's never going to happen." And yet he often was found wandering about with a camera in his hand, photographing what he wanted to photograph when he wanted to photograph it, if he wanted to photograph it. For him, the joy in capturing the image was in capturing the image. It was fun. For a living, he did something else entirely. How free he must have felt— absent of judge and jury, need, or worry.

Like my son, my husband also understood something about creativity I had not. So, when I was fifty, my husband said to me, "You're not happy." It was morning. We were getting ready for work, and we were in the kitchen. We had one child who had graduated from college and was living on her own, one child still in college, and one child in middle school who was about to miss the opening bell. There was no time for philosophical discussions about the state of my joy.

Still, I stammered, "What? I'm happy." After all, I was tenured and had earned full professor at two different institutions. I chaired a substantial department. I had no health issues, and the children were doing fine. Our marriage of twenty-six years was solid. What was there not to be happy about?

He persisted, as he usually does when he is showing me he knows me better than I know myself. "You are not happy because you are not writing."

I stared at him for a beat. This was nonsense. "I don't write anymore. I don't have time," I scoffed. "We're going to be late."

"No. You are never going to be happy unless you start writing again."

What the hell is he talking about? I thought.

"You're a writer. Writers write," he said, and went off to work.

I am loath to say this, but my husband is rarely wrong when it comes to analyzing me, a trait I really hate about him. What he knew that I did not know at the time was that creativity is as important to my wholeness as breathing. When I thought of being a writer, I thought of publication, prizes, having a recognizable body of work. For him, it was much simpler. *Writers write.* The

act of creating was enough. There was joy in the creation itself. The important transaction is not between the artist and the marketplace but between the artist and the work. When I was a kid twirling around the living room belting out "I'm Gonna Wash That Man Right Outta My Hair," the joy did not come from my belief I would be a star someday, though I did think that. It came from the feel of my body in motion to the music, the thrill of singing the notes, the pleasure of the moment. I didn't spend all those hours, days, and weeks on the library floor or writing poem after poem or story after story because I thought it would make me proficient by some rubric of creativity. I did it because these acts gave me "surcease from sorrow." *Writers write.* One of my favorite professors, the late Ken Deal, taught me creative writing, and was one of the first people who told me that I had a gift, but he always reminded his students that some people want to write and some people want to have written. I didn't understand that at first. But my husband was telling me the same thing. The prizes, the accolades, the achievement of having written, are not the same thing as writing. My husband wasn't telling me I needed to have written to be happy. He was telling me I needed to write to be happy. He was telling me that I needed to nourish the creativity in me in this specific way. And so I began to write again.

I was filled with trepidation. I didn't even know if I could still write a decent poem, but a colleague told me about a week-long workshop on Cape Cod with the eminent writer Marge Piercy.

"You should apply," she said. "I took my husband and daughter with me. I think Marge will love you."

And so I applied. My elation at being accepted was short-lived when I was asked to submit fifteen poems within the month. I didn't have fifteen poems. I started digging through boxes for manuscripts, pages, old assignments from creative writing class, anything I could submit. But thirty years is a long time. And we had moved. Who knew where those poems had wandered off to? I missed the deadline. There was an email that said, "Where are your poems? Are you serious about this?" Was I serious about this? More like nauseous. Some way, somehow, I managed to find some poems, write some, and cobble together a fifteen-poem manuscript. I sent it, and went, with my husband and young son, to Cape Cod, where my creativity was rekindled. *Rekindled.* Too mild a word. More like, where I became a raging conflagration. Words poured out of me. Poems poured out of me. I did not worry if they were good enough or "right," I just kept writing and writing and writing. How thrilling it was to burn again. To play. I felt . . . happy. Whole.

I continued to attend workshops. My husband was delighted, because these workshops were often in beautiful places like the aforementioned Cape Cod or Key West. And along the way, I learned some things about myself. Though there is a kind of urgent magic in being a prodigy, there is an enormous grace in being a writer of a certain age—both given and received by the self. The days of writing poems like my twenty-year-old self were long over. I had "seen some things." I couldn't go back to being that promising young poet, whatever that meant. I had to find the grace in being a woman of a certain age, and a professor, a wife, a mother. I had to find the grace in not having published my first collection until fifty-five and, now, the second at sixty-one, the grace in the fact I am just now emerging.

Emerging. This term we apply to beginning writers who may one day, if the fairies and God say so, be important, whatever that means, or at least sell some books, is very odd, with its implications of metamorphosis, caterpillar to cocoon to butterfly. It's as if somehow the "unemerged" are knobby lumps with the potential to transform into something else. A writer who has arrived? Is there a GPS coordinate? Maybe it's like art or pornography. We will know it when we see it. Isn't this how we think of it? Or rather we think those who emerge flutter into the Promised Land, and those who do not remain cocooned in the wilderness.

And me? Certainly, I was cocooned in a barren creative wilderness. Or was I? Maybe I didn't need to find the grace at all. Maybe I just needed the courage to let myself be who I was. When I was selected as a Cave Canem fellow, I was excited. However, I didn't really fathom what the organization was or what it meant or how hard it was to get in. If I had known, I would never have had the courage to apply. When I got there and found myself surrounded by so many gifted young, very young writers, I felt actual panic. I said to one of the founders, "You have made a terrible mistake." And she said, "No, we haven't." Though I was gratified by her confidence, I was truly afraid. For the first time I saw clearly that I was three decades behind poets in their twenties, some of whom had already published a book. Or *two*. That kind of thinking is exactly the problem I would like to address. Creativity is not a race or a measuring stick or the production of any particular age. There is no starting line nor finish line. There is only the work. As intimidating as Cave Canem was, it was also affirming of these ideas. As I looked closely, I saw there were a few people my age and older who had put aside their writing to raise children, work in other fields, survive bad marriages, do something else. We had been chosen, not because of our age or market value or experience, but for our work. Nobody treated me like an old lady. Instead, I

was just another writer having to produce a poem a day like everybody else. And as I produced those poems, out of decades of reading and thinking and living, I realized that creativity will not be compartmentalized.

How many times had I chastised myself for not having become a writer earlier or at least a creative? As if I weren't teaching and parenting and living, my days heaped with tasks, as fast as I possibly could: sewing elf costumes for the kindergarten class, cooking thousands of cupcakes for the school bake sale, writing plays for Sunday School, endless days of making something out of nothing though I was broke and tired and depleted. Wasn't I living a life of constant creativity? Don't most of us? And yet I could not disabuse myself of the thought that almost four decades of teaching college students coupled with making this life was somehow not evidence of the right kind of creative work. I often felt ashamed, as if I had failed, because I wasn't well established, because I didn't have a stack of books and/or prizes so high I couldn't see over them. But should I? Or who says? Or mind your business and stay out of mine.

I am not going to lie. Rearranging my thinking about creativity has been a chore. It can be intimidating to walk into bookstores, proverbial hat in hand, and ask for readings or convince them they should carry my book. And it is humbling to ask people I could have given birth to for reviews and blurbs. And certainly disconcerting to encounter the surprise on people's faces when they see me with the expectations I will be writing about flowers or spending time at the condo by the beach, then hear my poems and think, *Who is this?* As one very well established poet said to me, "You look homey, but the poetry that comes out of you is anything but that." She was not the first to offer that opinion. I get it. I get it. Everything about me says "former soccer mom," and nothing about me says "edgy." Even in my teens and twenties, I was by all measures as tame and bland as apple pie. The edgiest thing in my closet even now is a pair of four-inch Christian Louboutin stilettoes, which I don't wear because they hurt my feet, and I am not willing to be uncomfortable. Discomfiture is the job of poetry, *my poetry*, because no one should judge a book by its sensible shoes. My poetry is a façade of sweet snow over a layer of ice underneath which lies a dangerous river. That ice will crack at any moment and drown anyone who thinks "homey" is a synonym for "safe." The disconnect between who I look to be and who I am is a thing with me. If I had a poem for every man who has walked up to me and told me I looked like a nice country girl, or every person who has said to me how they could never have guessed someone like me could write poetry like I write, I would be able to fill ten volumes with poems. When I was in my early

thirties—married, settled, two small babies at home—I walked into the corner store to buy some pork chops. I had on my appropriate long velvet pencil skirt, a very nice sweater, and a button-down. My hair was probably braided in a crown around my head. The young butcher, maybe nineteen or so, came out of the back in his white butcher's apron, leaned against the door frame behind the meat case, toothpick hanging from his lip, and looked me up and down, down and up. I looked at him. He smiled. I think he was missing a tooth. He said, "You look like a girl who knows what to do with some collard greens." This line was meant to be a come-on. This man had checked me out and found me to be a nice, homey girl, somebody who could cook him up a proper meal and probably rub his feet without complaint to assuage his long day of being a butcher. I said nothing to him. Just got my chops and went about my business as he watched me walk away. He didn't know I was a poet and that one day he would end up wriggling under my gaze in a poem called "Possible Responses to the Nineteen-Year-Old Butcher at the Corner Store in My Neighborhood Who Said 'You Look Like a Girl Who Knows What to Do with Some Collard Greens'" which ends with the line "Boy, you ain't ready for my collard greens. Not nearly."

I do not bite in real life, but my poems are full of teeth. I am interested in the ways history and the contemporary moment intersect, the current fraught political moment, the irony of living in a country at odds with its own narrative spin. I write revenge poems and always get the last word. More importantly, I think of myself as a revolutionary poet, performing a public service of telling my world about itself. Maybe it's because I spent so much time in the library reading Sonia Sanchez, Amiri Baraka, and Carolyn Rodgers. When I look at the world, I see fire, destruction, despair. If there are flowers in my work, beware: they are rotting or carnivorous. If there are puppy dogs, they have been run over in the street or infected with rabies. I write about the chaos, the mess, the absurdity of American life, of life in general. I do not mince words, nor flinch, nor look away. I like the dichotomy between who I seem to be on the outside and who I am on the inside. It approximates a structural element of many of my poems which invites readers in with humor and pathos and then traps them in a house of mirrors. Humor for me is a tool of rage. My first year at Cave Canem, a woman in my class who was thirty years my junior asked to publish one of the poems I had presented in class in an important, edgy national online journal. I have no idea if when she saw me she thought of me as "homey." If she did, she found that home to be interestingly dysfunctional.

There is an expected order to things, though we all know that order is as imaginary as Twitter. For years I lived my life according to the timeline of supposed-to: driver's license at sixteen, check; college grad in four years, check; married in mid-twenties, check; first baby four years later, check. First book and PhD by thirty? No check. Timelines were just dandy, until they were not, until I fell off the standard trajectory and landed, as most of us do, wherever life took me. So many obstacles to my plans. My mother died. Sent me out of graduate school, into marriage, and into a job teaching developmental English. By the time I went back to graduate school, I had two small children, one and three (a fact that made the Academic VP, my boss, tell me I would never make it because women with small children need to stay at home as his mother had). I took a full-time job building a new academic program, birthed a third child as I was trying to write my dissertation, and did this and this and that, which always kept me from writing and publishing this and this and that. See, I am still justifying. Still justifying. Still trying to explain away what has stood between me and translating my creativity into poems, stories, essays, and the rest at the right age. Still trying to explain why my cocoon was practically fossilized before I was able to begin to wiggle my way out. I will be a very old butterfly indeed, fluttering my wings around the yard enamored of the beauty of the world at a time when most of my kind should be readying for death, having laid their eggs and pollinated all the requisite flowers. I would, but the words of my husband ring in my ears: "Writers write." The question inherent in my teacher's admonition rings in my ears: "Do you want to write or do you want to have written?" The advice of Rilke rings in my ears: "If the Angel deigns to come, it will be because you have convinced her, not by your tears, but by your humble resolve to be always beginning: to be a beginner." And despite all cultural impetus to the contrary, I reject the very notion of emergence and the idea that creativity and innovation are the purview of the young.

Two stories. The first is about a former student. I am going to call him Buster, since I hold the power and can name him as I please. I took some of my majors to the inauguration of Montgomery's first Black mayor—a momentous occasion, given the city's history. The Montgomery Performing Arts Center was crowded, and the joy of the moment was palpable. We found a long row of seats right in front of the central walkway that divided the lower seats from the middle section. As we stood there chatting, waiting for the program to begin, Buster walked toward me. I thought he was coming to share a few words about the significance of the day with students

or just speak out of courtesy to his former professor. Instead he said, "Good morning, Grandma!" and moved on to chat with someone else. I was stunned, and then angry. This man didn't know me except as his professor. At the time, I was in my fifties. Aside from the fact he was older than my oldest child, making the probability of my being his grandmother very slim, I was appalled by the disrespectful intimacy of the salutation. Would he have called a male professor Grandpa? I uttered a very late "My name is Dr. Trimble" to his back as he moved on to what were, in his mind certainly, more important people and matters. His words, startling in the moment, were just a few more in a long line of utterances and actions that diminish and dismiss older women academics and artists.

With aging comes the deterioration of the body. I do not look twenty anymore, or thirty or forty. I look my age, meaning to many I have outlived my female usefulness, meaning I can no longer reproduce. Now that I was no longer his professor, the former student returned me to the role of aging woman, who could then be dismissed with "Grandma," as in "Just go sit on the porch, Grandma, and watch the young play." The culture says, "We don't need you, so can you please don your cloak of invisibility and silence so we won't have to deal with your unsightly wrinkles or your irrelevant observations?" Not this woman. As I have gotten older, I have gotten more creative. All that energy I once used for the nurturing of others—faculty, students, children—I now use to nurture my ideas and craft. This notion has nothing to do with whether women choose to have children or not. It's about what they are expected to be doing by a society suspicious of female activity outside the domestic sphere. I don't have to be silent. I am not an ingénue, sweet and demure. Nor a young faculty woman being good for tenure and promotion. I am a teller of truth, a witch, an oracle. If I claim a cloak of invisibility, it will be as superpower. Who will see me coming, looking all homey, until they feel the kick of my comfortable stiletto hit their gut? That former student had best be careful not to stand too close. He has no idea the "Grandma" he was talking about is on fire with creativity.

The second story is about my mother, who was technically my stepmother. When I think of this woman, who came to me and my widowed father like a muse dropped from heaven, she is standing in the front yard of my house by the big mimosa tree like the first time I saw her. Her yellow dress has intricate cutwork just under the collar and a skirt so full she might have begun to twirl, a pinwheel of sunshine. Yet even if she had, I could not have been more fascinated by this goddess in the dark shades looking movie-star beautiful, as if she had just popped off a Sidney Poitier set. My

father was dating her, and they were on their way out. When she became my stepmother—because, if my father's story is to be believed, I had insisted on it—she led me into another world, connected me to a part of myself that would be essential to my creative identity for the rest of my life. It was she who let me paint a mural on the den wall, who listened to my endless stories and laughed in all the right places, who not only let me read any book she had in her own expansive collection but also opened the doors of the library and set me free. The first time I met her, she was fifty-seven. What has age got to do with it? Nothing. Everything.

I am now four years older than my mother was the day I met her, and though most people would consider me an old lady, I never once thought of her or her friends that way. They were always doing something—having cocktail parties, playing bridge, going to programs, giving speeches, organizing fundraisers, dressing up for dances, wigs and jewels in place, ample bellies cinched tight in girdles, and makeup done just so. Mostly, they laughed loudly and did as they pleased. All these women were well past what many would consider their prime, yet they were fascinating, vital women, full of vim and vinegar. It occurs to me that they knew something that these commercials pushing youth at women with their promises to lift and tighten all that has fallen and loosened do not: this time beyond the childbearing years is not a curse to be reversed, but a blessing to be embraced. They had not left behind their creativity but had made space for it. They had reached, at last, the Promised Land. And now, so have I. I am the most dangerous woman of all: a free one, who knows her own mind and is required to answer to no one. No more childrearing duties; no more having to hold or bite my tongue, having to corral my gut or hips or anything else spilling outside the norm. I am freed from the expectation of having to be anything at all but what I want to be. What could be more of a Promised Land for me than the wanton creativity of my own mind?

The work of soaring is arduous
requires more than muscle alone.
—Paula Lambert, "Anatomy of Birds"

For the Birds

Wendy Reed

Upon our arrival at the intake counter, a volunteer hands us a card to fill out. She points to the shoebox I've lined with a T-shirt and asks, "What type?"

"Ruby-throated hummingbird," I say. "A juvenile."

"It's that time," she says.

"That time?"

She says something about the arrival of fall as she disappears through a door that closes and cuts off her words.

—— I had been working on my laptop in the kitchen when I'd heard a faint noise at the window. I looked up but didn't see anything unusual. Because it's estimated that a billion birds in the United States collide with windows each year, I keep items on the windowsill as deflectors. The current collection included a few green tomatoes, some vases with rooting plants, a greeting card, and a pair of binoculars. The window looks out onto our covered patio, where lizards and frogs frequently nap on its sun-warmed concrete, though birds usually stick to the edge of the yard near the feeders. Had the sound been a bird? It seemed too faint. I stepped to the back door and scanned the patio. Everything looked normal. On the table beneath the window were a pair of coleus plants, my rabbit's foot fern, a sweet potato vine, and the spot where the wrens had nested, the memory of their cheeps and trills still a bittersweet echo.

Father Wren had hauled in twigs twice his size, maneuvering them beneath the fern and into an old wooden toolbox I'd turned into a shelf. Mama Wren flew in long bouquets of grass she used for lining. I'd seen each egg, newly laid, and in the hundred-degree temps had worried they might poach

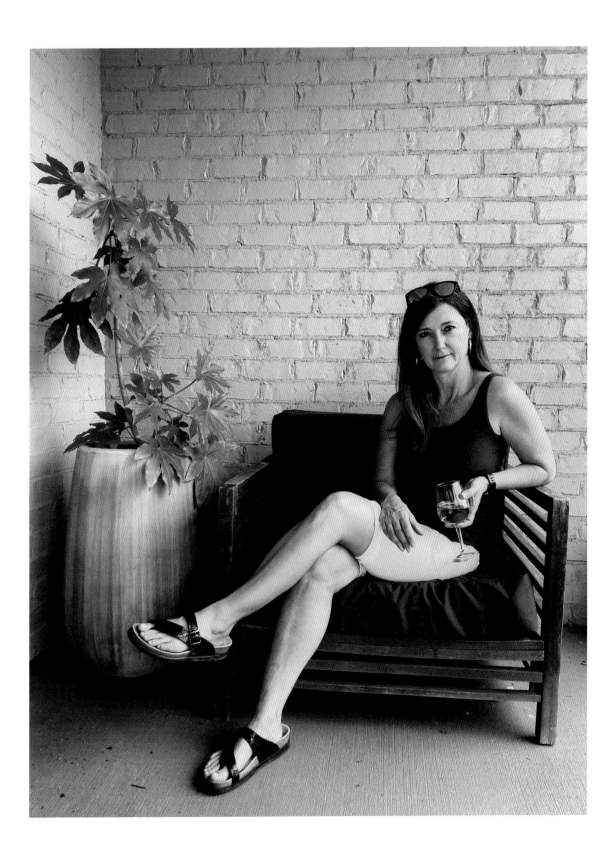

before they hatched. Even our dog Pablo was anxious the night they started chipping through the shell with their special egg teeth. He came into our bedroom and barked to let us know something was going on.

When the babies fledged, I witnessed the first one emerge and videoed the second with my phone as it stepped off the table into the air. I expected a clumsy flutter—but they didn't even gently tumble. For our baby wrens, it was free fall all the way down. My husband and I spent hours herding them away from the street and back into our yard, where there were no cars or cats, as they stretched their wings. When it was too dark to see anymore, we went inside, comforted by the knowledge that they were healthy and spunky and had as good a chance as any fledgling ever had of making it through the first night in the great big world. When rain woke me at midnight, I hoped that they'd come back home to the patio for cover.

By the time I joined my husband in the backyard the next morning, he had already refilled most of the feeders.

"I know that you'd want me to tell you," he said, not giving me time to even swallow my first sip of coffee, much less imagine what he was about to say. "One of the babies drowned in the big pot."

Drowned?

I couldn't process his words. *Drowned?* How could that be possible? I'd been so attentive, taken such care.

Images of the baby birds popped into my head. They'd looked every bit like the baby dinosaurs that they were, possibly angry and always hungry. Little tufts of bedhead feathers sprouted and quickly turned into tiny mohawks. I could see those thin mustard-colored stripes of beak opening wide. But now, one of them no longer opened. I closed my eyes and there it was, floating motionless—in the deep pot I'd failed to turn upside down. Which one had it been? Was it the smallest of the four? The one who usually faced opposite his siblings? I squeezed my eyes tighter, but the image of the baby bird kept floating. I couldn't seem to breathe. Why had my husband told me? Of course he'd told me. He couldn't *not* tell me. He couldn't keep that from me.

Why didn't he keep it from me?

Were it not for the mites, the nest might still be on the table, part memorial, part reminder, like the altar of my childhood church into which was carved: "Do This in Remembrance of Me." After removing the abandoned nest, we hosed the table and the concrete beneath, as if everything could be washed clean.

⸺ It was the day following the one with the odd, faint sound that I was in the yard picking figs and heard what sounded like a fired-up wasp coming from the "altar." But no wasp was beating its wings against the window above, trying to get in, and no flies were buzzing around as they sometimes do. The noise stopped, then it started again. I slid the fern over where the nest had been. Nothing was there, but the buzz grew louder. It was coming from the urn-shaped planter. Thinking it was too late in the season for nesting, I'd stuck a pot of lanky pink and green coleus inside the urn to keep it from falling over. Carefully I peeked into the urn, and to my horror I saw a blur of wings. It was a hummingbird. The tiny thing was trapped between the pot and the side of the urn. I gently removed the potted coleus, and the little bird flew up and toward the back of the yard.

Determined to prevent any more collisions, I went inside and added Post-it notes to each windowpane, so that bright yellow squares glowed from the center. Later, as I ate lunch on the patio, the squadron of kamikaze hummingbirds warred as usual. One perched atop the hanging-basket tower that I'd fashioned from wire and surveyed the territory, his ruby red gorget dazzling in the sunlight. Flying jewels, the first white explorers of the Americas had called them. *Joyas voladoras.* More often than not, though, it was a female who sat on the twisted coat hanger, her pale throat streaked with shades of gray, anxious and ever watchful. Overhead the sun shone. And in the words of Mr. Audubon himself: "One of the most extraordinary things among all these adverse circumstances was that I never for a day gave up listening to the songs of our birds, or watching their peculiar habits."

That evening, instead of working on an essay that was past due, I kept staring out the kitchen window.

"What are you looking at?" my husband asked.

There was nothing special about this change of season. The butterfly bush was shedding its lavender petals. The indeterminate tomatoes had escaped the raised bed and were creeping over the yard. The heat had finally broken. Yet I kept looking as if I were waiting. What could I be watching for? Maybe this was just another way to procrastinate.

"I'm just enjoying the view," I said, turning back to my laptop. He could've raised an eyebrow and given me the writers-are-full-of-bullshit look that I deserved, but he opened the back door to go out, stopping when I blurted that one of the warring rubythroats had apparently spent the night trapped in the urn with the coleus. "But she flew off, so I think she's okay," I added.

A few minutes later I heard him call through the back door: "I'm not sure your bird's okay."

She could only fly a few seconds before plummeting.

— Of all the places to shelter, she'd chosen a supposed self-watering, vinyl raised bed that nothing but onions and mint would live in. It reeked. We covered it with cardboard and tried to push it to the patio, but the wheels wouldn't roll through the grass.

"Buckle up, Harriet," I said as we lifted the makeshift chariot and carried her to the patio for closer inspection.

Harriet. Her name had rolled right off my tongue as if I knew her, as if she and I went way back.

— My husband immediately went into architect mode, while I channeled my inner physician, an unrealized dream from long ago that never died. I sterilized an eye dropper and within minutes had fresh nectar at the ready. Harriet was unsure at first, but she soon stuck her beak into the droplet and perked up. Before long she began flicking her long tongue, capable of lapping nectar up to eighteen times per second. I'd only seen a hummingbird tongue in nature videos. In person, it was no thicker than a hair and barely visible. It was there, then gone. Like a whisper. Like a day. Like life itself.

After losing the baby wren, I'd consoled myself that because wrens often nest in the area where they'd hatched, I might get another chance—bird restitution you might call it—next spring. Next *spring*. Not next *month*. Harriet looked up at me with those intense dark eyes, the question of trust plain and clear. How could I turn the proverbial bird in the hand away? But if she was seriously injured, were we equipped to take her on? Her tail looked crooked. One wing didn't fold the way the other one did. Her feathers looked wet above her legs. I had no idea what all might be wrong with her. Still, she appeared lively and alert.

I stood up, adjusting my neck brace, and whispered, "You and I aren't so different," as I raced inside, turning the corner as fast as I could into the bathroom.

Some races you know you'll never win. I run a daily race, where losing less badly than the race before is considered victory. There are no prizes, and I compete alone, yet it's a race that I've been losing for years.

You see, most people have a bladder.

I have a colander.

—— In the doctor's waiting room, I sit with a dozen other patients. Eight women. Four men. Various ages. Everything is shiny. Even the soft vinyl chairs have a sheen. I feel out of place in my yoga pants.

Recent posts on the clinic's Instagram promote Exclusive Back to School Botox Specials and Bargain Days for Fillers. An adolescent emerges and exits, not a pimple on his face. When my name is called, I follow Dawn to a small room. Gone is the swanky decor, but the walls look freshly painted. Is "Generic" a Sherwin Williams color? I wonder. Dawn asks the perfunctory questions and hands me a disposable drape. "The doctor will be right in."

No other woman in my circle spends as much time at different doctors' offices. One physical therapist joked that it was too bad I didn't get frequent flier miles. More than one physician has told me, "Getting old ain't for sissies," as if using sexist language and an ageist cliché was the way to explain everything. Maybe senescence does go a long way toward explaining some of my diagnoses: the knee, the hip, a corneal dystrophy (called Fuchs' and I'm not even kidding), thoracic outlet syndrome, Raynaud's phenomenon, adhesive capsulitis, calcific tendinosis, thyroid nodules, chronic but non-allergic rhinitis, spinal hemangioma, mitral valve prolapse, and cervical facet arthrosis, which—after semi-retiring and finally having a place of my own and the time to write, something I've been waiting my whole life for—would, if I sat at my computer for any length of time, inflame cervical nerves and cause excruciating pain that would make writing all but impossible. I call them flares, and they require lots of drugs and eighteen to twenty-four hours to subside.

Someone who was not a writer told me, "You'll just have to do other things," as if being a writer is a choice. Choosing not to write may indeed be an option, but what that means in the end is that you're a writer not writing. Maybe like a hummingbird that's unable to fly. When the pandemic hit, it was not a choice I could trust myself to make. To distract myself during the summer everything was shut down, I became a census taker, and the winter the COVID-19 vaccine came out, I signed on to work at the mass vaccination clinic—outside, all day every day. Going door to door and being on the front line, freezing and fighting rain and winds that required bricks to keep forms from blowing away, was preferable to being safe and snug at home, not writing.

Fortunately, a visit to the pain clinic introduced a procedure that helped—radio frequency ablation—or I couldn't be writing this. But it's a different issue, another prolapse, that took years for me, a well-known

over-sharer with a fascination for all things medical, to be able to discuss: *pelvic organ prolapse*. Somehow it sounds more official than *incontinence*, a term that makes pelvic regions sound geographically illegal. Lest you start to feel pity for my dizzying array of diagnoses, let me assure you that I'm in decent shape. I can box jump thirty inches, plank for three to four minutes, and beat my high-school-quarterback husband regularly in pickleball, and all with a torn biceps tendon. I may be a woman of a certain age—but inside, I'm still that fifteen-year-old who, when told by two muggers with guns to hand over her purse, responded: "Here, take my Bible instead."

In other words, I'm still unwise.

To be fair, the moment with the muggers, even though they fired at my boyfriend and me, felt less harrowing than the bladder fail during a ride in a full elevator. There's no place to hide in a five-by-six box, unless you count burying your face in your husband's chest.

My urogynecologist thought she could fix me. That was in 2014. What she did was cause yet another issue, the issue that led me here to this generic exam room, past a male gynecologist who tried to mansplain menopause and sent me home with a dildo he called an appliance. He wasn't helpful and had no idea why I sometimes felt like a briar was inside.

But I did learn that Alabama's antiobscenity law criminalizes "appliances" that might cause genital pleasure. Never mind that most lawmakers—and probably most Alabama residents—couldn't draw anatomically correct genitalia, especially the clitoris. But because scientific knowledge has been demonized as evil by some in my state, especially when it comes to sex and women, I shouldn't be surprised. I simply thanked that doctor, took my appliance, and left. Google would be more help, I thought. But I was wrong. Eventually I even gave up googling until my gynecologic nurse practitioner said she would be more help if I were currently experiencing the problem. It was Writing 101, the thing I preached to my students: Show, don't tell. I could *tell* her something felt like a briar sometimes, but if I wanted to be effective, I needed to *show* her.

"Aha," she said at the next appointment. She described it as more razor than briar. I wanted to hug her, throw my arms around her, and thank her for the validation. But that's easier said than done in stirrups. Before I could ask what the next step was, she'd recommended a specialist.

"Dermatologist?" I repeated.

"Of course she does regular dermatology, but I think she's the only one in the state with a vaginal specialty. Probably there's somebody in Atlanta, maybe Nashville."

She was spouting geography, but I was stuck back at *vaginal*.

"You've got to be kidding," I said, knowing full well that nurse practitioners aren't exactly known as healthcare jesters. "There are *vaginal dermatologists*?"

"I'll take care of the referral," she said, calling the doctor by name, but I misheard her because my ears were still ringing with *vaginal dermatologist*. I left thinking she'd said Hulga. I imagined telling my husband: "Good news. I'm going to see the *vaginal dermatologist*." I imagined rescheduling my hair cut: "That day won't work because I've got to go to see my *vaginal dermatologist* Hulga." Maybe I would ask my German friend: "Do you know Hulga? The *vaginal dermatologist* here, not in Atlanta or Nashville."

I, however, told no one.

—— Now that I'm finally here, I undress, don the disposable drape, and click Wordle on my phone, but the wall across from me, papered in pamphlets, is too distracting and just far enough away that I can't read the titles. I consider rolling myself in the crispy paper like a burrito and hopping closer, but hopping isn't my forte, so I snap a pic instead and zoom in: *Life is a journey, don't let wrinkles tell your story*, one says. *Ready for an About Face?* another asks. *Sweat less, Live more*, commands yet another, and one more exclaims, *Anti-aging Intelligence—That's GENIUS*. There are dozens. It's nuts. Nothing, however, mentions vaginal dermatology. Maybe vaginal dermatology pamphlets are also illegal in Alabama. I think of my friend's poem "Spectacle" in which the sudden blooming of an amorphophallus named Alice has people lining up to nuzzle her folds. The poem addresses the way we shy away from anatomical language, substituting prim approximations. Alice the corpse flower reminds us of the temporality of life and death and how taboo both pulls and pushes us away from what is natural, of how conflating Morality and Mother Nature has twisted and tied and corseted women until we can't tell if we step into culture's straitjacket by choice or not. Walt Whitman sang of the body electric more than a century and a half ago, yet in the age of GPS some of us still say "down there."

Medical textbooks of today—*today!*—still get it wrong. Knowledge about our own genitals is not immoral. But Viagra being covered by insurance while vaginal lubrication is not is more than immoral—it's systemic inequality that's been passed down for so long by men that many women don't even recognize it as patriarchal. In Alabama, the church and the patriarchy might as well be synonyms. Men are entitled to pleasure. Boys, after all, will be boys. But women embracing pleasure is shocking, not to

mention selfish. For a moment I feel bold, like I can single-handedly free society from sexism. How blind does one have to be not to see the double standard and how ridiculous it is? We're the only state in the nation that criminalizes vibrators, which kill no one, yet we celebrate the sale of guns, which are made to kill. My own voice grows thunderous in my head. Give me a cape and I'll deliver us from stigma. Give me a pulpit and I'll preach against shame. Give me a light saber and I'll—I don't actually know what light sabers do, so better give me a torch—enlighten the shadows of ignorance. This is my sixth decade as an Alabama woman, and I've learned to roar. This is my furious season, and I will not be shamed. I will get loud.

The sound of the doctor at the door snaps me out of it.

I toss the phone onto the chair as if guilty and sit up straight. I smile and, in some kind of effort to jump-start my voice, extend my hand to introduce myself. She looks at my hand. I remember the pandemic isn't over. Below her piercing blue eyes, she's wearing a mask. My own nose is naked. "Sorry," I whisper, letting my hand fall. Though she's got my medical tome in her chart, she asks, "What brings you here?"

For those ninety or so glorious—and previous—seconds, I had been so brave. Verbose even. Now I have a chance to speak, to tell the story of being a woman of a certain age to a specialist, the story of what it means for me. I know the vocabulary and am long past resorting to "down there," and I've never used my friend's prim approximation "birdie," but I confess it suddenly sounds attractive, all those soft feathers and the ability to fly away. Instead, I take a deep breath. I'm a word nerd, after all. I teach the importance of being specific, the power of story to change and even save lives. "My nurse practitioner said you might be able to help. That you're the only doctor in the region who specializes in . . ." I stumble, pause, but take another breath. Still I hear myself say: ". . . in *this* type of issue."

Maybe I'm not ready for that cape after all.

⸺ Within a few hours of Harriet's chariot ride, she had a two-and-a-half story palace, complete with floor-level garden for organic insects, multilevel perch options amid a huge firepit-screened skylight, a couple of ramps, and not one but two hummingbird feeders. It even had the benefit of an overhead fan. I dubbed it the Palace for Hurting Birdies, until someone on Instagram rightly pointed out the ambiguity.

Things to know when rehabbing a hummingbird: they burn up to 12,000 calories per day and they "refuel" every ten minutes; they don't have a bladder; their metabolism is seventy-seven times faster than ours. The internet

is unanimous: rehabbing hummingbirds is extremely difficult. They often die. I blinked away the image of the baby wren, turned off the patio lights and fan, and told Harriet good night. If she made it through the night, we could decide what we wanted to do in the morning. The bird rehab center opened at eleven.

—— I awoke the next morning to the back door closing. I heard the microwave ding and my husband's footsteps. He was bringing me coffee in bed.

"Did she make it?" This time I wouldn't be caught by surprise and readied myself for the news.

What followed was a too-long pause. The blackout curtains made everything dark, and I felt déjà vu rising.

"She made it," he said. I realized he'd only been letting his eyes adjust. "And she's hungry."

It may be ridiculous to call it redemption, but that's how it felt.

As I fed Harriet another round of breakfast, I noticed a tiny red fluorescent speck on her neck. Only the adult males have red necks, but juvenile males, if you catch them in the right light, often sport hints of what's to come.

Just like that, Harriet became Harry.

Life is not an exact science. Throughout the animal kingdom both males and females are allotted about two billion heartbeats. We humans tend to spend ours judiciously and may live more than a hundred years. Hummingbirds roar through theirs furiously in three years or so. Wrens and other songbirds double that and then some. Despite "birdbrain" being pejorative, it is the brains of songbirds that led researchers to a groundbreaking discovery: adult brains can grow new neurons. Turns out aging isn't only degenerative; it can deliver fresh nerve cells. A key moment occurred in 1981, when it was discovered that the volume of the area in a male canary's brain, which controls song-making, changes seasonally. It peaks in the spring for courtship and shrinks in the summer. In the fall it starts expanding again—not so it can repeat the same songs, but to learn and rehearse *new* tunes. Carl Honoré, godfather of the Slow Life movement and author of *Bolder: Making the Most of Our Longer Lives*, contends that aging may "alter the structure of the brain in ways that boost creativity." Even so, he notes, "No matter how much kale you eat or how many hours you spend doing Pilates, your body will work less well over time." Both may be true, but it's something else that rings truest for me: while researching his first book on slowness, Honoré got slapped with a speeding ticket.

My husband and I were still standing at the Alabama Wildlife Center counter when the volunteer returned. "Put a stamp on the card inside and mail it back in this," she instructed, handing us a little donation envelope. "In a few weeks, we'll mail it back to you with an update." She thanked us and returned to the birds. Back at the car, I took the card out and saw the square for the stamp and blank lines for our address. I flipped it over where several blanks had room to list date, species, age, sex, and name. She'd written *Ruby-throated hummingbird, Juvenile, Male*. Next to that I read *BB674*.

"I hope they're better with hummingbirds," I said to my husband, "than they are with names."

⸺ Not only had I demurred when it came to saying the name of my *vaginal dermatology* issue, I'd gotten the dermatologist's name wrong. It was not Hulga but Vlada, the feminine form of Vladimir. As in Putin. Which means "possessor or ruler of the world."

You have not lived until Vlada, ruler of the world, uses a pitchfork to inject steroids into your un-anesthetized *vaginal dermatology*.

Or until Vlada holds you hostage with her steel-blue gaze and interrogates and lectures you: The clitoris is as large or larger than a penis. Personal lubricant is bad bad bad—use olive or coconut oil instead. Soap also bad bad bad—use plain water. Before you leave, she will introduce you to her new acquisition, an electric chair called Emsella, which you hope is more effective than the slogan on its pamphlet: JUST SAY NO TO INCONTINENCE. The breakthrough treatment is FDA approved for men and women, noninvasive, and not a stitch of clothing has to be removed. High intensity electromagnetic energy causes pelvic floor contractions—equal to about 12,000 Kegels penetrating up to ten centimeters in one twenty-eight-minute session. Some say it takes getting used to, but in one pamphlet yoga and wellness expert Victoria Woodhall calls it her "vibrating happy chair." No wonder Alabama insurance doesn't cover it.

When Vlada focuses on my bladder rather than the reason I was referred to her, I manage to squeak a reminder and assure her that I've adjusted to colander living and will get through these next years, until a procedure likely to work for me makes its rounds through research. She gazes into me, trying, I think, to determine if I'm lying, to gauge whether or not I comprehend the serious outcomes of incontinence. I hold her gaze because I do. I know them like the back of my hand. It's highly detrimental to quality

of life, comparable to stroke and kidney disease; it markedly reduces life satisfaction for men and women over forty; it's a significant economic burden; UI (urge incontinence, one of four to six types of incontinence, depending on who's counting) is a predictor of institutionalization. She hasn't blinked, but neither have I. I also know that three out of four women in their mid-sixties will experience incontinence; that the unpredictability of certain types is as much the reason women wear black pants as is their slimming effect; that it's hell on the interior of cars; that it isn't limited to the bladder; that people are too embarrassed to talk about it (but hopefully not to read about it); that when you're in that elevator full of people and UI hits, there's nothing to say. There's only shame.

And the feeling for several minutes that I might die of it.

Humiliation is a synonym of shame, and both concern being made to feel lesser in status or worth, but shame involves a violation of a social or moral standard. In American literature, we might think of Hester Prynne in *The Scarlet Letter*. In Middle Eastern and North African countries, women—most recently Mahsa Amini, who sparked international outrage when she died in the custody of morality police—can literally die of shame because honor killing, double standards, and sexist mores and laws are not history. Nietzsche said, "We have art in order not to die of the truth." I'm extremely fortunate that UI is not fatal; it's material. And though writing about the many humiliations of aging will not ward off Death, it gives me courage to laugh in Its face.

"About that briar," I say. I'm unsure of the pronunciation, but thanks in part to my nurse practitioner and Google, I'm ready. "My concern is the horizontal fourchette scar—a result of my surgery—that rips at the slightest pressure." Fourchette—French for little fork—is where, posteriorly, the labia minora meet and join together, forming a fold of skin at the bottom of the vaginal opening above the perineum. It's where, just before delivery, obstetricians perform strategic incisions called episiotomies in order to prevent the thin tissue from tearing. I had three babies, two episiotomies (the third came so fast the doctor barely arrived in time to catch him), and no problems until the pelvic surgery, which should have taken an hour or two but took close to five. I might as well have had a Volkswagen backing in and out the whole time.

"I'd like to trade my Fourchette in for a Fivechette," I say. I imagine she smiles behind her mask, those icy blue eyes warming as she promises to fix me.

Instead, she informs me about pudendal nerve damage.

I can't help but notice the Emsella pamphlet: ENJOY THE RIDE.

⸺ The Alabama Wildlife Center is underfunded, underappreciated, and I imagine understaffed. I felt certain the bird update cards were designed to discourage calls. Calls would be inconvenient for a short-staffed facility. As "an accident" (my sisters were sixteen and ten when I was born), I have lived much of my life trying not to cause any more inconvenience.

I dialed the number anyway, and when no one answered, I left a message. After asking how BB674 was, I said I needed to know ASAP because I was writing something and had a deadline.

Maybe there's something to growing new nerve cells.

Someone called back: "BB674 has feather damage to its outer primaries and some pulls and broken tail feathers." They won't know how he'll molt until the spring, so he'll have to overwinter in rehab. No mention was made of damage to his furcula, the fused clavicle that Paula Lambert in her poem "Anatomy of Birds" says allows birds to bear the rigors of flight. My grandmother called it the pulley bone, but it's more commonly called the wishbone. Furcula, like fourchette, means fork but in Latin. Lambert ends her poem with a reminder about the wishbone: it can flex.

Humiliation and shame are also paths to humility, which originates from *humus*, meaning earth, ground. I'd assumed "humor" had the same etymology, but life is nothing if not surprising. "Humor" comes from the Latin for bodily fluids.

This winter you'll find me pulling for BB674—from Vlada's electric chair—and still flapping my wings furiously, trying to stir the air.

I Want to Do My Thinking Myself

Yvonne Wells and Gail Andrews

After taking up traditional piece quilting in her forties for warmth and necessity, Yvonne Wells of Tuscaloosa, Alabama, quickly began to make the form her own. Her celebrated story quilts draw on topical and personal subjects, including civil rights, faith, and what she identifies as sociopolitical issues. Her work was championed by the noted collector Robert Cargo, whose Robert Cargo Folk Art Gallery was located in downtown Tuscaloosa and some of whose collection is now at the Birmingham Museum of Art and at the International Quilt Study Center and Museum in Lincoln, Nebraska. Yvonne's work has been exhibited around the world and hangs in the Smithsonian National Museum of African American History, among other museums and galleries. She and University of Alabama professor Stacy Morgan have collaborated on a book about her work titled *The Story Quilts of Yvonne Wells*, due out in 2024. Yvonne has said that she creates her art based on the three Hs: what the head sees, what the heart feels, and what the hand can create.

Gail Andrews is director emerita of the Birmingham Museum of Art and a nationally recognized authority on folk art and textiles and author/ editor of several works, including *The Original Makers: Folk Art from the Cargo Collection*, coauthored with Emily Hanna. She and Yvonne have been friends and colleagues for three decades.

On Friday, June 17, 2022, Gail met Yvonne at her home in Tuscaloosa to talk about Yvonne's life and work. They were joined by Anne Kimzey, a folklorist with the Alabama State Council on the Arts, where she manages the Alabama Folk Arts Apprenticeship Program and the Literary Arts

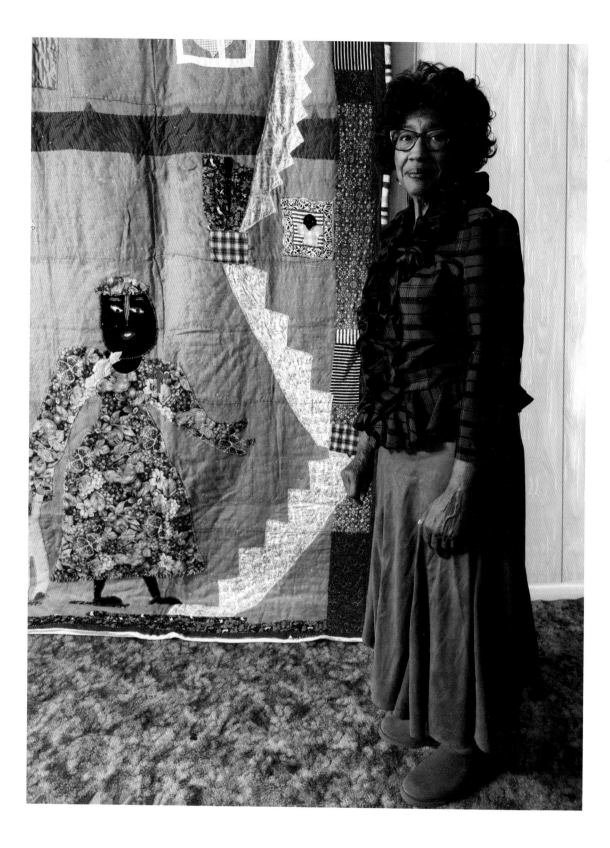

Program, and by this volume's coeditor Jay Lamar. It was a scorchingly hot day, and peaches were in season.

The conversation that followed has been edited for length and clarity, with approval of the participants. Afterwards, as Gail, Anne, and Jay prepared to leave, they talked about the schedule for Carolyn Sherer to photograph Yvonne for the book. Yvonne said she might need to reschedule because she had just learned she was to be honored that same day by the Tuscaloosa NAACP chapter at the 2022 NAACP Juneteenth "Living Legend" Luncheon.

YVONNE WELLS: Well, I'm so glad y'all decided to come by here.

GAIL ANDREWS: Well, we are grateful that you not only said yes, but that you have worked so hard to make it a great visit. It is wonderful to be able to see all these quilts. I'm excited about Stacy's book. I look forward to it coming out.

YW: I am too. He's worked so hard on it.

GA: How did you and Stacy first meet?

YW: He met me at Kentuck. I think he had heard about me, plus he teaches African American cultural arts at the university [University of Alabama]. He invited me to talk to his classes, and I've been to his classes many, many times and made quilts from some of the small pieces that his students made. They would bring them to me, and I would make a quilt out of them and give it back to him. I think he has one or two hanging in the hallway there by his office. Usually when the students make something, you don't know what they're going to make, but they know I need to turn something in so I won't get a failing grade (*laughs*). I use what they give me and try to let them know that you can use just about anything to make a quilt.

GA: As a teacher yourself working with young people, in your career and then now with the university, is that something near to your heart?

YW: It is. I've always thought I was a teacher, even before I became a teacher, because I would always have kids over to play and I was in charge of teaching. You know, there is always one (*laughs*). I've always liked students. I've always liked trying to inspire, encourage the young people. In the schools when I first started to teach, there was a great need, and there's a greater need now because the students are missing a lot of things. But my time was my time, and this time is now.

GA: When you say missing a lot of things, are you thinking about COVID right now, the lack of interaction—

YW: Yeah, that too. I just think COVID has put the students two or three years behind.

GA: Both academically and socially?

YW: Yes, because both of those go forward together, but they have missed those two years and all those interpersonal interactions. Socializing is a great teaching tool, and you cannot learn without others. You might say, "I can do it by myself," but you can't do anything by yourself. I mean, you do many things by yourself, but as far as learning, you have to have another object—another thing to teach.

GA: And to be willing to have a give and take with other people.

YW: There's nothing better.

GA: Speaking of learning, how did you learn to quilt? How did you get started?

YW: Well, when we added on to this house . . . I think it was [19]78 when we completely finished or stopped because we were worn out simply because we were making it ourselves. We were doing it ourselves with a little help from professionals. My husband had gone down to Gainesville, Alabama, and torn down a house that was given to me. An older antebellum home. Two, three fireplaces were in it. When we were downstairs, here, if you saw that wood . . . it's what we cleaned up and put in here.

GA: Similar to quilt making in that you're taking these materials and making something out of them?

YW: Making something out of nothing and making that object worth the time that you've put in it. There are people who would say this is magnificent, and there would be people who said this is junk. I keep moving. Keep moving, yes.

GA: When you finished your house, is that when you decided you needed to make something else?

YW: When we put that fireplace in downstairs, it wasn't throwing out enough heat. So I said, darn, I'm going to make something I can cover my legs with, and that's how I got started. It was a coverlet. It wasn't big at all, and it felt good. I said, darn, I think I can do something better. So I started piecing strips and blocks together and finally I got a quilting book from my aunt, and she said, look at this and see if you can do it. I said, I can't follow a pattern. I can't cut straight. I was tearing it, and of course it was irregular, but that didn't bother me. I sewed it together anyway, but after that or maybe about a year or so later I said, I don't like this feel. On the floor downstairs by the door is where

I made my first story, "The Crucifixion," and that was probably around 1984 because I exhibited it at the Kentuck Arts Festival in 1985 and won Best of Show, and I came home and I said, Robert, what's wrong? Something is going wrong here because I won out of all of those people, and he [Robert Cargo of Cargo Folk Art Gallery] said, well, you're good. I came to the realization it wasn't how it looked, but what it was saying, and that's where I am now.

GA: How has your work changed, do you think?

YW: It hasn't changed that much. Well, it has changed because I don't make as many as I was making, but the dynamics haven't changed. It's just that I'm moving at a slower pace than I did when I first started, and that's natural. I'm older now, and I don't function as quickly as I once did, but I am still at it.

GA: Yvonne, how did your storytelling start? I mean, there is such a strong tradition of patchwork and appliqué in quilt making. What happened between you and the fabric and the floor that changed your approach?

YW: I think we needed to talk to each other, and we needed to have something to say to each other. I think that is how it got started. I was feeling stuff, but I wasn't making that stuff with the patchwork.

GA: Was it stories that needed to be told?

YW: Yes, there was something in me that needed to be brought out. So that's how that story got there—I mean, the stories got there, and they were in a variety of subjects. You know, it wasn't all religious, even though I started off with a religious story. They [the quilts] could also be sociopolitical. I have so many names for them because I was seeing so many things that fit in so many categories: religious emphasis, children's moment [for young audiences], sociopolitical, and miscellaneous. So that's how I got there.

I've always been quick and fast and always doing stuff. That's why I think my family gave me the harder stuff to do as a child, because I was quick. I didn't make it look exact. Nothing I did was exact, but to me it was fine if it was off course. I just incorporated that into the story.

GA: You don't collaborate. You're independent and doing your own work. You have your own vision. Have people tried to get you to collaborate with a quilting group?

YW: Oh yes, I've been asked to join groups, but that is not what I intended to do and never have, because I would always look at those quilts as perfectionist and every needle, every stitch, was about the same size. Then I was looking at mine. Mine were walking stitches, and I thought

that was good. So I didn't want to change what I was doing to come to what they were doing, even though theirs were beautiful. I thought, so were mine. They're just different styles.

GA: What's the difference between sharing a story visually and verbally?

YW: Visually they [viewers] can look at it and read their own story, but if I told the story verbally, they would only hear what I have said. But if they're looking at a quilt, they could say, oh, this flower looks like a balloon. That's their vision. So that's the two collaborations that would come from telling and looking.

GA: Which means more conversation?

YW: Yes, it's conversational.

GA: Between the viewer and the quilt?

YW: Yes, yes, because I see quite differently as an artist than you as an observer.

GA: Have you ever had anyone who wanted to become an apprentice with you?

YW: I think they would love that, but I just never invited anyone because I work independently. Oh, that would drive me crazy because they would be looking over what I'm doing and wanting to talk, and all the time I'm working, I'm telling the story even though it's not coming out verbally. It's in my mind like the two [quilts in progress] downstairs. They're already just about to drive me crazy because they are ready for me to get them going.

GA: So they talk to you?

YW: Sure, and I talk back to them. That's crazy, but that's what I do.

GA: Sounds logical!

YW: It does.

GA: It sounds as though you've found your voice: you're in a conversation and it's your voice and the story that's coming to you. Is that true? And have you always had these stories in you? You've always been an artist?

YW: It just didn't come out until the eighties, or maybe the seventies. Later seventies. As far as doing them, I would think it was the late seventies, but 1979 is the number that comes to my mind because I know my daughter went to college that year, and I had made a quilt, and she took one with her. So that's where I think the jumping pad was at that juncture in life.

GA: So she was the last to go, to leave home, or did you have—

YW: No, I have a son.

GA: A son. Was he still—

YW: He was still here. They were still here. This is where they lived, upstairs. I have two children and four grandchildren and three great-grands. I tell you, they're moving in (*laughs*). I'm loving every minute of it, though.

GA: You've had some of that, grands coming and going, recently?

YW: Yes, indeed.

GA: It's fun, and then it's like—

YW: Yes. The good thing is they leave, and I say, ah. That's why I can't keep the house [straight] because they just want to come to grandma's house. And I want them to come. Yes, I want them to come.

GA: Yvonne, there is, as you know, a very significant history of story quilts within the tradition of African American quilts, beginning with [nineteenth-century folk artist and quilter] Harriet Powers, and then going forward with so many other makers. Do you see your quilts fitting into the trajectory of story quilts, or do you see them as something separate, different? Is it a continuing tradition in your mind or—

YW: It's because I think Harriet Powers's quilts kind of look like some of my quilts as well. She too is telling a story, and it's considered folk art, but there have been people who tell me that mine was not as much folk art as it is contemporary art.

GA: It can be both.

YW: It is. I don't argue with people, because I don't know. I don't know what to argue about, because I tell the stories, but I'm not an art historian, and I'm not necessarily interested in going and looking it up. I want to do my thinking myself.

GA: Of course. Well, of course, and it's all contemporary.

YW: Right.

GA: I see your quilts as such an important part of quilt history; yours are unique, unlike anything I have seen, the ways you depict stories, the fullness of characters. You have brought something new and powerful to the tradition.

YW: Well, I think that's because I don't use just fabric. I use other objects like paper and strings and fishing lines and all that kind of stuff and whatever the needle can go through, and it tells my story how to use it. Like I said, I've been called crazy, but that's okay.

GA: And I love how you find something at a yard sale or thrift shop and then it can take years before you find just the right place for it in one of your works of art.

YW: Yes, it does. I have fabric that sits here for a long time before the story comes. At some point, I will need it to tell a story. Once was lost, but

now it's found. That's what is written on the quilt that I made for my church. I found this piece of—it wasn't a handkerchief. It looked like somebody had torn it off of a dress, but I brought it home and didn't know what I was going to do with it, and I put it in the piece for church, and when I was explaining that to the members, they looked at me. You found that old stuff? And I said, yes, I find a lot of old stuff.

GA: And when you see something out in the world, how do you know what gets to come home with you and what just needs to stay there?

YW: Well, if I like it, and I think it's going to fit into my narrative, I'll bring it home. I'll bring it home, and it's just so much fun. It gives you so much pleasure in rambling through and finding pieces: oh, it's going to go with this and this is going to go with that. But until recently what I have always been able to find were flags. Can't find them now, but the hardest thing is my collection is now getting very low. I can't find any Alabama flags.

GA: I wonder, why?

YW: I think people are beginning to see the significance of it. Do you see that picture on the back wall? That's the bicentennial [of Tuscaloosa] quilt. That's the whole bicentennial quilt there, and that was the last [flag] that I had of Alabama. I've looked since I've spoken with you, can't find it. Can't find it. So I make them my way, but a lot of times it's the uniqueness of an old flag and where it has been or where it has flown and what the message was. That is what I like, and usually the more used they look or torn they are . . . they've served their purpose, and I want that.

GA: In one interview, you talked about a quilt that you had made that, you said, said a lot about you, and it also said a lot about your husband, in terms of [his] neatness and orderliness versus your more chaotic nature. This was in that very early exhibition at Williams College, *Stitching Memories*.

YW: Yes.

GA: And what was it about your life and your husband's life that was reflected in that quilt? And I wonder if over time your quilts are still talking about you and how they are perhaps reflections of you at a given point in time.

YW: I think they are still talking about me because—well, my husband being military, everything had to be just right. Just right. The right color. I can tell them every time because he liked things to have all things matching. I just never . . . I've always put blue with green and that sounds pretty

to me, but there are many who said something is crazy about it. But as far as my husband is concerned, he wouldn't say very much. He understood it was my thing, but if I asked him, he would say what he thought. I didn't change it, but I wanted him to feel as though he was a part of the process, even though I was doing the project. But when he did speak, you had to listen, because I said I'd hate to tell him that that might be right, but you know, I may need to do this. He found a picture of a quilt in a flyer from Parisian [department store] when it was at the mall. He brought it to me and he said, Yvonne, do you think you can make that? And the pieces were so small, I could never make that. But he asked me so lovingly, I tried, and I made it. But I would never do that again. But that part of the quilt that you saw in *Stitching Memories* is a reflection of the jigsaw way of me putting down a perfect quilt while quilting.

GA: What made it the perfect quilt?

YW: Anything that I make (*laughs*). I have decided that anything I make is the perfect quilt because I consider it a perfect quilt. It's what I did, and anything I made, I thought, is perfect. And you know how I came to that conclusion? They [traditional quilt makers who emphasized perfect stitches] were such a dominant force in saying that this is it, but here comes Yvonne. What I'm doing is right, and what they're doing is right.

GA: Can you just tell me a little bit about your process, as much as you can share with us? Do you go in with an idea first?

YW: Well, I've already thought about the two that I have downstairs and am in the process of making what I have thought about. But I still have in mind others that I haven't started on, and that's my process. That's the beginning of the process for me. After that, you have to look at it. I'm looking at this piece, and I want to know . . . you may need to have a title, but sometimes I don't have a title before I'm finished. But I know what I want to say on that piece. So I would sit there and look and go through all that fabric. That's so therapeutic. It's a therapeutic gesture that I do, and it begins to say, this piece of rag or piece of fabric is this, and this torn-up piece of dress or coat or something over here, I know what it's going to do. There is a piece downstairs I'm going to put in. It looks like a big long scarf. It's going to be put in one of these [new quilts], and it's going to blow your mind because it doesn't fit to a lot of folks, but it fits me. So the process is no two pieces are designed exactly the same, even though there are three or have been three [in a series], but each one can speak on its own accord.

GA: And how do you know when it's complete?

YW: It has a feeling of completion, and if you don't have that feeling, you have to put it down and look at it again and see what it is that you haven't done that is calling you back.

GA: And do you ever put any aside and then come back to them much later, or do you try to—

YW: Oh, no. No, I've got to go straight through it. I need to go straight through because that other piece is calling me, and a lot of times I'm working on two at a time. I used to do five at a time all over the floor. The furniture downstairs needs to be taken out because it gets in my way, but I'm working on the floor.

GA: Do you have some that you are more pleased with or less pleased with?

YW: You know, each one has its own ending. Some do not please me, but there is maybe one that may say to me . . . it's not saying what I really wanted it to say. Could I have done this differently? And maybe I could if I had made the next two. Usually the first one, if it's not what I want to say, I will make another until I've gotten to what I think it really should look like or should be. But each one in its number—one, two, or three—is still a good or completed work. I used to make three of a kind but now things have changed, and I'm not making as many as I did in the past. It has always been my desire to make three.

GA: Did something happen about three?

YW: Well, Robert [Cargo] said Trinity: God the Father, God the Son, God the Holy Ghost. I just always knew that that was Trinity. And I always knew that three was it. One, two, three strikes, you're out, and that kind of thing. My momma would count to three, and you better be here, and three licks on the leg. Something's magical about that.

GA: Is it different now when you don't do three?

YW: Well, it feels kind of strange when I don't do three, but because I'm aging—and I think right now because of age—I'm thinking I need to make more subjects or more one-piece quilts than I did when I was making three.

GA: Could you talk a little bit more about what you want to do and other things that you have in mind to do?

YW: I don't usually tell folks what I'm doing.

GA: Or just a—

YW: Well, I have two going on now, and these two are still sociopolitical, which is kind of strange because I haven't put a religious piece in, and I know that it's coming. But the topics I don't see changing because

the topics that I have now cover everything. I don't know of anything that I would make now that would fall outside of these categories that I already have. So right now I'm doing two sociopoliticals, and I don't know what I'll be doing next, but I know not too far off there is going to be something different.

GA: But you don't see any—

YW: Me quitting? No, no. I just don't see that.

GA: Speaking of that, some people talk about reaching an age where they are finishing up. Not that the drive to create abates, it may in fact increase, or perhaps shifts, and artists want to ensure their work has a home, or they're not going to quit writing or quilting or painting but may start spending more time with their grandchildren or other pursuits, and I just wonder if you are—

YW: Seeing the end? Well, I'm in my eighties. So I know it's coming. So there's nothing I can do about it. But I am not preparing for when I'm not quilting. I'm just quilting because I can and because it's satisfying. I can't say it's closer to me now than it was when I first started, because I've always quilted. I've always thought it was just wonderful that I did it. Nobody told me how to do this, and I want to continue to do that, and like I've said before, if I am making an impact on someone, I want to let that go on as long as I can. However, like I said, I know there is going to be a time . . . but I don't want to stop. When the time comes, the children can have all this, and they can keep it or find someone who is interested in it.

GA: Are there stories you haven't told that you're anxious to tell?

YW: No. There are stories that haven't been told, but I have not been anxious. There may have been situations where I have not gotten to them, but I'm just—

GA: But they are percolating?

YW: Oh, yes, they're there. Once I get it, it's there, and eventually I'll get to it. I think I'm seeing now as I did when I first started, what I wanted to say or what I am saying.

GA: That's perfect.

≈

GA: You grew up here?

YW: Yes, Tuscaloosa. Born and bred . . . two blocks away from Stillman College.

GA: So this is your—

YW: This is home. We built here in 1970. We've been here since 1970 in this house. My husband was military and he traveled a lot, and at one point the wives of the Marines could not follow them. He was a Marine at that time. We came back here then.

GA: Some people get restless, and they don't want to stay in one place, or think they've said everything or done everything they wanted to do about where they live.

YW: I'm not restless at all. My son who used to live in the house next door, he built a house down in Fosters, Alabama. He said okay, Momma, it's time for you to move. I said no, this house has so much of us here. Since my husband died, I can see even more clearly all of the hard work that he put into this. I don't think that I could leave it because like I said, we hammered and nailed. We did that, and I remember my husband when we finished, he was up in the attic in the bathroom there, and he hit the last nail and he stayed up there and just laughed and said, thank you, Jesus, I'm done, I'm done. It took us three years. Took us three years to build it because like I said, my children, my husband, and our friends all helped.

I have a very, very supportive family. So each one of them would say—they said, this is yours. You do with it whatever you want to, and if we can help you, then we will. And I couldn't do it without them. Every year my son would build me a tent for Kentuck. Every year, but I haven't been there in two, three years now.

GA: Did you go to Kentuck last year?

YW: I did not. I was supposed to go, but I started to caregive—started caregiving of my sister, and I couldn't leave her that long. So I just decided that I just couldn't do it, and I didn't want to put my children through that, because they had started to do things that they wanted to do without me. So I just said, well, I would do small things. I will never forget Kentuck. I would love to go back, because that's my beginning. I would do things that they asked me to, and I would help wherever I can in programs, but because of home situations, things are different now.

GA: I mean, you said you make these quilts—you make them for yourself. So even if they weren't shared with anybody else, you'd still be making them?

YW: Yes. I still will be here. And the quilts will still be here.

GA: And what has it meant that so many other people loved your quilts or what has it meant to share your quilts?

YW: Oh, it's kind of funny because every time I go [to Kentuck], you kind of feel people cringing—here comes this lady with this funny stuff, you know, in here with us. But I just never let it bother me after I had a conversation with—I think it might have been with Robert Cargo at that time or with Georgine Clarke [founding director of the Kentuck Association, and Visual Arts Program manager for the Alabama State Council on the Arts]—some of the people whom I respected. So I never let that bother me. But there are people, and I don't know if it's still the same today, that said I needed to go to school or take a workshop to learn how to quilt, but here I am doing the same thing.

GA: But you've been so well received at so many places.

YW: I have, and that has been interesting as to why, because I know there are many people out there who are doing beautiful folk art, and some of them don't get the invitations that I have.

GA: I think too you became such a great voice for your pieces. I can remember going to Kentuck and people would just be, you know, three or five or ten deep wanting to hear you talk about the work. You know, as you have said, you're not a public speaker, and then you became one through your quilts.

YW: Yes, I did.

GA: That's a big transformation as well.

YW: Well, I just never talked much, but I could do it. I could do it, and the quilts helped me to speak.

≈

GA: You are working downstairs?

YW: Yes, I am. Upstairs is the storage area. This is where I talk to people who come, and this is home. It's not a studio. This is home, and that's why I leave it like this when people like you come in, to let you know I'm at home, and I like being at home because it has a feeling about it. I could easily go and rent a space, but I think I'd be leaving something here in order to get there. And I'd be missing something here because I'm over there. I make my home my studio, so if I stay here, it's all right here.

GA: Do you mind if I ask when your birthday is?

YW: Okay.

GA: You don't have to say.

YW: All right. December 26, 1939.

GA: Day after Christmas.

YW: I'm a Christmas baby, yes. . . . I like my birthday. I do, and the more I have, the more I like it.

GA: Do you think quilting is your gift from God?

YW: I do, because like I said, my first story quilt was "The Crucifixion." I believe had I started off with something else, I can't say I wouldn't have liked what I'm doing, but I know the first step was through Him, as far as telling stories, and as I did that piece and started to branch out in different subjects and different categories, I try to put a piece on each quilt that signifies that it is designed by God.

GA: And when you are working on it, does it feel prayerful?

YW: Oh, yes. It feels peaceful. Quiet. Serene. And since my husband has passed—I know I keep saying it over and over and over again, but it's still new to my heart since he has passed—I think it's even more profound than it once was.

GA: And do you feel like that prayer or peace or connection to God, do you feel like that transmits to other people?

YW: I think so, because a lot of people would come up to me and say, I know how you feel. I see how you feel. I hear how you feel. And those kind of things are very relevant to me. I said okay, I didn't know that it was showing, and it wasn't that I was trying. It's because it was there, and it would always come out.

I'm so honored to be asked to do something like this. I am, and I thank you for doing this. I don't know how much it will help sell a book, but at least you heard me.

Onslaught

Patricia Foster

It's hard to determine a beginning, the time and place where disaster shook me loose from my creative life and demanded all my attention. Was it the week of caring for my ninety-seven-year-old mother, ill with diverticulitis and cellulitis and struggling through a bad cold during Hurricane Sally, a storm that roared through her Alabama town, cutting us off from water, electricity, and mobility? My mother was so frail I had to leave her lying on the couch while I collected ditch water to flush the toilets. Was it a week later, back home in Iowa City, celebrating my husband's birthday with cupcakes and ice cream, then finding him paralyzed on his study floor at 3:00 a.m., his sweatpants twisted around his feet, his words slurred, his head sparking with pain? Was it my husband's second stroke fifteen days after the first, and the endless three-day stay in the emergency room because there were no available beds in Neurology due to the COVID crisis? Or was it a month later when my mother was whisked off to surgery, given a colostomy, and then lay dying in a hospital bed in her den as I tried to tend to her?

Tonight, thinking about that so-recent time, I stare out into the darkness beyond my study, a light mist shimmering against the glass as if the air itself is raining. *What was it that did me in?* But of course I have no idea. Disaster has no maps, no GPS coordinates, no projected sequence with a "beginning, middle, and end" as I expect of a story. To my surprise, disaster can simply go on and on, a fickle parody of plot.

An onslaught.

And yet as I stare into the dark, what returns to me again and again is a long, difficult night in my mother's house.

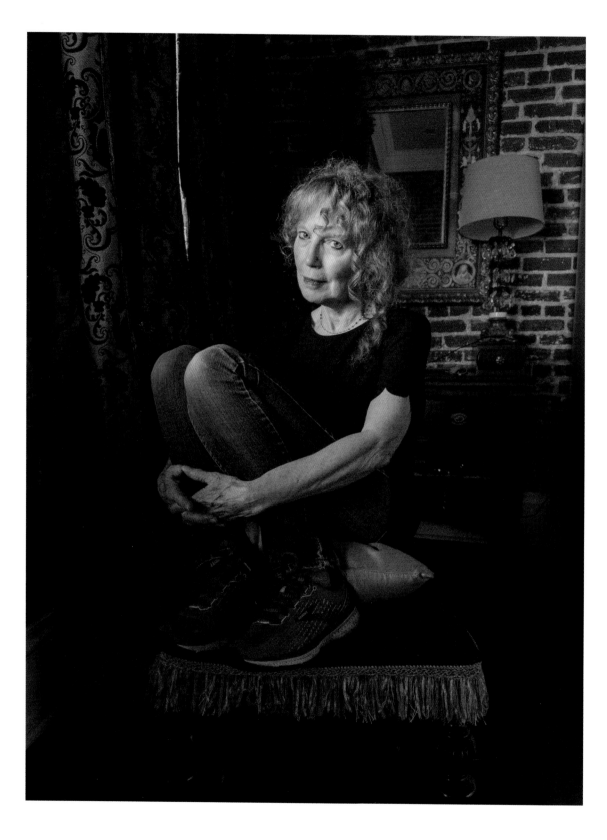

⎯ It's 3:00 a.m. and outside a dog is barking, the sky black and starless. I sit at my mother's kitchen table, a spill of Diet Coke staining the linen tablecloth, my husband's pill caddy in the center beside the salt and pepper shakers. Even in the dim light I can see my elderly mother asleep in her hospital bed beside the double French doors, white blankets wrapped around her diminishing body.

It's the middle of November 2020, the coronavirus raging all around us.

"Pat," my mother calls out, startling me, her voice suddenly clear and strong. I'm surprised that she knows me, knows that I'm here. Yesterday she was delirious, talking constantly, involved in an intense, private conversation, the words mumbled, unintelligible, a free-fall of sound.

"I'm coming." When I lean over her bed, her eyes are anxious, her face pale, the skin taut against pronounced cheekbones. *I have those bones.*

"Can you get my head straight?"

I try to move her head without hurting her, cradling it while shifting the pillow to the center, then gently lowering her head as if she's a newborn. Next, I lift her right foot, placing it on the small, rounded pillow at the bottom so that her aching heels won't touch the sheets. My tasks complete, I stand quietly beside her, only to watch her right foot slip off the pillow and her head droop sideways, my tending irrelevant.

"Are you okay?" I want to ask, an absurd question, but she's asleep again, her breathing regular, her body so familiar to me in sleep it's hard to believe she's dying.

Released, I slip down the long, carpeted hallway to check on David, my husband, who lies on his back in a king-sized bed beneath a wooden headboard I call the King's Mount. Because it's been only two months since his first stroke and six weeks since his second, we needed the neurologist's permission to fly from Iowa to Alabama to take care of my mother. Now I watch his chest rise and fall, relieved but simultaneously worried because he has a small aneurysm, a tiny, ragged pea, bulging in his right internal carotid, which means he must be careful not to fall or strain or lift anything heavier than a half-gallon of milk. I listen to the whirr of his CPAP machine, grateful that he's asleep, a light blanket thrown over him, the rhythmic words of "The Wasteland" on Audible drifting out of one earbud.

I turn.

Secretly, I want my mother to sleep and my husband to sleep so that I can crash on the couch and dream myself into another world, leaving the pulse and beat of this frazzled day behind. I unfold my blanket and fluff my pillow on the couch, glancing at my mother, then immediately I give up and walk

back to my station at the table. *I can't sleep, can't relax, can't let go.* Like some forsaken soul, I stare at the cloudy surface of my mother's oven door, at the orange ceramic jar beside the stove, stuffed with wooden spoons, while my mind beats out a drumroll of worries: Will my mother live through the night? Will she wake enough to say goodbye? Will my husband regain all his cognitive powers? Will his aneurysm remain benign, giving us time to consider a neuro-interventionist repair? Will I be able to manage if something else goes wrong?

I move the salt and pepper shakers, wipe the tablecloth of crumbs with my hand, then move the shakers back to the center of the table. I sit up straighter, my heart clenched, worrying how I'll organize a funeral and give my mother a decent burial during the pandemic in a town I haven't lived in for fifty years. I worry that she'll slip into unconsciousness before we have a moment of intimacy, a word, a look, a kiss. I worry that her finances are in disarray, her assets diminished, her house falling apart and needing extensive repairs, the yard still cluttered with ugly stumps from Hurricane Sally. I worry that I won't know what to do without her, who to call every day, a way of checking on her but on myself as well. And somewhere buried deep beneath these concerns, I wonder what will happen to me, to my writing life and the fragile world I've depended on: writing as a profession but also as a "way through."

For the last thirty-five years, I've spent most of my time in willed solitude, alone in my study reading and writing essays and stories, critiquing student papers and prepping for MFA graduate classes at the University of Iowa, reading theses and dissertations, going to readings and plays, and probing the hidden part of myself, hoping to see the pattern of who I am. It's the only way I know to live, a life I carved out with painstaking stubbornness and sacrifice, a life I worry might, very soon, seem like a memory, my inner life as dry as a winter leaf.

But I don't *know* this yet. It's just a premonition. A shiver in my consciousness. I glance at the clock. 3:34 a.m. When I turn to look at my mother, her hair soft and dark against the pillow, her face uncommonly pale, her bruised hands still, I feel only the raw, naked pull of her.

I get up to check on her again.

⌒ Three weeks later, after my mother's intimate graveside funeral and a first clearing-out of her house, I'm home in Iowa City, anguished that I was not able to say goodbye to my mother, who died near noon on November 20, just as I briefly turned away to check a beep on my phone. Each morning

PATRICIA FOSTER

now, I look at her picture, the one we chose for her memorial, kiss it, say "Hi, Mother," then turn to the many executor's tasks, then to the physical therapy appointment for my husband.

Like many people trapped during this pandemic, my life is disrupted, out of whack, my time divided and dedicated to others. What matters now, I remind myself, is that I honor my mother's wishes and give my husband whatever assistance might improve his health. "We need to do your exercises," I tell him this afternoon, watching as he balances on one foot, then the other, encouraging him as he marches in place, leans over to pick up three different-colored balls I've left on the floor, and finally lies down on a yoga mat for stretches. Afterwards I tuck him in for a nap on the upstairs couch, trying to reassure him he doesn't "have an expiration date," then return downstairs to peel carrots, chop broccoli, and wash celery, grateful he no longer has excruciating migraines or nausea, no longer needs me to walk beside him up and down the stairs, and no longer surprises me with bizarre hallucinations, believing we're squatters in our house or petting imaginary dogs, a black one and a white one, playful dogs that make him smile. Alone in the quiet, I stare out the kitchen window, the ash trees bare and still, a thick crust of snow spread across our deck, the sky so blindingly white I can't stare for long.

The very next day, David falls in the snow and loses his glasses. At first I don't know this. I only know that he can't find the eggs in the refrigerator, then can't find the bread. It's only hours later when he can't find his slippers, tucked too far under the couch, that I remember. "But where are your glasses?"

"I don't know," he says, perplexed, then sheepish. "I may have lost them in the snow. I fell this morning, slipped in a snow drift on my walk, and they may have fallen out of my pocket."

I think of his aneurysm, that tiny fragile menace just waiting for us to mess up, to provoke its weakness. Anxious, my pulse throbbing, I stare out at the snow. And then slyly, I wonder if I can cannibalize these details for a story—the fall, the lost glasses in the snow—though I haven't written a word in months. Jesus, what am I thinking? *Ridiculous*, a voice inside me chides.

"You can get new ones," I say quickly, reaching for my phone to make the optometry appointment at the university hospital even as I hear beeps from my email inbox, a string of messages with any number of demands: from the estate lawyer, a termite inspector, the real estate agent, the carpenter hired to repair my mother's bathroom window, an accountant, a banker,

an estate sale agent. Just the sound of those beeps, with their call to duty, depresses me. "Anyone who thinks wills, probate, escrow, letters of testamentary, closing agents, and beneficiary policies are interesting needs to go to therapy *right now*," I often mutter to myself.

I feel insane.

I know I'm not alone. All around us the world has stopped, the pandemic closing ranks and paralyzing ordinary life, new cases rising above 200,000 and deaths already at 65,000, a reality that stuns us. David and I take precautions, part of the uber-vulnerable, both over seventy, with David medically compromised, while the political world, spurred on by Donald Trump's vicious lies, lays waste to orderly solutions and a sense of hope. Our college town, usually so vital, so literary, grows silent and anxious: gray moods in a gray landscape of bare winter trees.

— *This moment in time*, I want to tell David as we're getting ready for bed, *feels surreal. It's like my brain is in the sky and my body is here on earth, the two disconnected*, but I know this complaint disguised as a description will upset him just when he needs eight hours of sleep. Instead, I think suddenly of my mother who, to everyone's surprise, was alert and talking the morning after her surgery. She even said to the nurse named Queenie, "It's good to be a queen."

I laugh, pleased by my mother's quickness.

"What?" David asks, already adjusting his CPAP mask.

"Nothing. Just thinking." I yawn, imagining my mother's hazel eyes lighting up as she speaks, the nurse smiling, my mother nodding.

And yet that night I dream I'm submerged in a small, marshy creek full of lizard's tail and jewelweed with a group of unmarried pregnant girls who've been banished from ordinary life. In the dream, I don't know why I'm here, why the girls are here, but like them, I feel the horror of being exiled and punished, my legs caught by branches and weeds while something sleek and venal—a snake? an eel?—slithers around the bend in my knees.

When I wake, still caught in the blur of the dream, the metaphor makes sense: trapped in dangerous waters, unable to get free. I desperately want to "do the right thing" for my mother's estate, but every day I have a sense of being so tangled in financial decisions that I feel inept, uncertain, aware of the vast distance between the language of literature and economics, between writing and administrative work. Why have I never read *A Guide to Finances* but will easily pick up *The Roots of Romanticism*? To handle the estate, I have to be objective, practical, and informed rather than intuitive,

psychological, and imaginative, which means I must put on a masquerade each morning in order to accomplish the many tasks. Now, as I brush my teeth, I wonder if the venal thing slithering around me will be my inability to successfully complete the executor's task (as my brother with Parkinson's disease warns me) or if these constant, necessary demands will eat me alive. I stare at myself in the bathroom mirror, my eyes flat, my hair uncombed, toothpaste dribbling into the sink, and there it is, the real danger: I might cease to feel at all, a sleep-deprived zombie whose heart is labored and sullen, her being so numb she doesn't have the energy to experience grief.

⸺ It's mid-January and I'm sitting at my desk while my husband naps—I hope for a few hours so I can work. A pang of excitement. I've been on call like an ER nurse, but now . . . *Here we go!* There's so much to say about myself, about the state of the country, about death and sadness and quarantine and, oh, the urgent need for new kitchen curtains. And yet when I open my laptop, staring at the empty page, the cursor blinking, nothing happens. No images. No thoughts. Not even a rant. To encourage myself, I reread an essay I began in early September before David's first stroke, but two pages in, my attention wanders. Writing: it's always been the sudden leap of story, a character who appears and demands a voice or the equal pressure to pursue the demons and rituals of my past, finding the hot current of feeling and riding it like a wave. But today I put my head down on my desk, wondering what is happening to me. Am I just too tired to think? Or has something happened to my thinking, to the apparatus of desire?

I try to remember how it all began—the writing bug, as my friends and I call it—the first time I *knew* this was what I wanted to do, the desire to define myself, or at least one of my selves, in words. To my surprise, I see it clearly, moments opening in my own private movie: It's 1980 and David and I have just moved from Los Angeles to Seattle to live in a two-story yellow house near Lake Washington with a front porch that wraps around three sides and a grand view of the lake. It's a storybook house, a gift from the gods we can't believe is ours. On this day I lie sprawled on the upstairs bed, immersed in a book while still-packed boxes sit stacked all around me. Though we've been here for less than two weeks, I've fallen in love with the Northwest, with the ice blue lakes and snow-clad mountains and the sheer relief that women in Seattle don't wear shorts and knee-high gym socks with high heels to the grocery store. Utterly annoying! I can hear my husband unpacking boxes downstairs, the clink of pots and pans, the opening of cupboards, but I don't stop reading. I've slipped into another world, and

when I finish the last page of *As I Lay Dying*, a book I've somehow missed in high school and college, I rush into the second bedroom, sit down at my desk, and write a story about a woman's red shoes. I type it quickly, intently, unable to move until I've finished, ignoring the fading of the day, the shadows of the fir trees, the silence from downstairs. I have no sense of time, no sense of what I'm doing—I've written only college papers and have no background in literature—except that the writing feels necessary.

Writing that story—and many more stories and essays during the next few years—taught me many things, most particularly that to be a writer is to live a double life, alive in the immediacy of *now* while simultaneously accessing the hidden parts of the self, sneaking beneath the surface to the forbidden corners of the psyche. For much of my life, I feared I'd be an invisible girl, not because other people couldn't see me but because I wouldn't be able to see myself, and yet writing demands self-interrogation—not merely a recognition of contradictions but a deep dive into the mess. This, I discovered, was intensely pleasurable and surprisingly addictive: I wanted only to write more and more, and yet, to sustain the work, I needed to be both selfless and selfish.

Selflessness, a generosity to others, is part of my raising as a girl growing up in Alabama—not just to offer solace to others but to develop a radar for their needs as well as my own. An admirable trait, though I'm no saint! As a writer, this attentiveness to others has often helped me acknowledge the pull of my characters, allowing them to lead the way into difficult, uncompromising territory.

But the selfish gene?

That I had to develop on my own. When I began writing, I knew I'd have to find and validate my internal voice, the primal, instinctive, authentic voice that says, "You matter," that says, "Be present to yourself," that says, "Internalize your validity and set your own boundaries," that says, "If you don't create a room of your own, it won't be available," that says, "Never diminish or exploit sorrow, but claim the material that is yours." Without the selfish gene, I discovered, it's difficult—if not impossible—to take the fierce, often subversive work of writing seriously, to recognize its importance regardless of its reception in the world. Without the selfish gene, it's hard to be both ruthless and gentle with your own work, to give it the love and respect and time it needs during many revisions. As I began to write memoir, I sank into the necessary excavation of myself and my mother, exploring the entwined worlds we inhabited as well as the nuanced differences

that kept us apart. Always, I felt touched by sorrow, and yet I couldn't stop. The need to dig deeper felt sacred and dangerous and necessary.

— In late January and early February, the weather becomes treacherous, a winter storm with windchills of −25°F and advisories of frostbite for anyone who stays out for more than ten minutes. For days I stare out at the cold, barren world, snow piling up on the streets and sidewalks, the roar of snowplows filling the air, the trees etched in white, the neighborhood empty of people walking their dogs. Whiteness everywhere. Lethal conditions. And yet the storm feels eloquent, this marooning, this danger, this excess, a metaphor for my heart.

My heart.

Every day I complain of exhaustion as if I'm a victim of Victorian neurasthenia, longing only for "a bit of rest," but at night my heart pounds. I feel my racing pulse, an insistent alertness when I lie in bed, listening to the wind whipping through the trees and David's regular breathing. I toss and turn. I pull my knees up, tenting the covers, then let them slide down to rest at the foot of the bed. I shift my arms. Tonight, frustrated, I get up to stare out the window, stunned by the starkness, the elemental fury, not moving until my feet are numb with cold. Once again tucked in our bed, it is dark and warm, and when I close my eyes, I see my mother lying in her hospital bed, her skin soft and smooth as if the wrinkles of aging have been swept away, as if dying has made her younger. She asks nothing of me, but still I hover, watching. When I finally fall asleep, I dream that I'm walking down a narrow path in southern Alabama in the early morning, the sky still hazy, the doves cooing, the leaves wet and glistening, my steps certain until I see my mother hidden in the bushes, huddled and shivering in her favorite pink robe now damp from the morning dew. It's the robe that catches my eye. Her face is tucked in close to her chest, her breathing ragged. "Mother," I whisper. "Oh, dear, oh, no," as I pick her up, surprised at how light she is, how frail. She responds only by curling up tighter. And then I'm rushing, crossing a small stream, being careful to hold her close, and gently laying her on a blanket in the grass, rubbing her hands, the sun now rising, her eyes still closed but her breathing softened, almost as if she is resting. I lie down beside her.

When I wake, something breaks in me, breaks because I haven't been able to mourn my mother, haven't been able to grieve, to say goodbye, to put my head next to hers and do the only thing I want to do: to say *I'm*

here, I'm here, I'm here. In so many ways, my mother was the most complex woman in my life, a woman before her time—sensitive, stubborn, intense, ambitious, traumatized by a difficult childhood, and hungry for validation—and though I knew I'd never understand her, I believed she was worth understanding, worth all my efforts, a paradox in the making. Even today as I write this, I can see her striding to the podium in the high school auditorium or to a microphone at a meeting of the Baldwin County Hospital Auxiliary or as president of the University of Alabama Alumni Association. How natural this was for her, standing at a lectern addressing a group, dressed in high heels, a pretty dress, her dark hair soft around her face, her voice confident, assured as if public speaking was the most natural thing in the world. It amazed me. And yet beneath the public certainty, there was something dark in her, a sense of unease and incomprehension, a self-grievance about who she was that frightened her, making her anxious and vulnerable and needy. She couldn't resolve it, and I couldn't help her resolve it, though she told me again and again her fears of being "not enough," of feeling dismissed or unseen or unloved, as if she couldn't release herself from an idealized female perfection she carried inside her head. I think now that she never learned to be deeply alone, never learned to trust that aloneness *is* the central reality of a life, the place where each of us must attempt to define our boundaries even as we're ambushed by mixed emotions and the chaos of contradictory demands, an aloneness that is exhausting and revelatory and often accompanied by sorrow. Simultaneously, she was imprisoned by the strict cultural norms of the time. Though naturally intellectual and ambitious, she began her adult life trapped in the repressive conformity of the fifties, our culture's patriarchal foot on her neck—*a woman does not make the rules*—and hemmed in by the Southern Lady demand to please others before pleasing herself. *Forget the selfish gene!*

When I was younger, I often felt suffocated by what pleased my mother, then guilty for turning away from the beauty of an oriental rug or a new set of china or the accomplishment of peeling five pounds of shrimp for a family dinner. As I grew older, I understood that pleasure was often an escape from the dutiful boundaries placed on women of her generation. Once I recognized this, my response dramatically changed. Yes, pleasure. You must have pleasure!

"You'll write your best work after I die," she always told me, as if only then would I be free from psychological constraints, free to reveal some truth I'd tucked deep inside my soul. What she didn't know was that she'd been the catalyst for much of my writing, a force that had awakened me to

the quarrels within myself, a muse who prompted my stories. There didn't seem to be an end to my attempts to write about her, her life tied intimately, urgently, and often opposingly, to mine.

As I lie in bed, awake now from the dream, my husband still sleeping, I remember her delirium the morning before she died, her body agitated, her mind confused, and yet there were moments, sometimes as long as twenty minutes, when she emerged, at least partially, from her confusion. In these moments I tried to focus her attention on food, because Thanksgiving was near, a holiday she loved, the family brought together in both a casual and formal way, the table set with an ironed tablecloth, linen napkins, good china, polished silver, the roast turkey ready to be carved. In truth, I just wanted to keep my mother with me, focused and talking. And so we planned menus, not just the Thanksgiving turkey but oven-roasted potatoes tossed in olive oil, chicken fingers stir-fried with green onions and peppers and leeks, spinach casseroles, sweet potato casseroles, hot buttered rolls, coconut cake, pumpkin pies, whatever I could think of to hold her attention. I remember that as we talked about food she smiled, a wan, otherworldly smile. Perhaps this is why, for days after my dream, I think constantly about feeding her, bringing her treats. I see her sitting in her white chair in the kitchen in her brown slacks and white pullover, watching me while I make blueberry smoothies, homemade zucchini bread, fresh applesauce, egg cups, anything she might be able to swallow. Feeding her both sustains and calms me, and for weeks it's this thought that relaxes me enough to sleep.

My heart quiets.

As if I've been given permission, I start writing in my journal, taking notes on the dailiness of my life—a flock of crows flying across the sky; a description of the two lovely men who buy my mother's house; the possibility of new curtains—staring out the windows at the storm, the trees finally still, the snow so thick it bends their limbs, the wasteland bleak and oddly beautiful. And then, days later, when the weather front pushes eastward, the skies clearing, sunny and blue, I sit at my desk, writing pieces of an essay about illness and marriage, and when I finish a rough draft, a new story about my mother demands to be written. It's only here, writing about my mother—an eight-year-old girl on a floating bridge, her feet dangling idly in the water; an old woman sitting at her kitchen table, trying to make a grocery list—that I begin to grieve, to let the loss of her enter my bones and take up its place inside me, large and scary and irrevocable, the words coming so quickly that I must hurry to get them down. Now I see her and feel her nearby, and there's both too much and too little to say.

⁓ Months pass. As the weather warms, tulips and daffodils cluster in our backyard, though the katsura trees are barely budding. I sit in my study and watch the season changing. All spring my husband's health has improved so much that he's almost back to the man he was before his two strokes. One day I sit with him in a treatment room at the university hospital and listen to the neurosurgeon discuss stent-graft surgery to prevent his aneurysm from rupturing. As I take notes on the procedure—the length and risks of the surgery, the type of anesthesia, the medications required—I know I won't have time this week or the next or the next for my own deep thinking, but I also know I have moved beyond the blank exhaustion of those earlier months, when nothing would come. Already I'm feeling the impulse, the need for solitude and self-containment, the desire to light my way into the corners of my own darkness, probing the secret life. My mother would want that—I see her sitting in her white chair, her face serious, her head nodding affirmatively, even insistently, to this thought—but I also know the selfish gene requires no backers, no support staff, no cheering squad. It exists in a created isolation. Whole, receptive, defiant. It exists because it must, a beating heart, *in me, in me, in me.*

Creativity and Illness

Anne Strand

The timing could not have been worse. On March 31, 2020, I had a massive stroke just as the first wave of COVID struck. As the ambulance dropped me at the hospital emergency room, my family waved from afar, helpless to be with me as I was wheeled through the door. When I woke up, I couldn't speak, not even to say my name.

To make the situation more dire, the hospitalist thought I had had a TIA, so I wasn't given the shot that would have lessened the full stroke's effect. When I was finally diagnosed with aphasia, it was too late. I was without means of communication, cut off from the rest of the world. I could speak to no one, and no one spoke to me. Staff members came into my hospital room, but I couldn't express a need, so they would leave immediately after they had performed their service.

After leaving the hospital, I was put into a nursing home for rehabilitation. I was still unable to communicate or do the simplest tasks. The TV might be turned on, for example, but I was unable to change the channel or ask anyone for help. I existed like that, helpless and speechless, for four days until COVID was discovered in the nursing home, and my children came to get me. They brought me to a safe place to recover. I was fortunate that my daughter, Anne Catherine (AC), stayed with me.

But she couldn't stay forever. She had her family and her work. When she left, I felt panicky and, after an hour, I managed to dial a phone and somehow let her know I needed her to come back. How my life had changed! The independent professional woman who had worked and finished post-graduate studies in Manhattan was now a fearful invalid, afraid to dial a

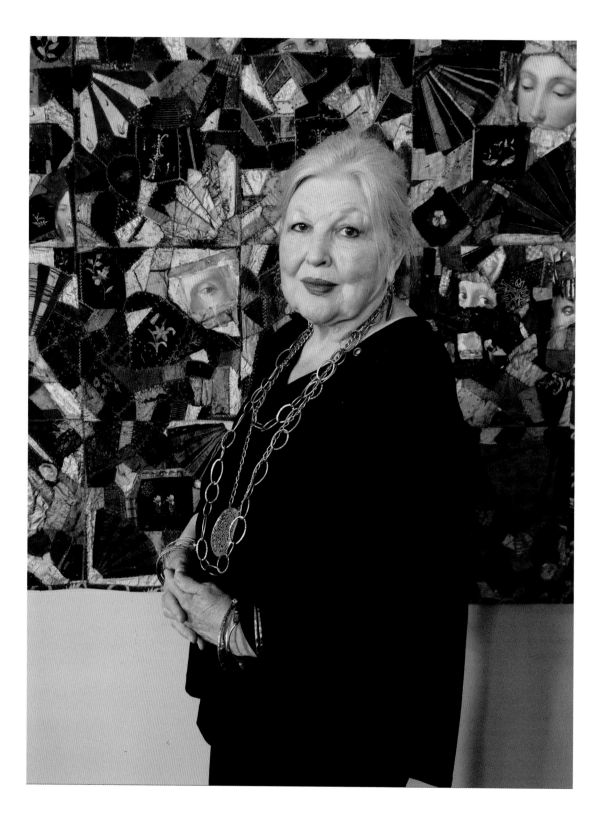

phone or rely on herself. Even my husband, retired from a successful career in educational administration but also medically challenged, could not offer the kind of physical support I required.

Oddly, being a stroke victim had always been one of my worst nightmares. I often thought about strokes, read about them. In my research, I encountered Jill Bolte Taylor, a scientist working at the Harvard University Brain Bank. From her book *My Stroke of Insight*, I learned about the brain's functions.

Our brains have two separate hemispheres, which can operate independently. The two halves are connected by a band at the bottom. Although they are equal in size and shape, the hemispheres do not perform the same functions, and they serve the body in different ways. The left-brain hemisphere allows us to see the world in parts. It analyzes, labels, thinks, and performs academic and logical tasks, for instance with mathematics and language. The right-brain hemisphere holds and perceives connections between things. It intuits and performs tasks that have to do with creativity, oneness, and the arts. It can't label, can't even name, but it knows what things are for. Some think, as I do, it is the portal to Love, or to God and the Divine.

Remembering that Love is always available to us through the right brain began to give me confidence. Also helpful was my wish to create. I'm not exactly sure when this wish began. Perhaps when I drew all over the walls of our house at three years old. Or perhaps when I was five and painted our porch steps pink with oil-based paint that I had mixed from cans of red and white left behind in the backyard by a worker.

These two personal passions—a search for the Divine and a wish to create—stayed with me after my stroke. But they faced continuing challenges. In addition to my aphasia, I now needed to use a rolling walker to get around because of the stroke, and a previously damaged back was causing me a lot of pain. I could not walk and I could not talk normally. Then on New Year's Eve 2021, I spent the night in a crowded emergency room with another calamity, this time a genuine TIA. This development discouraged me further. My brain seemed stuck in a fight-or-flight pattern. I was very depressed and reactive. Suddenly I had no urge to create. I even began to wonder what had allowed me to want to create all those years.

I cried all the time, and I'm sure people didn't want to be around me. Some therapies I tried only seemed to make matters worse. I went to the Amen Clinic in Atlanta for brain X-rays, which included a series of tests. On these tests I scored very, very low, which affected my self-esteem.

It wasn't that I didn't try to seek help. I kept looking for other solutions. I tried a Fisher-Wallace band around my head to use small amounts of electricity to treat my depression. I even drank a vile-tasting mix of vitamins and minerals. Nothing seemed to work.

At first.

Then slowly, slowly, my persistence began to pay off. As a result of these therapies, however difficult they were to endure, my attitude seemed to improve. After three months, I began to want to create again.

But I was still suffering. Suffering differs from pain. Suffering is not based on reality, but on the story we tell ourselves about it. I realized I was listening to the wrong story, writing the wrong story. So I determined to look at my suffering with a new lens. I remembered that suffering comes from not being able to take the next step—from wanting to hold on to the past and refusing to adapt. What if I looked at my situation differently? What if I admitted that I would probably be on a walker for my lifetime?

When I began to look at things in this light, the suffering began to abate. I still had pain and difficulty speaking, but through this admission I changed the story I had been telling myself about how I had been living and, in the process, changed my brain and my attitude toward how I felt. I let go of the need to live a pain-free life in order to be joyful.

With my new attitude, I adopted some new strategies to reframe my pain and put it in a constructive light. I stopped thinking of change as an enemy. Shifting began happening in my world and in my mind. I helped it happen. First of all, I moved my studio into my dining room. I then moved my dining table into my living room to more easily entertain dinner guests.

Not that life was suddenly one big party. I was sick to see everything moved, and I still hurt all over. I hated to drive by my old studio, the Bridge Tender's House on the river bluff, and see it empty and unused. But shifting was the order of the day, and so shifting it would be.

Through these shifts, I started looking in other directions—back into my history and out toward others and their lives. With my brain medically better, I reminded myself that my years of painting and as a psychotherapist had taught me the healing delights of my calling. One of my sons calls me Wise Woman–Spirit Guide, and I would like to think that is true. I am most fulfilled when I can guide myself and others in finding and nurturing that fragile connection between our own unique selves and the sacred energy of the universe. "Connection is why we are here," says the popular researcher Brené Brown. "It gives purpose and meaning to our lives."

Connection is all around us, if only we experience it fully. We are connected to others we can see and touch. We are connected to our colleagues and loved ones, including those we can no longer see. We are connected to others through time and space when they own a painting or a book by us. Connection and the love that comes from it is what life is all about.

LOVE
 is the one ingredient
 that holds us all together.
—John E. Fetzer

And there's a reason that love can accomplish this—a physical reason. Remember Jill Bolte Taylor and the band of tissue that connects the two halves of the brain? Neurobiologically, there is a circuitry that resides in the right brain that is constantly running and available for us to hook into. We are wired to connect, to love, and to find a place in this universe.

When we fear we are unworthy of connection, we fear that we do not have a place. We are lost. I have always had a fear of being lost. When I was four years old, my mother mistakenly dropped me off at a place where, to her great sadness, I was badly hurt. I wound up being a different child when I came home that day—feeling existentially lost, disconnected, with all my fuses blown.

This disconnection also occurred when my father suffered a massive heart attack at forty-one and died of another shortly after my fourteenth birthday. I became even more depressed and further disconnected from the flame of joy within. You couldn't "see" any of this disconnection from the outside. To others, I seemed happy. But as you might imagine, I was not being Me. I was performing "me." And on the inside, I knew something was radically wrong.

I was facing a challenge that we all face. It's a sacred challenge: to become who we are destined to be within the only time we are given—the precious, fleeting moment of the Now. It is what the Divine has given us. The past is over and the future is dependent on the Nows of what will soon be past.

But how can we actually capture the present moment?

My answer to that question is simple. It is contained in one word: art. The making and sharing of art has been a redemptive process for me, my journey into awareness, and what some call a "soul retrieval." Art heals. It has healed me, and I believe in its healing power for everyone.

Here is an example of how art has been healing in my life and how it

can supply the connections each of us is searching for. One fall afternoon in Manhattan, my husband and I were exploring Chinatown. At a grocery store on Mott Street, I found some paper, brilliant with metallic gold and bright saffron ink rectangles stamped with red lines. With no idea what the paper was made for, I began using it for a series called *The Imaginary Landscape*, which explores the mystery behind reality and its connection to the divine realm.

This happening was more than fortuitous. It was revelatory. It was healing. The paper I had admired was Chinese spirit paper, used by the ancients to communicate with the spirits of their ancestors. I ended up using this beautiful paper all those years for the similar purpose of making contact with what had been lost in my own life and the lives of others. The dual purpose reflected the imaginary landscape that lies behind reality and connects us to all things.

My life's journey has taught me the importance of connections, especially in art, theology, and psychology. My work formed an amalgam of these three disciplines. I discovered this lens when I was thirty-nine, studying at the New York Studio School in Paris with the painter Elaine de Kooning, renowned Abstract Expressionist artist, teacher, and critic. This school taught its students to concentrate on the figure: you sculpted the figure, you painted the figure, and you drew the figure. They did not give you a scarf or a hat or anything to add to the nude figure to enhance the composition, and they did not give you anything behind the figure except a blank, charcoal-smudged wall.

One day after painting a model standing on a worn green desk, I told Elaine, who had by then become my mentor, that it looked to me like a nude standing on a green desk at a Holiday Inn. She told me something that I will never forget: "Anne, you're missing the point—even a nude standing on a green desk at the Holiday Inn has a spiritual quality when you've painted it. You need to look at that fact and not forget it!" I believed her, and when I did, a piece of myself came home.

And so began my awareness of mysticism in my art. A mystic is sometimes defined as a person who finds, by meditation and self-surrender, a sense of unity with the One—someone who experiences the truths found beyond the senses and the logical intellect. When I call myself a Mystical Expressionist, I seek to express what lies within and is all around me. "Expressionism" is a term used for capturing the color, light, mood, and feelings of the inner eye. This is sometimes referred to as the "third eye," or intuition. What the artist experiences internally is recorded on the outside

in visual form. Expressionism, a deeply spiritual act of faith, occurs within the liminal space between fantasy and reality.

> We must risk delight . . .
> We must have
> the stubbornness to accept our gladness in the ruthless
> furnace of this world.
> —Jack Gilbert

After my stroke, I could not find this liminal space or tap into my feelings of creativity. But by reclaiming what has been lost and finding the courage to return, I found my way back to embracing and experiencing the mystical, with its authenticity, gratitude, and oneness.

Let me say it again. Art heals. It leads us toward the mystical, as does writing, music, and breathing. It wakes us up. Much scholarly research has been written about this phenomenon. Art reveals to us that the brain is the source of creativity and the home of God. Art renews how we experience our lives.

This is especially true with imaginative art, one particularly effective method for this journey. Imaginative art allows the inner world of the artist to inform but not duplicate the shape of the world depicted. The imaginative artist weaves a conversation between the creation outside and the feelings within.

In my works today, I continue the ancient tradition of art of this kind. In them, I do not seek to replicate the unattainable perfection of the natural world. My works attempt to surround, catch, and hold the spirit in form, space, and ordinary time.

I am using this artistic philosophy in my newest endeavor by including antique fabrics in my creative storehouse. I accomplish this end by rebuilding perishing quilts with the art materials I have collected over a lifetime. I don't consider using a quilt unless it is lost, orphaned by its family and extensively flawed, or just a fragment. By collaging these orphaned fragments into canvas or displaying them as hanging quilts, I redeem the damaged pieces of handwork by layering or embedding them onto canvases with weavings, rag-papered images, Chinese spirit papers, gold leaf, and more. These additions repair and embellish the fragile fabrics and damaged threads.

My fervent quilt-saving is an homage to my aunt, grandmother, and great-grandmother, and all the previous generations of women who were marginalized and unsung as the artists they were. Looking beyond the

shattering silk—the silk is the first to go—I enhance these aging ladies with my art and bring them into a new century. The broken or silent faces embedded within my surfaces invite the viewer to hear the silence and notice the feminine in all people, both males and females.

Imaginative art can heal the viewer as well. Experiencing art can be as much a creative process as making it. Exploring art through the senses can be, like exploring nature, another form of what is sometimes referred to as "the stillness break"—a break from our ordinary lives when we incarnate rather than evaluate and enter the breath of stillness through the heart.

The "stillness break" is only one of the methods I am using to continue my recovery. My typical day now includes many of these methods, all of which require me to use all my creative mind to accept my new life. I usually wake up early, often after not having slept well, and often in pain. At that moment I will practice some breathing exercises called "breath-counting" taught to me by the Reverend Dr. Nelson Thayer. These exercises allow me to go within myself and encourage my body to accommodate its new state of being.

After I get up, I might stay creative by inviting my daughter or a friend to visit me and have a cup of coffee. We will sit in different spots in the house or garden so as to "shift" our point of view and look anew at what we are seeing. We talk about our connections within our family and how we can support each other. I take a moment with my daughter or friend to acknowledge how each of them has supported my husband and me as we age. I formally acknowledge that the community of love around me—family and friends—has stepped in unasked and made our lives better.

After my visitor leaves, if I am feeling well enough, I take my walker and move into my new studio—my old dining room—and work on some ideas for an exhibit I am putting on in a few months. Creative work is one of the most effective methods of connecting art and mind and improving one's attitude toward the physical body.

If I tire from working, and I do, I lie down and dream. Things can come to you effortlessly when you don't try so hard. That has been a lesson I have been made to listen to. Now is the time to accept.

After lunch, I might look for a different form of creativity. If I am tired of painting, I will sit down and write. Creativity comes in all forms. For years, I used the morning journal from *The Artist's Way* to write about my feelings and what I am grateful for—a practice that definitely contributes a healing guidance.

If I become discouraged, I will try to remember that healing often comes from doing, not thinking about doing. The pain will subside when you are working but comes back in a flash after you have finished. And so I persevere to work a little longer.

Late in the afternoon, when I have exhausted many of these creative practices of connection and healing, I meditate. Sometimes when I meditate, I concentrate on the story of the Wounded Healer.

> Every work of art stems from a wound
> in the soul of the artist.
> —Ted Hughes

The story of the Wounded Healer holds a special place for me. Over time, the spirit can secretly heal our deepest wounds as we grow into adulthood. Our earliest wound, once perceived as the mark of our victimhood, much later changes its form and reveals its true significance, the cost of finding the heart at the depth of the wound.

Here we find the sacred wound. Now transformed, the sacred wound becomes a vital ointment for the world, a gift that the original wound has fostered. And so the ordinary life journey for each of us becomes a spiritual journey. We see the Divine in all things, even suffering, and wish to bring our gift to heal the whole world.

> In the inner stillness where meditation leads,
> the Spirit secretly anoints the soul
> and heals our deepest wounds.
> —St. John of the Cross, Mystic

This is the gift I have been given to share: we are, every single one of us, capable of recovery and of intuiting much more than we think we can. In doing so, we must embrace our imagination. We must carve out those moments of connection when our imagination brings us in touch with the Divine Creativity, which in turn brings meaning into our lives.

It has been my experience—and I wish it for you as well—that in these treasured moments of stillness, we come most fully to our senses. In those moments, all the ordinary elements in our lives—even the pain, even the suffering, even the setbacks—are transformed and will seem ordinary no longer. Through our creative senses, we become "lit up" from inside. The founder of analytical psychology, Dr. Carl Jung, understood this truth

when he said, "the sole purpose of human existence is to kindle a light of meaning in the darkness of mere being."

I continue to learn about kindling my own light. My illness has been an education for me and a reawakening. T. S. Eliot said it best: "We shall not cease from exploration / And the end of all our exploring / Will be to arrive where we started / And know the place for the first time." That place is deep in our hearts, in our connections, and in our creativity. Through embracing and cherishing these highways to the Divine within us, we are free to better love ourselves and our world.

A Question I Wrestle With

Janisse Ray

For a few decades now I have been watching books disappear from the cultural landscape. This would be less terrible were I not deep into a lifelong love affair with books—as a reader, a collector, and a writer of them. It also would be less terrible were not so many other things I love disappearing, and if I had not reached the "disappearing" stage of life.

Bare Bones

You know where I am going with this, but let me lay it out for you anyway.

I am changing, on the outside and on the inside. I have entered the "invisible" stage of my life as an older woman. When I stand in the sun, my hair now is almost exactly the color of Spanish moss. My body is thicker, my muscles less defined. Wrinkles deepen in my face. On the inside, I'm more bent toward justice, more willing to speak out, more happy with myself, more intuitive, and more keenly aware of hidden meanings. All this means that I'm less willing to compromise, tolerate, and pretend.

I am a boomer, one of the change-making generation that some parts of society (the corporate, empirical, colonial forces) are trying to shut up. On social media and sometimes in person, I'm being told to shut up.

I am a writer, and my offering is less needed every day. I am one of many. Our MFA programs have turned out hordes of literary writers, many of them brilliant, many clamoring to have their voices heard. As I turn sixty, there is a great deal of cultural noise, much of it violent in its self-centeredness.

I find publishing through traditional venues more and more difficult.

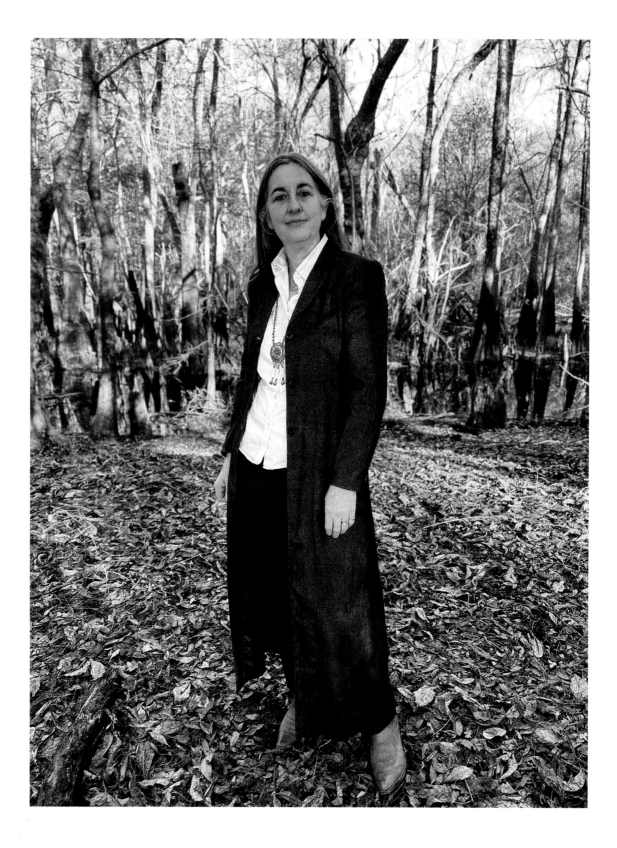

How I Found My Path

Probably I knew earlier than eighth grade that I wanted to write. After all, the Bible was poetry and my father worshipped it. I heard him say that two manner of people—poets and saints—"inherit the earth," and I wanted to inherit the earth, whatever that meant. I'd written a clumsy, elementary verse about Thanksgiving when I was eight or nine, "Now what do I spy / on the table so high / Is it pudding / and pumpkin pie?" and my father had folded it carefully and locked it away with important papers in his safe. That I became a writer in that moment of clicking tumblers is entirely possible.

Early on I got signs that pointed me to my path. For many, many people—women especially—this doesn't happen. Sometimes it never happens. After my first book came out, after a reading at the Margaret Mitchell House in Atlanta, a short-haired, earnest woman approached me. "I'm sixty and I still don't know what I want to be when I grow up," she said. "I can see that you've found your calling. How did you do it?" She was looking at me as if I were a counselor.

"I believe it will come to you," I stammered. "There's time."

Society directs women to submit, to marry, to bear and raise children, to take care of others, and to think of others before we think of ourselves. The woman in Atlanta had reached retirement without the pleasure of knowing her own work in the world.

Perhaps she robbed herself of that pleasure. Perhaps she was robbed of it.

At any rate, my path became clear to me early, thanks to the parents that my soul chose, and I was afforded an opportunity to go to college, where I graduated with a degree in creative writing. I was on my way.

Then when I was twenty-six and still unmarried, I got pregnant. I knew that the trajectory of my life was going to change dramatically. Although I was dubious about my prospects, I married my baby's father and delivered a gorgeous baby boy, Silas. Married life was difficult, a complication I had foreseen, and soon I found myself in divorce proceedings. All of these major changes happened quickly, almost within the span of twelve months. A year after my son was born, I found myself a single mom.

I was young, I was determined, and I had a daimon that kept directing me. Determined to chase my dreams, determined to travel and have adventures, I arranged to go teach English in South America, and it was there, a few years later, that an epiphany occurred to me.

One Sunday afternoon Silas and I hiked a remote mountain road in the Andes of Colombia. I needed to get serious. I needed to settle down, into my

life, onto my path. I didn't want to teach English in foreign countries. I didn't even believe in obliterating the diversity of languages from the world.

I remember vividly the epiphanic moment. I was walking through a bowl of tall blue-green mountains, the road dusty before and behind, passing huts constructed by hand of deep orange clay. These huts were set within small plots of peas and corn, with blooms of impatiens and geranium spilling from makeshift planters. Children watched me pass. Farmers paused their hoeing of terraces to pass a few words. All of it was a story.

I loved nature; I loved writing. Nature and writing, writing and nature.

Put them together, a voice said.

Nature and writing. Writing about nature. Nature writing.

That was the moment my mission clicked into place. In that moment all doubt fled from my mind.

I returned with Silas to the United States, to Tallahassee where we lived. Right away I began to volunteer for a conservation magazine. When a job opened, I applied. Two years later I was working as assistant editor for *Florida Wildlife*. I had a good job with benefits, a cool kid in a free school directed by a dear friend, and a two-story rental with wooden floors. At work I wrote chatty stories about fishing rodeos and worm-grunting. At home late at night I read library books on writing and wrote in my journal.

But I wanted to write more, write better, write crooked, write square, write penniless, write rich, write whisper, write loud. The only problem was, I had no time to write. I was the single parent of a five-year-old, a scholar of nature, and a full-time working woman with a large community of friends and a desire to marry again.

During those years I had one beautiful and powerful force in my life, my writing group. Twice a month four women naturalists who all wanted to write gathered in each other's living rooms and porches. We four called ourselves the Hungry Mothers. We free-wrote, reported contests, discussed books, and talked hungrily and longingly about our dreams.

My own dream was ballooning. It was getting too big for my circumstances. Night and day it called my name, low and urgent. Late in the evening, as my son slept, I scribbled into a black hardback journal ideas and feelings, pieces of poems and essays. My daimon was hounding me to move forward. But how? I reviewed possible options. Could I find a wealthy man to marry? Could I move back in with my parents? Could I go to graduate school? Could I afford it?

I kept casting lines into my future. I joined the Audubon Society and began to write its newsletter. I signed up for an ecology field course. I dated

environmentalists. I had long conversations with my friends about the environment. The Hungry Mothers continued to meet.

The University of Montana was among the first creative writing programs in the country to offer a nature-writing degree. One joyful day standing on my front stoop I found out I was accepted, awarded an assistantship. I'd be teaching English 101 to undergrads.

Author

My first book came out in October 1999, when I was thirty-seven years old. I felt very lucky. At that time the publishing world was dominated by men, usually older, straight white men—most agents, editors, reporters, and publishers were men. The world of publishing, centered in my time in New York City, was willing to let in a few ovulating women. I happened to get in, and I'm grateful for that.

The statistic I learned then (one that is no longer accurate) was that for men, the average age to publish a first book was twenty-seven, and for women, forty. I was lucky again: I had beat the average.

Having a book out was incredible. I was able to experience a cascading love that unbelievable numbers of people felt for books and authors. I wasn't being feted in New York, not like Pat Conroy, for instance, with limousine rides and black-tie galas, but the onrush of attention was exhilarating. Rank strangers wrote me love letters. They sent gifts of blank journals, Easter candy, and their own brave poems and stories. They invited me into their libraries, bookstores, churches, and homes. They left pinecones on nightstands beside beds I would occupy, chocolates on pillows.

As I said, strangers showered me with love. Their love was a waterfall. It tumbled all around me.

A crazy love for book writers was especially evident in the South, I think because the South (still, in 1999) had a particular and fascinating relationship with its authors. The South was emerging from the period we call Southern Gothic, which produced some of the best fiction in American history: Flannery O'Connor, Carson McCullers, Tennessee Williams. William Faulkner published *The Reivers*, which won a Pulitzer, the year I was born.

It was clear that the way to the heart of the South was to write a book. I had done it.

Similar love poured from the Northeast, the Midwest, the Pacific Northwest, the Southwest—from every corner of the country and sometimes from beyond our borders. People felt something either in the writing

or between the lines, and they reached out. If I hadn't understood before, I understood now. Books meant something to people. Books reached people in ways nothing else could.

When my first book came out, it was reviewed in the *New York Times*. The reviewer was a man (now deceased). I read his review once, put it away, and didn't look at it again for twenty years. I didn't have the words then for how I felt about that review, but years later I would hear the feminist literary scholar Betty Jean Steinshouer, in her 2022 talk "Scribbling Women in Florida," say of Sarah Orne Jewett that reviewers had damned her work with faint praise.

By then, however, I was riding an awesome wave. That's what it felt like to me. Around me huge love cascaded directly from readers, and I tried to be present with that, not think of what I wasn't getting from New York. I could file a tepid review in a folder and not look back. Because by then, as much as I detest this particular metaphor, I had learned that I am an empire builder. I wanted more books, more money, bigger audiences, a longer reach, grander awards, bigger print runs, more visible results.

Obstacles

When I was young, I recognized my father as the greatest bargainer in the world. To him, the deal was more important than anything. If he wanted something, he was going to get it, and he was going to get it at his price. He always wanted to complete the deal, no matter what. Someone told me once that they felt my father always got the better of them. They always, in the end, felt that they lost. I had enough of my father in me to look at a story as a deal. What did I need to do to complete it? What could I do to turn a "no" into "yes"?

My father, who died in 2019, had a belief that if you're on the right path, doors will swing open. If you find obstacles in your path, he would say, you're on the wrong path.

I think he was wrong about that. On any path, obstacles can get thrown up. Any vision involves struggle. You don't stop if it starts raining and you have a flat tire. You don't ever stop. I was willing to work hard. And I did.

Even so, publishing was never easy, and not only because I am a woman. I am a nature writer, proudly working in a genre deemed a "marginal literature" for the longest time, although I never hear that term anymore. Nobody wanted to hear that the systems of earth were failing and that we humans were part of the problem, and if *nobody* wanted to hear about

environmental crisis, then *corporate publishing* didn't want to hear about it either. There was another thing. I am a southern woman, and damn if it isn't astonishingly easy to write off that voice without actually listening to what the voice is saying.

For a marginalized woman to claim her power and to say *I want this* is huge. In order to get what she wants, that woman will have to work hard. Even if she works hard, though, there's a good chance she won't get what she wants.

I wasn't going to spend time moving a boulder out of my way: I was going around it, figuring out another way. To hell with being a faithful servant, a good woman, a pretty woman, a team player, a convenience, a position to fill.

I remember being asked, in a Q&A at Berry College's Southern Women Writers Conference in 2012, if being a woman had held me back. I'd been a feminist since high school. I kept my own name when I married and never let being a woman stop me from doing what I wanted to do. I drove a truck. I changed my own tires and my own oil. I could use a chain saw.

I answered the question with all the honesty possible at the time, saying that no, being a woman had not cramped or stifled or silenced or bound me. I had been the driver of my own vehicle. I had always steered. I was proud to say that.

The question, however, reverberated in my head. I kept revisiting it. Had being a woman held me back as a writer?

I couldn't answer it fully until years later, actually when I read Terry McDonell's book *The Accidental Life* about his career as an editor, which coincided exactly with the first two decades of my writing career. McDonell had run magazines in which I had tried to publish. Likely my stories and queries had passed across his desk. What I learned is that most of the writers with whom McDonell worked were men. Often he invited them on an adventure, to shoot, to golf, to hunt, to watch ballgames, to paddle, to hike, to party, whatever. He mentions a few women with whom he worked, but they were mostly back at the office. His memoir made evident the many ways in which nature writing has been a men's club, a hunt club, a sports club.

I began to see that as a southern woman writing about nature, I had played a role not totally of my own making. I could fill a diversity mandate. I could rep the South and womanhood and motherhood and poverty. How many times have I been the only woman on a panel, in an anthology, at a reading?

Like Ruth in the Bible, I was good. I was cheerful, friendly, even apologetic. I was happy with what I got. I was not going to ask for more. How easy it was for organizers to have me.

Like Marilyn Monroe, I had a sexuality to exploit. (Okay, not really like Marilyn.)

Like any woman of childbearing age, I had a sexuality to *overcome*. The gravity of this sank in after I'd read a number of John McPhee's books, trying not to feel overrun with jealousy that anything he wrote was published first in the *New Yorker* and then in book form, until he had dozens of published volumes. An epiphany struck me when I finished "A Forager," McPhee's beautiful and groundbreaking portrait of Euell Gibbons published in 1968. McPhee arranges to trek with Euell for a week, I think it was, first on the Susquehanna River and then the Appalachian Trail, foraging along the way and preparing wild-crafted meals.

No way could I, as a woman, call up Euell Gibbons and invite him camping for a week.

Detractors of my stance are already at work, thinking "Of course you could have. You could have invited a friend along. You could have invited his wife. You could have invited a photographer." Yes and yes and yes. For centuries women have been able to find ways to live outside societal norms. They dressed as men, they refused to marry, they took male pen names, they played sports, they used birth control, they had abortions, they wandered off into the wilderness alone. The fact remains that issues of sexuality are real, and the burden of them is placed more squarely on women—to deflect, to make clear, to avoid, to be careful.

Like my mother, I had a house to take care of, meals to cook, laundry to wash, a child to raise. All that took time. Like my mother, I could not afford a housekeeper. Unlike my mother, I was also for almost two decades a single parent and the head of a household—the breadwinner.

After my sixth book, *The Seed Underground*, I quit writing for a while. To write it had taken me three years, and I'd been paid an advance of $4,500. The book's text is about saving seeds, and its subtext is hope. Seed diversity is a subject I've been crazy about since I was in high school, and I was working with one of my favorite publishers, Chelsea Green, which was run by a brilliant woman, and with a stellar editor, also a brilliant woman. The book splashed, won five or six national awards, and was translated into French and Turkish. It got my picture in tons of newspapers and magazines.

But my income hovered at poverty level. Royalties weren't flowing into my bank account. I didn't have health insurance.

Even a child could understand: book writing wasn't working.

Then It Got Worse

As the years passed, publishing became harder. I was sending out lots of writing that couldn't find a home, not where I wanted, meaning New York and the big magazines. I sent book manuscripts to one of my male literary agents without even a return call. I found another agent, with no better luck. I tried to do a better job at playing by the rules—I turned book manuscripts into book proposals, as if they'd never been written. The same things happened.

Occasionally some piece was taken, if I got far enough down the list of important magazines and if I was willing to forgo being paid and if I was willing to let an editor chop it up like it was a dead body and then ask me to sew (there's a verb a woman would use) it all back together.

And my eggs were running out. Fewer publishers wanted to feature an older, graying, eggless woman who is also southern. This is a trend we've seen coming.

This wasn't happening only to me. The great Chickasaw poet and writer Linda Hogan was dumped by her agent and couldn't find another. She put out a notice on Facebook asking if anybody knew one. So many writers—especially older women writers—suddenly went silent.

The Latest

In 2021, a decade after my last book had published, I got lucky again. I submitted a book to a contest and won $10,000. I sent a proposal for the same book to a university press. The publisher liked it, accepted it, and set a fast pub date. It was like the old days, such a happy feeling. I never have wanted to publish trash—books are printed on trees, and trees are too precious a resource to waste. Plus if some reader gives me the gift of a few minutes of their time even, I want them to go away happier, uplifted, elated, and transformed.

Trinity University Press worked hard to publicize and market *Wild Spectacle*, sending out a few hundred copies to editors and influencers (book reviewers at the newspapers are mostly gone), setting up an

impressive book tour, and trying to get the word out to every reader left standing.

But the sales numbers were low, too low.

Lots of things about the book world are topsy-turvy. Success of a book or even a story no longer depends on the writing. A poorly written book often gets more attention than a well-written one. (There are glorious exceptions, books like Charles Frazier's 1997 *Cold Mountain*.) Instead, how well a book does financially is most often determined by an exponent of the number of dollars thrown at it. And self-publishing, for all its democratic flagging, has flooded the publishing world and our bookshelves with mostly unvetted, unedited manuscripts published too soon. Most books I pick up these days I find impossible to read. I have less time left to read books that are not true to themselves (and to me) in every possible way.

A Question I Wrestle With

In my late fifties a big question began to gnaw at me: *What should I do with the last part of my life?* I was set to turn sixty on a numerically auspicious day, 2/2/22, and in advance of my birthday I read Stephen Jenkinson's *Come of Age: The Case for Elderhood in a Time of Trouble*, attempting to shed light on this problem I had.

Jenkinson is a contrarian philosopher and a proponent of dying well. His nonconformist roots, like mine, are wedged in the counterculture movement of the sixties, which for all its flaws produced stunning thinking and lasting cultural transformations. Jenkinson talked about books becoming a "nostalgic memory." In *Come of Age*, he recounts walking the aisles of an airport bookstore before a long flight, looking for a book but finding nothing that interested him.

"Really, they're not even bookstores," he writes. "They are grottoes of grim fascination with technology, and they are selling gizmos that promise to enhance the reading experience but are clearly helping to make books— the paper kind, what they call now the bricks-and-mortar of the trade—a nostalgic memory. This is something that is happening in your lifetime."

For thousands of years, human society barely changed; humans had millennia to live in relationship with the earth, to learn how to survive on it. With the advent of industry, change itself sped up, until the world in 1900 was almost unrecognizable to a person born in 1800, and the world of 2000 to a person born in 1900. We have been living in a mass extinction of culture, a cancel culture of its own. Like so many historical changes—from

seed-saving to corporate hybrid seed, or from mules to Model Ts—it is happening fast.

I see it for myself, and I know you see it. The world I live in now is almost unrecognizable as the one into which I was born in 1962.

The great civil rights activist and congressman John Lewis said, "You must do all you can do while you occupy your space during your lifetime." The question of what I should do with the last part of my life led to more questions: *What is the path I'm supposed to be on? Do I fit in anymore? Where do I belong? Am I still on my path and simply need to recognize it? Should I keep writing, although my work reaches fewer people than ever? Am I being asked to work harder, to push harder? Am I doing all I can do? Is writing no longer my work? Is my work done? Or do I get another chance to do great things?*

Believe me when I say I was racked by these questions. My father's theory about being on the right path and finding no obstacles was not working.

When I spoke with close friends about this dilemma, most of them told me what you are probably thinking. They said not to stop. That we don't know who our work touches. That if the work *touches one person, that's enough.* That Van Gogh never in his lifetime had a following. That he only sold one painting. That he died poor.

I am unmoved by the words, because I know for a fact that there exists a Zen balance between effort and effortlessness. Effort is *my* job. Effortlessness is the work of the spirit. When I do my job but the spirit does not, something is awry.

One evening I spoke by Zoom to a couple of Audubon Society groups from California. In a signature moment of truth telling, I revealed a synopsis of my current existential thoughts. An ecologist and activist unmuted herself: "But we need the stories," she said. "Those of us out here, doing the work, need the stories to inspire us to keep going."

For a moment, I wavered. Inspiring the change makers sounds pretty good.

The Power of Books

I deeply and thoroughly believe in the power of books to do the one thing I am most interested in doing, which is to change the world into a better place than it was yesterday, and to change its humans, starting with myself, into better versions of ourselves. I've seen and experienced this transformation over and over. I believe that's what books are for—they are a tool for transformation, probably the best tool we have. Writing is activism.

Story is written into us biologically. When we are born, until we turn three or four, we are caught in the vortex of our own needs. We are hungry, we want our diaper changed, we are scared of the dark, we don't want to be alone. Then our brains change and we develop what's called "habit of mind," a state that allows us to consider other beings and their needs. From that point on we can enter the head space of Laura Ingalls Wilder or George Washington Carver. We can learn what other people, other characters learn. We can experience epiphany through the epiphanies of others.

Therefore, all of us are story listeners, storytellers, and story keepers. We need stories. In your lifetime and in mine, I can't imagine that fact changing.

But Things Are Changing

The world is changing around us. Readership is changing. The numbers are down. Fewer readers read fewer books, fewer book collectors collect fewer books. There are fewer bookstores, fewer bookshelves in homes, fewer times that someone is spotted sitting on a park bench or a bus seat reading. I can imagine a day when no book ever gets checked out of a library. We aging creatives are faced with adjusting or dropping out; with using our unique perspectives to offer wisdom or shutting up; with following our dreams or aborting them; with plowing forward or closing up shop.

These Few Things I Do Know

1. I cannot stop writing.
2. However, I may stop Being a Writer. Most of writing life as it exists today fails to interest me. I can tweet or TikTok with the best but have no desire to add to the clamor.
3. I have written a few unpublished books and essays that I believe will bring comfort and clarity to some few people. I will proceed with making those available in nontraditional ways, including the dreaded self-publishing.
4. "You don't look your age" is a way of saying that being young is far better than being old, that being old is a horrible mandate we all must face. I have turned sixty beautiful years old. I no longer ovulate and have no interest in childbearing or child rearing. As an object of romantic attachment, I am useless. My goal is to stay as fit and healthy

as I can but to work even harder at becoming a good elder, which our young people, our world, and our planet so desperately need. And which our old people need as well.

5. I am not giving up. I will head with determination in a new direction or with renewed vigor in an old direction.

6. I'm watching for a mandate. For now, it's

7. Come of age.

Enough

Mary Gauthier

I was humming along, doing what I'd done daily for the last two decades—living the semimanic life of a DIY self-managed musician, looking for new ways to grow an audience, build my business, and make a name for myself in the crowded world of singer-songwriters, when something sizable shifted, and everything felt different.

I'd moved to Nashville at age forty to start this pursuit, a decade after I got sober and walked away from several restaurants I co-owned in Boston. I attacked songwriting and the music business in more or less the same way I took on the restaurant business: Wake up, strike a warrior pose, and assault it. I'm a fighter by nature, and I go at business like a soldier trying to take a hill. I've pushed myself year after year, focused on forward movement. I wrote, recorded, and released ten records in twenty years. I wrote a book on songwriting, got it published, and have toured almost nonstop, except for during the pandemic shutdown, when I shifted quickly to weekly online shows.

Recently I've noticed that the struggle has lessened, and the climb is less steep. I did not become rich and famous, write a hit song, or receive new honors or awards that drew attention to my work. I had a big birthday: yes, I turned sixty, but so what? I'm healthy, sober for three decades now—no drugs, no drink, no smoking. Most days, I swim a mile at the YMCA. Yes, there is more silver in my hair, but there's nothing shockingly different about my energy level or ambition. No big changes there, yet.

So what's different?

The shift, I believe, is one of perception. My name, if not my music, is more known now. I am a familiar face in places where troubadours like me

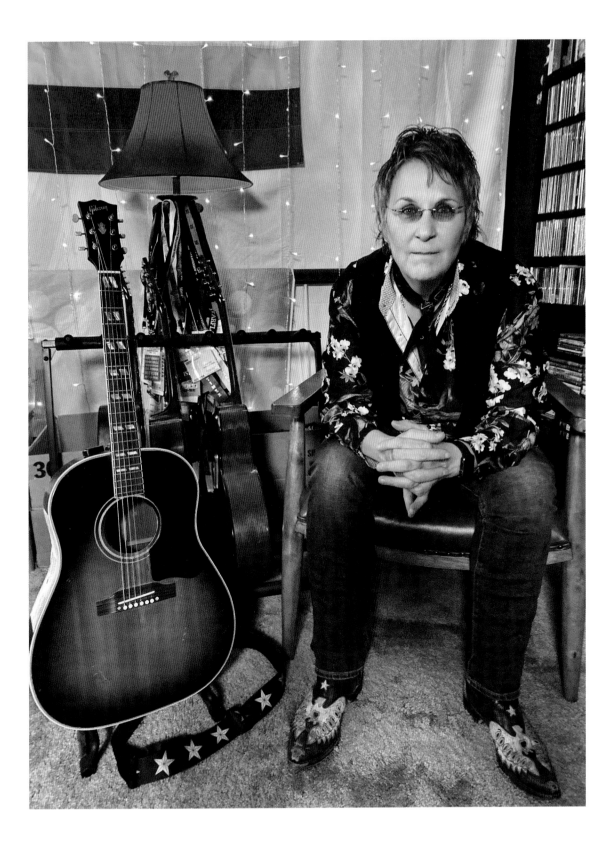

work. I've crossed a conceptual line, become recognized as a legit artist, a music business lifer. I am being treated with more respect, and it's a surprise, a pleasant one. Ever since I left the restaurant business, I've thought of myself as a musical upstart, fighting long odds by entering the business later in life. Consumed with staying in the game, I never imagined what it would be like to successfully, well, stay in the game. But the shift in how I am now seen is palpable. I've become established. Is this what I was working for all these years?

Well, yes.

Stability, it seems, happens gradually, but the recognition of it happens suddenly. After decades of working to lay down a foundation in the unpredictable world of music, a career notorious for its capriciousness, and seemingly overnight, the work has paid off.

I am settled in.

Solid.

When I hang with musicians I admire and respect, I am treated like a peer. Sometimes I am the one with the longest musical career. Gig offers I used to battle to get are coming in unrequested. People in the industry know me; they take my calls now. When I congratulate or compliment younger artists, they often say, "That means a lot, coming from you."

From me?

I didn't see it coming.

There's been a paradigm shift.

It feels good, right, and true, but it also feels weird. Drumroll, please.

I've become an elder.

⁓ Walking back to my hotel after playing a show in downtown Halifax, I walked past dozens of young people milling outside the downtown bars, leaning against lampposts, drinking, smoking, talking in small groups, checking each other out, and I flashed to scenes from my youth when I did such things. An old, familiar loneliness washed over me. I recognized it in some of the faces I passed. When I was their age, I was searching, longing for something I could not name. Plagued with the feeling of not being enough, of not being worthy, I measured my worth in the eyes of others. It was a wild goose chase, mission impossible. What I was missing had to come from inside, but inside, I lived with a hole that I tried to hide. This inner void was where addiction took its root, where dropdown menus of bad decisions were hatched. The hunger for *more* defined me, *more, more, more*. It was a gravitational pull downward, the voracious, aching emptiness.

I do not feel that way anymore.

The hole is gone, it has transformed into a wholeness. Age has brought with it a sensation of rightness. I know who I am, and I know my own worth. Years have brought gratitude, grace, and their sacred sister, serenity. I have what I was looking for then, a calm confidence, a certainty of my own value.

I do not want to be young again. Sixty is all right with me. It's the young side of old, and I will take it, thank you very much. I would not trade the hard-earned comfort I feel in my own skin for a return to youth, even if I could.

— Concurrent with my new awareness of my own maturing in the musical world I run in, two influential and profoundly important musical heroes of mine, John Prine and Nanci Griffith, passed away. John passed in 2020 of COVID-19, and we lost Nanci in August of 2021.

Long before I got sober and began writing songs, their music wormholed its way deep into my soul. I bought every record they made and went to their shows when they performed near me. Their music provided a life raft when I needed it most. It crawled inside and steadied me, rearranged things and gave me hope, leaving me with a lifelong reverence for their work.

After I got sober, became a songwriter, and moved to Nashville, I met both John and Nanci. I opened shows for both. Bucket list stuff, for sure. In a small way, after that, we became friends. I never told them how their music saved me—I couldn't possibly articulate what their work meant to me—but I suspect they knew. They were more than influential. Without their music, I doubt I would have found the road to my own. Neither had huge radio success with their own records, but they both regularly played in front of thousands of adoring fans. Other singers cut their songs, and there were even a few hits along the way. Smart songs, written by southerners in the folk tradition. They did it their own way and showed me how I could do it, too. Teachers, giants in my world. Gone, within months of each other.

— I've been with the same therapist for decades. I don't see her regularly now, but when I need her, she'll book a session with me. Knowing she is there calms me. The relative serenity I enjoy today is a by-product of the deep therapeutic work we've done together. I went in last week to see her for a brushup, and at the end of the session she casually mentioned she is pulling back her practice, booking fewer appointments, taking more days off, and not taking on any new clients.

I jokingly said, "Slowing down, huh? Well, you cannot retire!"

She said, "I'm seventy years old now, Mary, and I do look forward to my retirement."

Until this moment, it had not occurred to me that she could, or would, retire. A panic washed over me. She is seventy? Hard to believe. I'd never thought of her age. To me, she was always just Deb.

No more Deb? Even if I could find a new therapist that I respected the way I respect her, it would take a long, long time to build the deep trust we have developed over decades. She's walked me through breakups, crack-ups, and emotional minefields, guided me through my slow but steady recovery from a laundry list of isms, traumas, and childhood wounds. She's helped me clarify, name, and deal with addictions and wounds that were killing me. I credit her (along with sobriety) with keeping me alive through the toughest of times. She knows me better than anyone else on earth, and I somehow figured she'd always be there. It never occurred to me she would one day call it quits.

— My longtime sobriety sponsor died a few months ago. He was forty-five years sober, and one month shy of his eighty-second birthday when he passed. Bobby N. was my rock, my touchstone, the person I turned to for all things recovery related. Staying sober takes a village, of course, but Bobby was the mayor. He knew what to say to calm me and help me find faith when I was filled with fear. He helped me remain committed, focused, my priorities in order. Sobriety first: from it, everything else follows. Simultaneously irreverent and devout, his guidance was a lifesaver. I adored him. He'd say, "Everything is in perfect order," and I *believed him*. He'd say, "No big deals," and I *believed him*. He'd say what we are praying to, we are praying from, and I *believed him*. If I called him when he was in a meeting, he'd answer in a whisper, "Hey, I'm in a meeting, I'll call you back."

And he always did.

A few weeks before he died, he said, "You do not need to work so hard. You're *there*. Slow down! Throw 'em a new song every now and then, but don't worry, your career is not going away. Relax! Enjoy yourself! Step out of the ring, Mary, you've won the fight. How about trying to have some fun?"

I loved him so much.

I will always love him.

And as usual, he saw what was happening with me before I did, and as always, he was right.

⎯ My network of support is being rewired as my most trusted mentors, advisors, teachers, and friends are retiring or crossing over. Loving them was a blessed gift; receiving their love, more so. It is love that has healed me, closed the gaping hole that haunted me when I was younger. Learning how to let love into my life has brought me peace. This is the "more" I longed for. It is the thing I hungered for but could not name. I have it now. I've had it for a long time. I am losing a lot of people right now, but I can carry their love with me forever. I do not ever want to forget that.

Aging, it seems (the physical, tangible parts aside), is about internalizing people's changing perceptions of me and my own changing perceptions of myself, accepting a steady flow of loss, and reaping the benefits of doing the physical, mental, and spiritual work I did in my thirties, forties, and fifties. I've never stopped long enough to define success, and perhaps this is why it feels surreal to embrace it. But I am there now.

Here.

Shall I say it?

I'm successful.

I have as much work as I want to take. I have the respect of my peers. I have peace, serenity, and love in my life. I have enough money, enough love, enough hope. My friend Fred Eaglesmith once said, "I am the richest guy I know, because I have enough!"

Yeah, me too.

The stakes seem higher now. Time is a gift, not a given. Death is no longer a far-off whisper, a remote possibility in a blurred distant sunset. It sits on my shoulder, speaks to me, announces its presence, daily. I wonder, how much longer do I have? I watch my friends in their eighties and see how the body inevitably gives way to the wear and tear of age. Aging inherently brings debilitation, and loss—this is not news. I see the ever-deepening lines on my face and the faces of my loved ones. I have plenty of energy and drive still, but I live with the myriad of new, daily aches and pains, creaky knees, sore joints. I'm starting to struggle with memorization and some memory loss, hearing loss, encroaching night blindness, the inevitable slowdown of metabolism. I have an awareness of the importance of old friends, and the importance of nurturing relationships with new ones, but I want to keep my focus on what's *not* inevitable. It's not inevitable that I become withdrawn and recede. It's not inevitable that grief stops me from loving with all my heart. It's not inevitable that my love grows smaller.

The question I ask myself now is: What does a sixty-year-old troubadour do with her remaining time on earth, now that she no longer needs to be hyper-focused on succeeding? How do I sit back and enjoy what I have built?

I honestly don't know. I do not know who I will be if not a fighter, fighting for success. But I love teaching, and I will do more of that. I enjoy mentoring and will offer myself up for more of that, too. I am one of those songwriters who spend their lives getting older and writing songs about it, so that is certainly in the cards. More songs, always. I love my work, but what will I do for fun? How do I learn how to enjoy downtime? What does a warrior do when the war is over?

The answer is, I do not know.

But I am going to find out.

I have enough, now.

Wet Leaves

A WINTER'S REFLECTION

Lila Quintero Weaver

The dogs roam the backyard, combing the fallen leaves with their noses. From behind the thick woods comes a glimmer of moon. Earlier Paul got the fire going. He set up a circle of lawn chairs and old blankets, so the four of us, plus dogs, could warm ourselves in rustic luxury.

Still, once the cold gets in my bones, I can't seem to shake it.

My daughter Jude must've read my mind. "Here, Mom. Let me pour you a cup of hot Tang."

Yes, we drink hot Tang in this family, a goofy tradition that began on a long-ago camping trip. Hot Tang plus room-temperature whiskey, if you care to know the full recipe.

⌒ Winter owes its existence to astronomy. Zoom out a hundred billion miles and the ancient machinery comes clear: Earth and her sister planets march to the beat of built-in clockwork. Inexorable, unchangeable. And Superman notwithstanding, do not try to negotiate with this ancient machinery. You will not win.

Correction: astronomy *and* geometry. The axis of Earth maintains a tilt of 23.5 degrees. Owing to this, hemispheres fall in and out of favor with

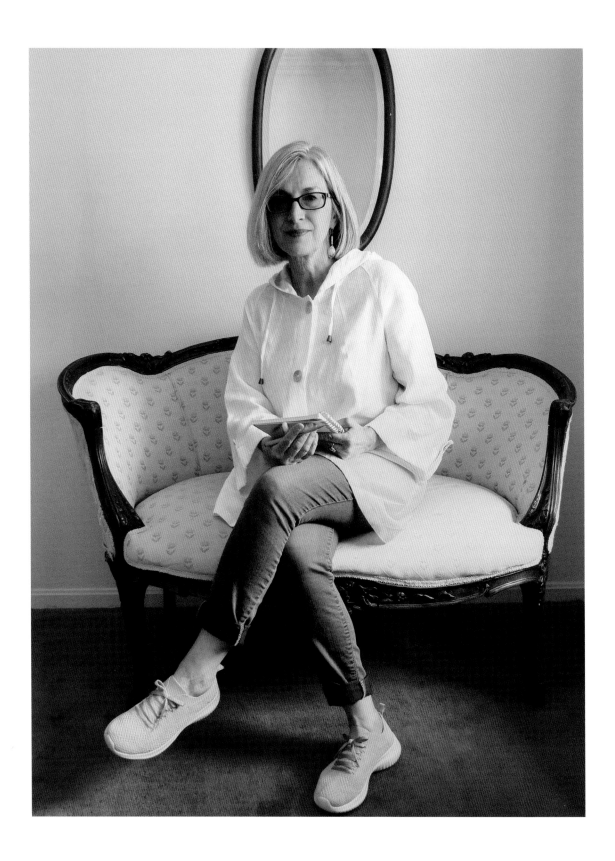

the sun. In winter, its rays approach us at a steeper angle, traveling a longer course to reach our waiting faces.

We lose warmth. We lose hours of daylight.

We lose leaves.

We strip down to the barest parts of ourselves.

And in the moonlight, this is lovely.

— Jude bends down to rub the flank of the closest dog. "Do you wear socks in bed? If I don't, my feet turn to blocks of ice."

Jude's boyfriend snorts. Clearly, he has suffered those icy feet.

Icy feet, icy sheets. This is why people in olden times used coal-heated bed warmers.

Every time the dogs pass through, dry leaves go *hush-hush*, like a drummer's brush on a snare.

— Wet leaves don't say a word. Drained of color, they yield their flattened forms into a moldering litter of organic crumbs and sticks and feathers and skeletonized insect bodies. Slowly, slowly, as everything becomes less of what it was, the potpourri turns into rich and richer loam.

Now the fire glows with a comforting tranquility. An hour passes and the moon crests over the treetops.

"Look at that moon!" Jude yells. "Good Lord, it's bursting full!"

"Oh wow," everybody says. Even the dogs stop in their tracks to see what the fuss is all about.

Did I mention that it's January, the month of the Wolf Moon? I can't think about wolves and full moons without replaying in my mind a chilling scene from the movie *Dr. Zhivago*. Sinuous black silhouettes against moonlit snow, the gleam of their eyes like tiny fires.

Paul tosses another log into the flames. I tilt back into my canvas chair with a contented sigh. "It's so peaceful out here. Don't you love how the fire hisses?"

Jude says, "Yeah, and how the sparks go *crack* whenever they escape."

"Watch their ears, the dogs catch every little sound," her boyfriend adds. We stop to listen, as if for the skitter-scatter of lizard feet.

There's only silence, then the panting of the dogs as they tear across the grass. What are they chasing, their moon-shadows?

"Did you know that in hibernation a chipmunk's heartbeat drops to single digits per minute? That's how they hold down their consumption of energy," I continue. "They're expending the dimmest wattage possible."

Jude says, "As if a chipmunk would burn anything but an itty-bitty, low-watt bulb!"

The idea of a curled-up chipmunk, of the cold earth packed all around its sleeping form, makes me wish for a cutaway view and a tiny bed warmer.

I take a slow drag from the hot Tang. The fire spits a trail of sparks.

≈

One sizzling summer day in the late sixties we drove Mama to Donnelly Airfield in Montgomery to start the first leg of the interminable journey to her native Buenos Aires. It was to be a monthlong visit. She was a champion packer, organized to the utmost. Still, after we'd said our goodbyes and returned to the car, what did we find draped over the passenger seat but her winter coat? In her haste to board the plane, she'd forgotten about switching hemispheres and seasons. I was eleven or so, and disconsolate at the thought that she'd suffer the cold down there.

Decades later, Mama made an observation that stayed with me. All too aware of her advancing age, she told me that behind her eyes, she still felt like a girl. A girl watching her image in the mirror transform into someone else. It all went so fast, she said.

It all went so fast.

The day came when she learned she had osteoporosis. Tears rolled down her cheeks. The long-dreaded cold front was coming in, and I didn't know how to comfort her.

More years would pass before she died.

On a trip of our own to Buenos Aires, my sister and I took a tiny vial of Mama's ashes to the street where she grew up. Her old childhood house had been torn down and replaced by a modern one. But old-growth trees persisted there, all along the edges of the sidewalks, where once she'd skipped rope with other girls.

We poured those scant ashes into the soil around a small tree of paradise, planted opposite where her front door would have been. The previous tree that stood in that spot must have caved in with age. But spring had arrived, and the just-opened blossoms of the young tree offered a dazzling perfume.

— Back by the fire, in the company of two dogs and three humans, Jude pulls her ukulele out of the carrying case.

I am prompted to say, "Did I ever mention that I saw Ralph Stanley in person? He sang 'O Death,' and it was so crazy good that a girl sitting next to me broke down and sobbed."

Ralph Stanley shared the stage with far younger men, yet he strummed and picked and wailed full out. A fellow of small stature and dwarfed by a sizeable cowboy hat, he stepped up to the microphone and pleaded with death: "Won't you spare me over till another year." His old-man voice scratched on me like a shiny penny.

Jude sighs. "Are you asking me to play that song? It's not in my repertoire. Sorry!"

"I know. Some people find songs like that depressing."

"*You think?* Shit, you're kicking pretty good right now to be talking that way, silly mommy."

Kicking, yes. Cussing a little and jousting against the machinery with the lame weaponry of antiwrinkle creams. But something deeper is happening that I don't yet know about. In one year's time, I will learn that my bones are in a state of erosion, just like Mama's.

"All right, play us something cheerful, then."

"Like what?"

The dogs come bounding in out of the dark. They want somebody to toss a ball, throw a stick, give them chase through the fallen leaves.

Scientists postulate that friendly dogs exist only because their wolf ancestors were drawn to humans. The extra resources supplied by human communities allowed those wolves to thrive and reproduce, more than wolves who shied away from people, and . . . well, you get it.

While Jude tunes the strings, an idea comes to me. "I've got a hankering for 'The Beat Goes On,' if you know it." No, of course she doesn't know it. Even *I* was a kid when they played that song on the radio.

Let us pause to note that Cher, who recorded "The Beat Goes On" with her partner, Sonny, is somehow preserved under glass. I am not.

By what right do I propose to lay a claim to permanence, when even Ralph Stanley ultimately didn't get "spared over"? Try as I may to bargain, try as I may to put a good face on it, parts of my parts are succumbing to the ancient machinery.

Behind my eyes, there's a space that hasn't aged a minute. As a twelve-year-old, I scribbled poems in a secret notebook. In one, I extolled hickory trees; in another, crocuses and daffodils.

That would-be poet buried her words in self-doubt, shoved the notebook deep inside a cardboard box. Eons would pass. Then came a frail shoot of prose, a return to words, and the discovery that many other writers have seized upon: that writing is a thatch rake capable of combing tangled thoughts into order. This is how I come to know myself.

—— I know that I still find solace and meaning in the natural world.

Hollowed-out logs. Damp earth, dark and loamy. Dormant ferns and yet-to-be crocuses.

Tree branches silvered in lichen. Owl roosts. Whisper-thin petals of oak-leaf hydrangeas. Tiny rodents that move furtively in the dark, hushed by mosses. Forest floors crusted with acorn shells.

And I know that by scrutinizing the workings of the natural world, I learn my place in the scheme. I learn to accept what I cannot avoid.

So much ravaged beauty; so many decomposing leaves going down, down into the welcoming earth.

In the moonlight, it's all breathtaking.

Moving beyond Purpose

Nevin Mercede

Northern born, and peripatetic by nature, I've lived nearly half my adult life in Florida. It isn't where I expected to land, but expectations usually stem from romanticized imaginings and not from what various life tensions produce as reality. Still, I'm pretty sure I've moved for the last time.

Florida earned the fit I now feel in being here. From the start of my first Florida residency nearly thirty years ago, the weather gained my affection: the soft prevailing warmth and predominant sunshine helped heal my separation from a ten-year relationship. Over time, the scrubby land and longleaf pine forests, the winter Gulf, the rivers, lakes, and ocean beaches in almost any season, and the native flora and fauna, especially the birds, all won my admiration and love—not least because of how they persevere against the multiple greedy ways that human "progress" moves interminably toward their annihilation.

I'm not alone here. Florida became my place because of my spouse, Bill, whose family removed him from his New York birthplace to Florida in early adolescence. His few sustained departures include his years of military service, time building lofts in lower Manhattan, and a stint in the Middle East he considered making more permanent until a job beckoned him back to Florida. Bill also tried living in Ohio when I first went to teach there, but cold, gray winters undid him and prompted buying the beach house. Crossing into Florida after time away, he always gets out at the welcome center and says, "Feel that air. It's like putting on a silk shirt."

Twelve years my senior, Bill's aging has been more present in our lives than mine. We joke that his warranty ran out when we married, though he really wasn't old yet, only in his mid-fifties. For years he's warned I'd

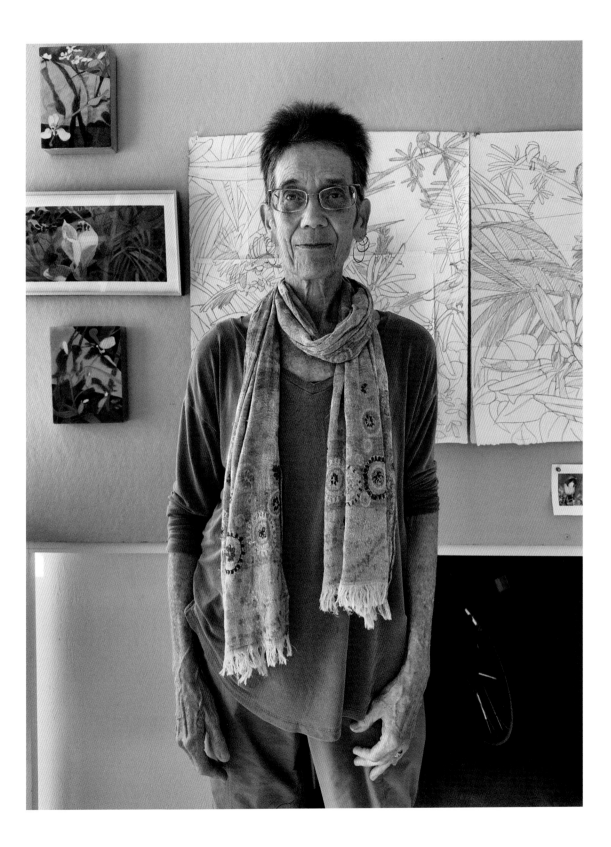

eventually suffer similar bodily insults, but thus far we're both thankful I haven't. And while this past year I finally joined him in needing fairly intensive physical therapy, our ailments and respective chances for a return to how our bodies moved *before* differ considerably.

We chose our Central Florida beach town decades before we expected to inhabit it full-time. Bill frequented the place from his teens, riding his motorcycle over on the then-shady two-lane roads from Orlando (1-4 wasn't yet a glimmer in anyone's eye). He brought me here early in our relationship to enjoy the Atlantic Ocean, cool on the white sand beach, and to meet a good friend.

Until a little over a decade ago when the county advertised our beach as supersized Orlando's favorite, the town retained its low-key small beach community feel. In large part this was due to the efforts of Doris Leeper, a mid-twentieth-century sculptor. In the 1960s she launched the work that prevented development from absorbing the south end of our barrier island. In 1975 that area became the northern fifteen-mile stretch of the federally protected Canaveral National Seashore.

Seven years later Leeper opened the Atlantic Center for the Arts, a multidisciplinary international artist residency organization. At the time we bought our house, they hosted five or six three-week residence periods annually, each bringing in three master artists and twenty-four associates. The stimulation of the public encounters with these residencies tipped the scale, balancing any reservations I had about life in a small southern beach town.

≈

My second full-time Florida encampment began at age sixty, five years after losing my tenured professorship through the closing of an historic and innovative small liberal arts college. I spent those five years in perpetually compounding mourning: first for a position I'd worked hard to achieve and a rare institution with educational ideals that matched mine; then for my career, as the world economy swirled down and my opportunities shrank.

Midway along that five-year span, my father died. Although he was ninety-five, and long slipping away with Alzheimer's, his death wrenched me in unanticipated ways. I'd expected that the years of his gradual decline would ease the final loss, but this felt as sharp and inexplicable as my mother's sudden death thirty years before. A few months later, the alpha of my two sibling cats died at fifteen. I spent more time in Florida after that, making it

clear the only sensible thing was to simplify and leave my northern home permanently.

My body relocated, but my sense of self remained adrift: displaced and depressed. Several years of obsessively long beach walks, sometimes twice daily, led me only to know that I needed to define the last third of my life differently. Attaining what it would become required several more years of trial and error, experimenting as I do when starting any new body of work.

First I had to find my way through the loss of purpose. Teaching art had driven my adult life and, in varied ways, my creative work. Since age factored into why, despite my deep experience, academic appointments eluded me, I needed a healthier way to continue growing older.

Unfortunately, our small beach house contained no suitable painting space, and I had no money to rent elsewhere. My long-trusted means of sorting through life's challenges would be inaccessible. Five years passed without my making art, though in that time span we designed and built my new painting studio and renovated our 1960s weekend beach cottage to better suit long-term occupancy.

〜

As I walk the sand, the rising tide teasing at my side and heading into a soft southern breeze, I no longer stare as the granules press to the sides of each footfall. I look around: sky, water, shorebirds large and small; runners, walkers, bicyclists out early to avoid UV rays and heat. Each morning sky radiates differently, changing in every direction, depending on the season and where clouds gather or disperse. Softly lapping water glides back, absorbing into another long slow rush of breaking waves, unless winds, or a storm as far off as a day, increase their size and sound.

Soon the season's first sea turtles lumber up toward the dunes and choose where to dig. Sometimes one wanders along the dune edge, meandering until the urge can't be ignored or, perhaps, a perfect spot appears. Soon after, she'll settle her clutch of a hundred or so eggs two feet down. Then, with sand kicked back to cover and fill, the dawn pulls her back to the sea, as it will the hatchlings eight to ten weeks on. The sun and sand incubate the eggs, but the loss of beaches to repeatedly higher tides, and scavenging ghost crabs, coyotes, and seabirds, too often intervene. When they manage to make it alive into the breaking surf, young turtles must survive at least fifteen oceanic years until mating initiates females' return to their birth sands.

Sea turtles were among the first Floridians to claim my heart. If I reach the beach before dawn, I might glimpse one heading back to the water. More often, I scan from dune to waves and back, giddy when fresh tractor-tire-like imprints reveal themselves. At each set, I follow the track west: will it terminate in a nest, or prove a false crawl, possibly winding a hundred yards along the dune base, then east again without delivering? As the weeks go by, I count new nests, an average of one per day over the first three months, then slowing. By late August the egg-laying tracks no longer appear, only the harder-to-decipher scramble of late-season hatchlings, considerably more elusive than their mothers.

After sunrise, seabirds light along the shore or float the thermals above buildings or waves. I walk and watch as they breakfast and bathe. Ruddy turnstones skitter with sanderlings amid gulls, terns, and the occasional skimmer. Should one fly off, others often follow, moving a distance along the beach before landing again. Sometimes one (most often a tern) seems to be cranky, ill at ease, or just feeling *something* it must let everyone know about. This bird walks up to another and nags at it, likely without receiving any response. So it squawks over to another. And another. I can't know what provokes this behavior, or what the birds understand of it, but it resonates: listen, everyone, come on, pay attention, please!

Among the birds common along my short stretch of the Atlantic, I find the strongest affinity with what I observe of the willet. Leggier, with a slightly larger body than the gulls, and considerably more solitary, she's both assertive and cautious in her tasks. Wading knee deep, she'll quickly move inland to avoid higher-cresting, belly-dampening waves. She stands a bit further out than the various smaller sandpipers skittering almost constantly along water meeting sand, at a distance from the stately crowds of gulls and terns or the shyly occasional and only slightly more serene plovers. With a head gesture similar to the lazy snowy egrets that beg treats from surf casters' bait buckets, the willet angles her neck sideways toward a sound I cannot hear and plunges beak into water, slurping down what she's found. I usually walk on long before she abandons her morning hunt.

Attempting to turn my past experience into current usefulness, I volunteer at the Museum of Arts and Sciences in Daytona. The education curator requests more accessible docent training materials for the permanent galleries. I tackle four or five of these, then a massive new collection opens to

the public in a brand-new building: the Cici and Hyatt Brown Museum of Art. I immediately agree to serve as a docent for this curious collection that depicts Florida's natural, social, and political histories, and to create informational materials on its artists and their works.

My excitement in investigating these works surprises me, and also most who know me. As a contemporary artist trained in the latter part of the twentieth century, I only recognize the few modernist artists, who here are outliers. The remaining 2,700 images reflect Florida as it existed between 1865 and 1965, the styles and subjects abandoned by art historians once the 1913 Armory Show introduced America to modern painting. What intrigues me most is the motivation behind creating this public museum: presenting images of the Florida that most tourists and many residents never see, to encourage interest in saving what remains of it.

About 12 percent of the works in the collection are by women, from all economic levels and with varied levels of art training. While alive, nearly all these women achieved recognition as important cultural agents. Some had gallery representation in New York, with works in many museums. Several were recipients of prestigious grants, one being the first woman to receive a mural commission from a Mexican university, which led to an unexpected public expression of gratitude by the country's president. Many of these women organized art fairs and exhibitions. Some were teachers. Others painted contentedly within their own small Florida communities, seeking nothing beyond the time and materials to continue making their work. I feel these women's absence from my education more deeply than the many male artists with similar résumés. I wonder how my journey might have changed, had even a few of their works and life stories remained above the waterline of art history.

As docent, I observe viewers of all ages closely examining nearly every work they encounter at the Brown, something rare in other museum settings. The images are naturalistic, easily readable because the artists' intentions were conservative, portraying things that are familiar. They generate in viewers a greater receptivity to, and curiosity about, the few more challenging pieces.

My interest in producing paintings that could elicit such comfortable admiration grows. Given the conceptual complexity of my earlier artwork, the idea of seeking popular attention feels disturbingly regressive. However, over time a goal clarifies: to produce "intelligent, accessible" art. After several attempts in the studio, I refine this to making reasonably identifiable images that also stimulate viewers' probing beyond the evident.

When I am stirred to deeply explore art that initially puzzles me, understanding often lies in how the material is handled, rather than a revelation of the subject matter (if that is even recognizable). Or it may be that the composition or color unsettles in some compelling way. Artworks that can't be grasped immediately succeed best when the examined mystery eventually satisfies in multiple ways.

≈

Just back from lunch with Janice, our typical three-hour-plus visit. We originally met through a library book group, but our acquaintance remained young in March 2020. Over the next year we came to more deeply know and care for one another through exchanging long weekly emails that tethered us to who we are within and beyond our families. We wrote one another in this way until we agreed to lunch again during the honeymoon phase of initial vaccination. The sensations from hugging her after that long year will remain with me always.

Having retired from her public relations work with the nonprofit Save the Manatee Clubs about a year before COVID, Janice had settled into some community activities when the shutdown arrived. She made an effort to remain engaged via Zoom, but ultimately determined that it wasn't a productive format for her. (Even after vaccinations and boosters, like me, she continues to avoid group gatherings that occur indoors.)

At lunch today she recounted a story that offered a different tack on aging women's sense of social invisibility. Not the familiar complaint when we feel no longer "seen" by men. Or when we can't get a bartender or cabby to acknowledge our signal. Or when people we pass ignore our greetings.

Janice and a former coworker were asked to collaborate on composing a memorial quote about the lifelong environmental contributions of a third colleague. Both felt uplifted by the experience of the collaboration, and by knowing that their writing would live in the larger world: where they used to be regularly engaged, where their careers had existed. Neither had done anything so connected to that world, or so public, since retiring. They recognized that in retirement they had been, and could continue to be, essentially invisible, voiceless to a world that once paid them regular attention.

Hearing their story opens a new view on my own. Only now do I more fully comprehend how the passage from work life to the life that follows, whether voluntary, timely, or forced, often ruptures our self-understanding. Attempting to ease the transition with activities that require leaving the

house, that put us in the world, can distract us but can't replace what is gone. For many, the loss of that purposeful, publicly validated endeavor may never be fully ameliorated. It deeply alters how we understand ourselves, even while those around us accept its face value: you retired, but you are still the person who did all you did. Enjoy!

≈

News that Antioch College will close after the next school year reaches me one day into my June 2008 research trip. The visceral effect of learning this sets off my grief responses, denial, anger, and bargaining repeatedly cycling through my attempt to fend off the inevitable depression. In the fall, amid the chaos attendant on helping students, colleagues, and myself navigate this final year, I accidentally shrink a treasured gift, a Fair Isle alpaca sweater, and resolve to become proficient enough to reknit it.

Knitting surfaces as the first of several non-studio-related obsessive practices. I bypass the usual beginner scarves, starting instead by making dancer's leggings, then camisoles and market bags, knitting multiples of these over a year. The knitting calms me through the interminable meetings we muster, hoping to forestall the impact of the college closing by designing a program to carry us over the upcoming year while alumni bargain for campus control.

Over winter break in Florida, I begin to unknit the tightly felted mess that was once my sweater, pulling apart the intricate colored patterns. It astonishes people who observe this part of the process: how can you just tear that apart? I wonder the same thing about the people who are closing the college.

The resulting yarn strands then soak to relax and air-dry, hanging everywhere I can find, on shower doors and rods, folding laundry racks and hangers. A women's size medium sweater absorbs nearly one thousand yards of wool. Knit after knit, purl after purl, six months later: a new sweater. I remain unraveled.

Knitting grows into a social crutch, a way to be around people without engaging, to be with myself without thinking beyond the varied cadences of repeated or alternated knits and purls, or of more elaborate stitch patterns. Discovering the increasingly complex yarn maneuvers involved in making knitted lace increases the time I knit away. Knitting buttresses me through loss, its hold slowing only after I finally push through depression, wrap my mind around acceptance, and stumble toward a healthier present.

～

Singing, like image making, provides me solace, especially singing with others. I was part of a community peace choir the year before moving to Florida and want to keep singing with others here. Although the Orlando Gay Chorus (OGC) presents the opportunity furthest from home, it is the only one with a social justice mission. So I audition and begin a weekly commute to Orlando for evening rehearsals.

Research reveals that the heartbeats of people singing together synchronize, which may explain the joy it produces: one big heart. But I also love the work of learning new music alongside other upper voice singers. I love hearing the sound of the four sections joining together for the first time and honing those harmonies over the months leading up to concert weekend.

What I don't enjoy is my seventy-five-minute late-night return journey to the beach. Half the drive is freeway: seasonally problematic, but mostly predictable. The other half is a rural four-lane state highway darkly fraught with unseen dangers. Deer regularly dart out from the woods on dark rural roads. Once in broad daylight, cars ahead of me brake hard to avoid cows wandering loose from a nearby farm, grazing on the median grass. Eventually I grow more comfortable and determine that the many times I've peripherally "seen" deer, I've only sensed wind moving through trees. I remain safe through six years of late-night trips home.

The Pulse tragedy that kills forty-nine Orlando LGBTQ+ community members occurs a few weeks after our 2016 spring concert. When I hear about it later that morning, I fear chorus members are among those shot, particularly as one of our swanky cabarets was earlier in the evening. I learn several singers spent time at the club that night but left before the horror at closing time.

Throughout the following year OGC responds through song to requests for *ninety-four* outreach events: memorials for the dead, fundraisers for the survivors, and morale reinforcement for the community. OGC as an organization, and a good portion of its singers and support staff, repeatedly stand up, vulnerable, but willing to face the terror that haunts the city of Orlando.

～

I am (slowly) converting the small plot of land around my house and studio into a refuge for a diverse array of primarily native flora, especially Florida wildflowers. They turn my yard into a haven for bees, birds, lizards, and

butterflies. Caring for and learning about plant life exhilarates me, but the wildflowers, shrubs, grasses, vines, and ferns around me also tender models for my paintings.

In addition to whatever volunteers arrive to be nurtured, I selectively plant young native nursery starts in either the sunny, sandy grounds of the front yard or the oak-shaded, leaf-enriched grounds of the back. Nonnatives and tropicals I put in pots to inhibit their invasive tendencies, and to easily move them when hurricanes or cold weather threaten. Some plants prosper, others fare poorly in their assigned space and need to be moved. Plants, even native ones, also die off from inappropriate care (the blazing summer heat pushes me to overwater). In this way, gardening resembles image making: success depends on tracking attempts that didn't pan out, then trying again, but differently.

$$\approx$$

I join the East Volusia Off the Beaten Track Studio Tour, my solution to obtaining viewers without engaging with galleries or art shows. I've started making floral paintings during the past year. A promising tack in my journey toward "intelligent, accessible" imagery, these merge a descriptive visual vocabulary with the compositional syntax of abstraction.

I aim toward celebratory activity, the sense that each blossom-character bursts with energy and intent. Unlike most showy tropicals and northern garden plants, Florida wildflowers tend toward considerably smaller blooms, so I paint them large and bold as dancers. They flow through environments of varied leaves and stalks bisected by a diagonal sector that simultaneously veils and propels. Formally this area augments aspects of illusionary space while providing contrast within the nature-filled setting. Conceptually, the diagonal shape represents the threat human imposition poses for nature.

Like much of my work, the early Florida paintings employ the triptych format. I enjoy the way an unavoidable interactivity between panels deepens visual and conceptual impact. The first group celebrates cyclamen, with panels titled *Beauty (dawn)*, *Grace (day)*, and *Hesitation (night)*. An eastern Mediterranean flower impossible to maintain beyond one Florida season, the plant's translucent beauty and delicacy present intriguing painting challenges.

I anticipate carrying the notion of capturing recognizable times of day into successive groupings, but then decide against that limitation. When

making images, I rarely end up with what I imagine at the start. The process continually pursues questions, enacts choices, engages analysis. In a similar way, choices unfurl my days.

≈

For several years, I consider leaving both the chorus and the museum, but each new season finds me driving again, reluctant to lose these aspects of my post-work-life identity.

The long drives to Orlando, especially, wear down my aging vehicle, my aging body. My last full OGC season, we try a new concert venue situated thirty minutes further from home. That concert week I drive nearly two hours each way for four nights and one day. Exhausting. But the location proves popular with patrons, and we start the spring season with the news it will be our concert site for the foreseeable future. However, it's 2020, so we conclude with a Zoom concert. Participation requires synchronizing two digital devices. Each singer listens to tracks on headphones and self-records while singing alone. It only becomes a chorus in the hands of the sound technician. The process alienates me, and my love for the organization, the people, can't bridge the gap.

Leaving the museum feels less conflicted. With no dedicated staff, the exhibited artwork rarely changing, and intensive research and writing no longer needed, my interest diminishes. Increasingly fewer people visit, and fewer of these want a tour. The galleries become window dressing for revenue-rich rental events: weddings, workplace social events, fashion shows. The donors' energies move on to other projects: a new office tower to house the entire company, and the transformation of Daytona's long-dismal city center riverfront into a verdant pedestrian park.

My commitment to OGC and the museum have waned for very different reasons, but for both, COVID provides a graceful exit. Ultimately, the isolation of COVID helps me discover a contentment I previously couldn't imagine. No reading groups, no distant driving. I don't have to be anywhere but where I really want to be. More time can go into painting.

≈

Among my daily garden encounters are its resident anoles: native Greenies (*Anolis carolinensis*) and invasive Cuban Brownies (*Anolis sagrei*). Both are rather small lizards with color-changing abilities, although neither matches

those of true chameleons. Both display red dewlaps billowing from their throats, provoked by all manner of circumstances from no apparent threat to chasing around with other anoles to luring a mate.

Greenies had the run of the place (Florida, Georgia, South Carolina) for eons until the Brownies arrived from Cuba on shipping pallets in the 1880s. One hundred years later Brownies had reproduced to such an extent that Greenies left the ground for the trees. Despite concerns of herpetologists that they wouldn't survive, Greenies did what was necessary: growing larger foot pads that make vertical climbing easier. And as the birds already knew, abundant, tasty insects live in tree trunks and canopy.

Anoles in my yard suggest graceful cohabitation, showing themselves throughout the day by skittering here and there. My moving an orchid planter for watering sends a shade-napping Brownie scurrying off. As often as one fully flees, another stops, turns, stares while fluttering its dewlap a few times, waiting out my next move. I regularly rescue them from the house, usually employing diversionary devices like the rattan footstool to carry them through the rooms and out the door. Unfortunately, skeletons of those too shy to hitch a ride outside also turn up, thankfully in smaller numbers.

≈

The first native flowers I paint, yellow walking irises, grow beneath the banana trees along the south fence. That area of the yard came about while I continued teaching up north. My husband wintered here and planted several banana trees a friend had given him. He likely also planted the irises, as I remember only oak trees and grass originally. I rarely spent time in the yard during those days when my schedule only allowed me a few consecutive weeks in Florida. Compared with my tame, green Ohio Valley garden, the Florida one felt wildly alien, replete with mosquitoes, no-see-ums, biting ants, and often relentless humidity and heat.

Our Florida outdoor spaces gradually become my province. Even though the experts caution against relocating native volunteers, I successfully move walking irises to several parts of the back garden. There they stand within the dappled light offered by the oak canopy, feeding happily off the fallen leaves, among the fern, spiderwort, pothos, and banana trees.

Walking iris blossoms present lovely miniatures: not quite two inches across, complete with three larger petals interspersed by three smaller ones, the latter never fully unfurling. Bright, deep yellow with cinnamon

freckles, multiple blooms sprout one after another from an almond-shaped pod that tops the stem. They open to reflect the sun and curl away at dusk. Single blooms go in a day, but successive openings from new shoots follow quickly. Eventually the last one shrivels away, the pod dries, and the stem falls to the ground, "walking" a foot or so from the parent. Rooting where it falls, a season or two later it shoots up leaves and podded stems of an entire new plant.

To date, the Florida paintings also feature lobelia, viola, hibiscus, spiderwort, clover, beach morning glory, and the tiny yellow flowers that promise tomato fruit. My gardens, though, contain many more flowers to celebrate. At times I wonder if my life will hold the time and energy for painting them all.

≈

Creative process aims at organizing bits pulled from life's chaos toward greater clarity. Gardening requires exerting some control over nature, even native plant gardens like mine that shy from "design" and embrace random appearances. Gardening, painting, writing, living, all repeatedly require selection, action, and reflection to move forward.

Like the seabirds, anoles, and sea turtles, I now wake each morning to follow my nature: to do the things needed to survive, the things I enjoy and draw satisfaction from. This includes the few social contracts I accept: lunch or Scrabble with a friend; monthly editing unofficial notes another volunteer wrote of a recent commission meeting. Writing this essay. I no longer seek a larger purpose. Thus my later-in-life epiphany: if what I am doing, and how I am doing it, engenders engaged contentment, I need nothing more.

Past It

Jennifer Horne

I was fifty when, after many years of sending out manuscripts and having them rejected, I finally published my first book of poems, *Bottle Tree*. Serendipitously, I'd been invited to a group reading at the Bottletree bar and restaurant in Birmingham, Alabama, about sixty miles from my home just outside Tuscaloosa. The interstate highway being prone to wrecks, construction, and random delays, I set out early and by luck arrived early, a little after two for a three o'clock reading.

I parked my car in the empty parking lot and walked inside. I was excited to have one of my first *Bottle Tree* readings *at* Bottletree and feeling expansive. No one else had arrived yet. A lone dude was behind the bar, shaggy-haired, young, fashionably scruffy in ragged concert T-shirt and jeans. He was, without urgency, setting up the bar for the event.

"I'm here for the reading!" I said.

"We're not open yet," he said.

"But I'm here *as part of* the reading," I rephrased my statement, thinking he might not have understood.

"Still," he said. A pause. A shift in his posture. "So you'll have to leave and come back when we're open." His eyes indicated the door, and his unsmiling expression said, *Obey me—I'm in charge of this place.* He meant for me to go away until he was good and ready to have someone else there, and he meant for me to follow the unspoken rules of southern politeness, especially female politeness, and say, "Oh, I'm so sorry, I didn't realize . . ." and slink off to where my presence was no longer a bother.

That was when *she* showed up. I was not about to go sit in my car in an empty lot in a part of town I didn't know and thought might be a bit sketchy.

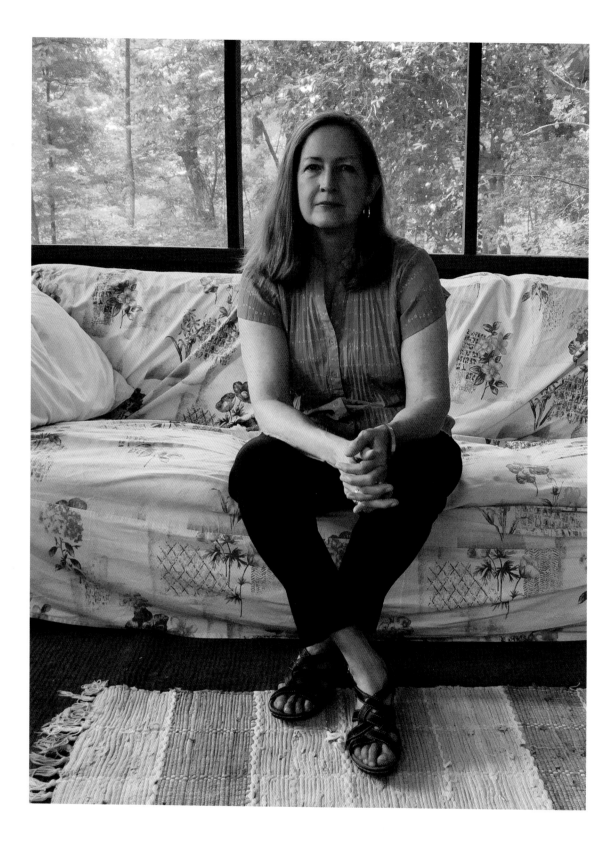

I was a published poet, and I was there to read from my book. And suddenly I had no patience with scruffy young men who thought they could tell me what to do. Not even planning to abandon polite discourse, I found *her* speaking, or rather blurting: "You can't make me leave. I drove from Tuscaloosa." (Somehow the extra distance seemed like a point in my favor.)

It surprised me that he shrugged, didn't argue.

Feeling that I'd had a bit of a Julia Sugarbaker moment but wishing I'd had more of her *Designing Women* eloquence, I sat down pointedly at a shaky wooden table and looked over my poems, held my position. And wondered where that voice had come from, and how, as someone who always carefully chooses her words, I had simply uttered words without thinking them through *at all*.

At first I thought she was my postmenopausal self beginning to emerge. "The F-You Fifties," one friend had called it. And there may be something to that. But she felt more like my eight-year-old self, who ran hard and rode bikes fast and climbed trees and sometimes fell down, who could be quiet and a bit shy with strangers but who knew exactly what she thought, had a strong sense of fairness, and often had daydreams of adventure and heroism. The girl who wanted to be a boy, not because she didn't like being a girl, but because as adolescence loomed, with its bras and demurely crossed legs and fixed hair and makeup and new rules on how to behave, being a boy looked like a lot more fun, with fewer restrictions and the ability to pee outdoors without having to interrupt what you were doing to go inside to the bathroom.

I grew into womanhood slowly. Eventually I learned to enjoy flirtation and the exercise of sexual allure. I also read the feminist texts of the sixties and seventies. I claimed, mostly, the kind of femininity that suited me, but I still had a hard time believing I could be both soft and strong, that I could be taken seriously and be sexy at the same time. And I did so much want to be taken seriously.

But now, having turned the corner on sixty, I am hoping to court that eight-year-old to speak up more. She's been around occasionally, and she helps me stand my ground when I need to, but I need her in this moment to speak to me: to help remind me of what physical fearlessness feels like, to recover the ability to simply admit I don't like some social activities and stay home. To feel and act every bit as good as a boy, rather than, as I sometimes do, letting some man at a professional gathering assume his own dominance and importance, deferring beyond politeness to a stranger at a

party who thinks he's so interesting, and isn't. We've all read about mansplaining and manspreading, but still it goes on.

Perhaps we need a new word. *Croneology, cronespeaking,* and *cronesplaining* have already been coined, but *croneography*—the writings of crones—is, I think, a new coinage, and also carries a punning implication of time, *chronos,* and how we span it. Such writings could help expand my space for dreaming, enlarge my field of doing, could offer advice on how, in the face of possible illness as I age, and of my own and others' mortality, I can get past whatever internal insecurities and long-term compromises, whatever external diminishments inhibit living my fullest, most creative life, for however long I have left.

— Perhaps my eight-year-old self can join with my postmenopausal self and the two of us can create a self uncompromised by anxiety about what others might think. After the rehearsal dinner for my sister's wedding, several years ago, I walked outside with my father and stepmother to help them to their Uber ride because my dad was having balance problems and needed a steadying arm. Their ride was on the other side of the street, and so I left them at the curb, stopped traffic, and went back to help him across. I was fierce because I was needed. Can I be that fierce on my own behalf?

In Twyla Tharp's call to action, *Keep Moving,* she urges and exhorts older women to retain or build back physical strength and flexibility as part of keeping their power in the world. I already stretch every morning, lift weights, walk, do planks and squats, and work in the yard. Sometimes I dance, sometimes I run in place. I've started doing tai chi every day rather than twice a week, and I do it instead of watching the evening news. All those things are good, but Tharp says we must keep pushing ourselves, and we must remember to keep taking up space as though we deserve it.

There are other ways of taking up space. I have taught myself several, over time: to raise my voice and continue to speak when a man interrupts me; to avoid diminishing my own efforts with phrases like "my little" or "I just" or "this is silly, but"; to not laugh at jokes that aren't funny to me; to respond with "hmm" and let that be sufficient if I don't agree with something but don't wish to engage with the speaker; to stop an online conversation when I don't feel respected.

I've also learned that I am competent, that I can handle most situations, and that I don't have to beat myself up over minor shortcomings. I can learn what I don't know. The downside of competence, though, is complacency,

the tendency to do those things one knows how to do, and gets praised for, and just keep doing them.

Older women are sometimes referred to as "past it." I want to redefine what that means: to be past all the crap, all the things that hold me back.

To be settled but not settle.

To be calm but not becalmed.

To be older but not old hat.

I want to do the unheard of, not be unheard, to be curious, not a curiosity.

I want to be assured, strong, experimental, playful, and put myself in situations that scare me a little bit and be confident I'll find my feet.

I am seeking a not-so-secret sorority of the unvanquished, not so I can "do it all" but so I can *give each thing my all*, without regret or holding back.

Truth or dare, we played in high school—why not truth *and* dare? I can claim my truths and learn from others', and still dare to learn, grow, even change.

In the Museum of Greek Folk Art in Athens, I stood and looked at the different costumes decreed for women at each stage of their lives: girl, marriageable young woman, wife, widow. Confining, yes, but also clear: you look at yourself, you look at others, and you know in what stage of life you are, or she is, and what is expected of and for her, for you. In the United States, some women wear red hats and purple, drawing courage and inspiration from Jenny Joseph's poem "Warning," which begins, "When I am an old woman I shall wear purple / With a red hat which doesn't go, and doesn't suit me." The poem also addresses a "you," perhaps a particular you, perhaps a general one, who can "wear terrible shirts and grow more fat" and do all kinds of other socially unacceptable things.

Am I an "I" or a "she" or a "you"? I wonder sometimes. So often as I prepare to walk out the door, I become "she" to myself, the she other people will remark on, and judge, and assess. *She looks tired. She hasn't gone to much trouble getting dressed. She doesn't have any makeup on. Her hair is graying.* Or, thinking more positively but still making a she of me, *She is dressed appropriately for this event, her hair looks nice, she doesn't look her age.* Generally speaking, no one tells you that when you get older you will have extra facial hair to deal with, that it becomes harder to trim your toenails, that your skin—*everywhere*— becomes thinner and less moist, that even if you weigh the same, the flesh around your middle somehow redistributes itself when you're not looking, so that your favorite old pants don't fit right. That men look through you, and you care, or don't, depending on the day. *She* cares, not I.

A few years ago, sweaty and in old clothes from gardening but needing to get a package in the mail that day, I stood in line at the post office counter with several other people. I was getting into my car when I heard the man who'd been in line behind me call to me across the parking lot. I couldn't quite make out what he'd said until he held up his left hand and wiggled his third finger. Married? Yes, yes, I was. He just hadn't gotten a good look at my ring, the last vestige of life-stage declaration we women still wear. I would not have described myself, herself, as looking attractive right then. Maybe it was pheromones.

It's tempting, leaning up to the glass and peering through to see what the future might hold, to Make a Plan, Chart a Course, imagine that you are Finally Going to Grow Up. I think, however, that I would rather grow down. As in, earth myself. As in, stop planning so much. As in, remember what it felt like to be a child and really not know the future, to finish college and have no idea what comes next, to take off on a trip and not know where you are going to spend the night. In fact, it seems a danger to me that I might imagine I could claim certainty, achieve order, suspend the laws of nature that say that everything must change and is changing all the time, always. I know better, although not always happily so.

My nouns these days are *wonder, curiosity, mystery*.

My verbs are *experiment, explore, experience*. All three words share the prefix *ex-*, meaning "out of," as part of their root words. What am I moving out of as I move toward? What am I getting past?

It is frightening to just trust that things will turn out all right somehow, that I can figure out what to do if they don't, that help will arrive if I need it. It feels so much more secure to try to plan, strategize, organize things over which I, truth be told, have no control. And yet. I can feel the cool wind of adventure on my face when I imagine a future in which I am a participant, not a would-be master, in which I trust in my ability to respond to difficult circumstances but don't "borrow trouble" before it comes.

I live among many trees, and I take a great deal of comfort from them. There are old and new and middle-aged trees, trees reaching for sunlight or bent by a strong wind, and all of them do their best to green out each spring; even the beaver-lopped maples down by the lake send up shoots to say they still have something to give. My favorite tree right now, though, is the one lightning stripped from top to bottom, a white streak running down its wide trunk, bare branches arced against blue sky. It is a gorgeous wreck of a tree, and it will stand until it doesn't.

Arrows for Our Quivers

THE POWER OF SOURCES

Katie Lamar Jackson

The voices, views, and experiences expressed in this book are marvelously distinctive, but almost to an essay they share at least one common thread—the universal and enduring power that can be found in the words, works, and thoughts of others.

As creatives, we often tap into that power by turning to other writers, artists, and thinkers for guidance, knowledge, reassurance, and inspiration. These sources are wellsprings of fresh ideas, they help us confirm our suspicions and beliefs, and they can guide us on paths forward. They mentor us.

Within these pages, our essayists do the same, citing everything from poetry and proverbs to scientific articles and songs as sources of inspiration and clarification. They look to diverse creative minds and souls: Rilke to Cher, St. John of the Cross to John Prine to John Lewis, Julia Sugarbaker to Julia Cameron, Maya Angelou to Chaka Khan, Erica Jong to Carl Jung, Twyla Tharp to Helen Keller, and many more. They consult the Bible, Greek mythology, and Zen Buddhism. They delve into astronomy, geometry, and ornithology.

Through these sources our essayists provide us insight into what and who inspires them, informs them, makes them think. They show us where they turn for direction and inspiration and where they gain power for themselves. As our essayist Patricia Gaines says of her favorite quotes from William Blake and Houdini, "These keen observations on life have been two of the arrows in my quiver, and they have served me well."

All this makes sense in a book filled with stories about creativity, because we all need sources of our own in life's journey and, as the *Merriam-Webster Dictionary* defines it, *source* is a "generative force," "a cause," "a beginning."

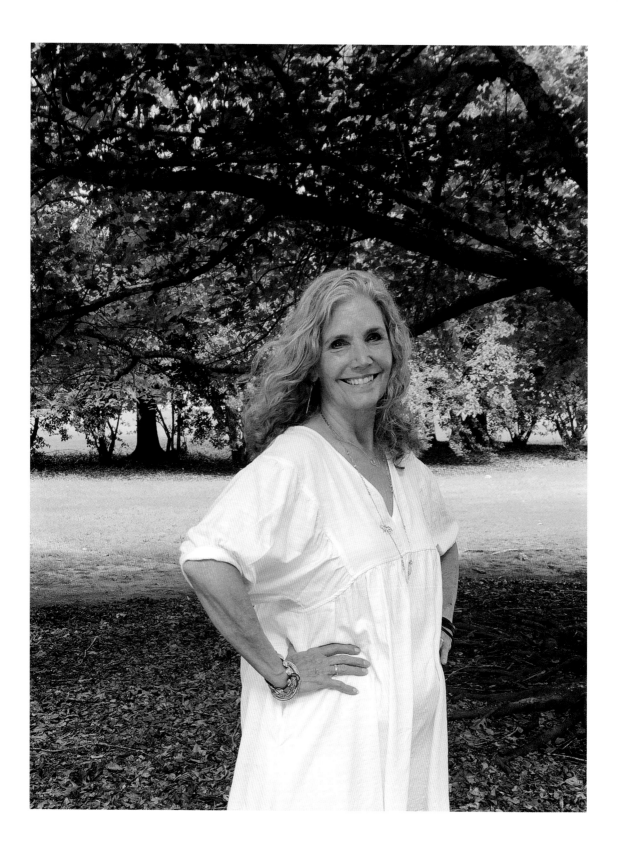

This book is a testament to the power of sources, both in its essays and in its origins. When Jay, Jennifer, Wendy, and I first began our discussions about this project, it was at the height of the COVID pandemic. We were each sequestered in our homes and lonesome for our community of minds and hearts—the energy that comes from sharing our individual strengths, ideas, and intellects—and we were hungry for the opportunity to trade thoughts, frustrations, advice, solace, and support with one another. Thankfully, technology allowed us a way to gather and become virtual companions in this coming-of-aging journey.

From its very beginning, this project also triggered our own searches for sources. The shreds and tidbits we happened upon ranged from books, poems, articles, and songs to podcasts, movies, and posts from social media mavens and "influencers." We frequently—in truth, constantly—shared these with one another in our meetings and through emails, texts, and eventually on shared document platforms.

That process of sharing ideas, our own and those of others, was powerful and productive. It also helped lead to the creation of this collection, which is brimming with ideas, strength, wisdom, insight, and further questions, all of which we hope—no, we know—will be sources of strength, power, and ideas as we journey toward the age of "old enough."

ABOUT

About the Editors

JAY LAMAR is coeditor with Jeanie Thompson of *The Remembered Gate: Memoirs by Alabama Writers* (2003). Her essay "Secrets" was included in a special edition of *Southern Humanities Review*, and she is a contributor to *Albert Murray and the Aesthetic Imagination of a Nation* (2010), one of several titles in the Pebble Hill Imprint series she established while serving as director of Auburn University's Center for the Arts and Humanities.

Lamar has written and edited for scholarly, professional, and public-interest publications for almost thirty years. She was founding director of the Alabama Book Festival and first director of the Alabama Center for the Book. She served as executive director of the Alabama Bicentennial Commission, 2014–2020.

JENNIFER HORNE served as the twelfth Poet Laureate of Alabama (2017–2021). Raised in Arkansas and a longtime resident of Alabama, Horne is a writer and editor of prose, poetry, and fiction who has taught creative writing in workshops across the Southeast and in school, university, and prison classrooms.

The author of three collections of poems, *Bottle Tree*, *Little Wanderer*, and *Borrowed Light*, she also has written a collection of short stories, *Tell the World You're a Wildflower*. She has edited or coedited four volumes of poetry, essays, and stories, and in 2020 she coedited, with her sister, a collection of their mother's poetry, *Root & Plant & Bloom: Poems by Dodie Walton Horne*. Her latest work is a biography of the writer Sara Mayfield, *Odyssey of a Wandering Mind: The Strange Tale of Sara Mayfield, Author*.

Horne has been the recipient of fellowships from the Alabama State Council on the Arts and the Seaside Institute in Florida, and in 2015 she gave the Rhoda Ellison Lecture at Huntingdon University in Montgomery, Alabama, and was awarded the Druid City Literary Arts Award, given by the Tuscaloosa Arts Council. For the spring semester of 2018 she was the Visiting Writer-in-Residence at Lenoir-Rhyne College in Hickory, North Carolina.

About the Photographer

CAROLYN SHERER is an American photographer interested in issues of identity. She works in series, making individual images to create a composite portrait of often-marginalized communities. Her past work has featured people with disabilities, people living with HIV, and multiple projects related to the LGBTQ community.

The current series for *Old Enough: Southern Women Artists and Writers on Creativity and Aging* puts a face on an underrepresented community of women in the New South who navigate ageism and sexism to express mature creativity. They are confident in their perspective—a strength forged from a lifetime of wins and losses. A visual storyteller, Sherer honors individuality by creating environmental portraits in personal space, yet seeks the bond of common humanity in a direct gaze.

Select images from *Old Enough* have been included in the 19th annual Julia Margaret Cameron Award for Women Photographers exhibition at FotoNostrum Mediterranean House of Photography in Barcelona, having won an honorable mention. A book of Sherer's images, *Just as I Am: Americans with Disabilities*, won a first-place IPPY (Independent Publisher Book Award) and the Gustavus Myers Outstanding Book award from Boston University.

Sherer's work has been included in exhibitions at the Smithsonian National Portrait Gallery, Pennsylvania Academy of Fine Arts, Birmingham Civil Rights Institute, Ackland Museum of Art, Kemper Museum of Contemporary Art, African Art Museum of South Texas, Tacoma Art Museum, African American Museum of Dallas, Birmingham Museum of Art, Wiregrass Museum of Art, Mobile Museum of Art, Montgomery Museum of Art, Abroms-Engel Institute for the Visual Arts, and the Huntsville Museum of Art. The images are included in numerous museum, corporate, and private collections.

About the Contributors

GAIL ANDREWS graduated from the College of William & Mary and received her master's degree from the Cooperstown Graduate Program. After an NEH internship at Colonial Williamsburg, Andrews joined the Birmingham Museum of Art in 1976 as assistant curator of decorative arts, subsequently serving as assistant director and ultimately as director of the museum for twenty years.

An acknowledged authority on folk art and textiles, she has written numerous articles and catalogues including *Black Belt to Hill Country: Alabama Made Quilts*, *Southern Quilts: A New View*, quilt and needlework chapters for *Made in Alabama: A State Legacy*, and the introduction to the book *Revelations: Alabama's Visionary Folk Artists* and edited and contributed essays to *Pictured in My Mind: Contemporary American Self-Taught Art*.

Andrews is actively involved in a variety of arts and educational organizations locally, regionally, and nationally. She served as president of the Association of Art Museum Directors, and in 2017 she received the Jonnie Dee Riley Little Lifetime Achievement Award from the Alabama State Arts Council.

SARA GARDEN ARMSTRONG is a visual artist whose decades-long practice embraces a wide range of scales and techniques, from large site-specific sculpture to handheld artist's books, all of which examine organic processes of transformation.

Her atrium commissions have focused on scientific phenomena and their interactions with the human condition, such as the installation for the National Multiple Sclerosis Society at the University of Alabama Birmingham Medical Center. A recipient of a Joan Mitchell Foundation CALL (Creating a Living Legacy) grant through Space One Eleven, Armstrong has exhibited nationally and internationally for over forty years. Museum collections include Museum of Modern Art, New York; Victoria and Albert Museum, London; Centre Georges Pompidou, Paris; Birmingham Museum of Art, Birmingham, Alabama.

The monograph *Sara Garden Armstrong: Threads and Layers* was published in 2020 and coincided with a traveling exhibition of the same name, which toured through January 2023, incorporating site-specific art for each location. The Gadsden Museum of Art published a catalogue documenting each iteration of the exhibition, featuring an essay by critic and artist Mary Jones.

Armstrong received her Master of Fine Arts from the University of Alabama and a Master of Art Education from the University of Alabama at Birmingham (UAB). After living in New York for thirty-six years, she returned in 2017 to Birmingham, where she currently lives and works. For four decades, her 21st Street Studio building has been home to more than a hundred artists' studios and many galleries. Currently it hosts the Alabama Center for Architecture, Ground Floor Contemporary gallery and collective, and twelve artists' studios.

CARMEN AGRA DEEDY is the author of seventeen books for children, including *The Library Dragon*, *The Cheshire Cheese Cat*, *Martina the Beautiful Cockroach*, the *New York Times* bestseller *14 Cows for America*, *The Rooster Who Would Not Be Quiet!*, and *Rita and Ralph's Rotten Day*. Her personal stories first appeared on NPR's *All Things Considered*. Funny, insightful, and frequently irreverent, Deedy's narratives are culled from her childhood as a Cuban refugee in Decatur, Georgia. She serves on the board of the Smithsonian Institute's Library and Archives (SLA).

An award-winning author and storyteller, Deedy is also an accomplished lecturer, having been a guest speaker for both TED and TEDx conferences, the Library of Congress, Columbia University, the National Book Festival, and the Kennedy Center, among other distinguished venues. A lifelong supporter of the institution, she opened the 2016 Art of the Book lecture series for the Smithsonian Libraries.

PATRICIA FOSTER is the author of *All the Lost Girls* (PEN/Jerard Award), *Just beneath My Skin* (essays), *Girl from Soldier Creek* (SFA Novel Award), and the 2023 collection *Written in the Sky: Lessons of a Southern Daughter*, and the editor of four anthologies, including *Minding the Body: Women Writers on Body and Soul*. She has received a Pushcart Prize, a Clarence Cason Award, a Theodore Hoepfner Award, a Dean's Scholar Award, a Florida Arts Council Award, a Yaddo Fellowship, and a Carl Klaus Teaching Award. She was a juror for the Windham-Campbell Literature

Prize in Nonfiction (Yale University) and a fellow at the Inaugural Writing Residency at Sun Yat-sen University. She was a professor in the MFA Program in Nonfiction at the University of Iowa from 1994 to 2018 and has taught writing in France, Australia, Italy, the Czech Republic, and Spain.

PATRICIA ELLISOR GAINES was born in Selma, Alabama, in 1939. She graduated Phi Beta Kappa from Birmingham-Southern College in 1962 and earned a Master of Fine Arts degree at the University of Georgia in 1966. The degree was granted "with distinction" by the revered artist Lamar Dodd, who asked that she remain and join the faculty. Instead, Patricia married the writer Charles Gaines and moved to Ireland. There she painted and devoted herself to raising a young son, Latham Gaines IV. Later the family moved to Iowa, then Wisconsin, where both Patricia and Charles worked as teachers on Operation Arts, a Title III program to bring the arts to culturally deprived areas of the state. Greta was born in Iowa and Shelby in Wisconsin. Finally settling in New Hampshire, Patricia Gaines taught at Proctor Academy and New England College and created two books, *The Fabric Decoration Book* and *Soft*. Her paintings have been exhibited in New York, Boston, Los Angeles, and Auckland, New Zealand. Her latest exhibition was at the Alabama School of Fine Arts.

MARY GAUTHIER is a professional songwriter and author whose most recent book, *Saved by a Song*, is an exploration of the creative process in service to recovery and healing. *Rolling Stone* said, "Mary Gauthier's book is a must-read music book. The Grammy-nominated songwriter dissects her brutally honest songs and preaches the 'magnificence of empathy' in a memoir that is just right for these times."

Gauthier was named by the Associated Press as one of the best songwriters of her generation. Her most recent musical release, *Dark Enough to See the Stars*, was preceded by 2018's *Rifles & Rosary Beads*, a collection of songs cowritten with wounded veterans. It was nominated for a Grammy award for Best Folk Album, and Record of the Year by the Americana Music Association. The UK Americana Association named Gauthier their 2019 International Artist of the Year, and Folk Alliance International named *Rifles & Rosary Beads* the 2019 Record of the Year.

Mary Gauthier's songs have been recorded by dozens of artists, including Jimmy Buffett, Dolly Parton, Boy George, Blake Shelton, Tim McGraw, Bettye Lavette, Mike Farris, Kathy Mattea, Bobby Bare, and Amy Helm. They have also appeared extensively in film and television, most recently on HBO TV's *Yellowstone*.

PATTI CALLAHAN HENRY is a *New York Times*, ECPA, *Globe and Mail*, and *USA Today* bestselling author of sixteen novels, including her newest, *The Secret Book of Flora Lea*. She's also a podcast host of original content for her novels *Surviving Savannah* and *Becoming Mrs. Lewis*. She is the recipient of the Christy Award Book of the Year, the Harper Lee Distinguished Writer of the Year, and the Alabama Library Association Book of the Year for *Becoming Mrs. Lewis*.

She is the cohost and cocreator of the popular weekly online *Friends and Fiction* live web show and podcast. She was also a contributor to the monthly life lesson essay column for *Parade Magazine*. She's published in numerous anthologies, articles, and short story collections, including an Audible Original about Florence Nightingale, titled *Wild Swan*, narrated by the Tony Award winner Cynthia Erivo.

A full-time author, mother of three, and grandmother of two, Patti lives in Mountain Brook, Alabama, with her husband, Pat Henry. Her newest novel, *The Secret Book of Flora Lea*, is set outside Oxford, England, in the hamlet of Binsey.

KATIE LAMAR JACKSON is a freelance writer and photographer with four decades of experience working as a journalist, author, editor, communications director, and educator. Her work has been published in myriad newspapers, magazines, books, and essay collections and covers a diverse array of topics—gardening, wildlife, the environment, arts and culture, history, biography, and travel among them. She has authored or coauthored ten nonfiction books, including the award-winning *Oracle of the Ages: Reflections on the Curious Life of Fortune Teller Mayhayley Lancaster*, *A Movement of the People: The Roots of Environmental Education and Advocacy in Alabama*, and *A Tiger among Us: A Story of Valor in Vietnam's A Shau Valley*.

Jackson holds bachelor's and master's degrees from Auburn University, where she worked for more than twenty-five years before retiring in 2012 as communications director for Auburn's agricultural and natural resource programs. She currently lives in Opelika, Alabama, where she is working on a variety of creative nonfiction projects on topics ranging from wild horses to eclipse chasing to the landscape of her birthplace, Tuskegee, Alabama.

ANGELA JACKSON-BROWN is an award-winning writer, poet, and playwright who is an associate professor in the creative writing program at Indiana University in Bloomington. She also teaches in the graduate program at the Naslund-Mann Graduate School of Writing at Spalding University in Louisville, Kentucky.

She is a graduate of Troy University, Auburn University, and the Naslund-Mann Graduate School of Writing at Spalding University. She has published her short fiction, creative nonfiction, and poetry in journals like the *Louisville Journal* and the *Appalachian Review*. She is the author of *Drinking from a Bitter Cup*, *House Repairs*, *When Stars Rain Down*, *The Light Always Breaks*, and *Homeward*. Her novels have received starred reviews from *Library Journal* and glowing reviews from *Alabama Public Library*, *Buzzfeed*, *Parade Magazine*, and *Women's Weekly*, just to name a few. *When Stars Rain Down* was named a finalist for the 2021 David J. Langum, Sr. Prize in American Historical Fiction, longlisted for the Granum Foundation Award, and shortlisted for the 2022 Indiana Authors Award.

NEVIN MERCEDE's artistic life has been a peripatetic one involving both coasts and several places between. After years of wandering the galleries of the Philadelphia Museum of Art, Saturday classes at the Philadelphia College of Art,

and Sundays drifting around the Barnes Collection, Nevin moved west, where she earned a BFA in printmaking from the California College of Arts and Crafts and an MFA in painting and printmaking at the University of Montana. She has exhibited works of varied media nationally since the 1980s while also teaching college-level studio art and art history, ultimately earning tenure at Antioch College.

In 2014 Mercede moved permanently to Florida in order to oversee the design and construction of the Beach House Studio along with a gentle expansion of her Beachside Periwinkle. Every year the native plant gardens that inspire her paintings become increasingly dense, and she looks toward living within a functioning xeriscape that enables more studio time.

JANISSE RAY is an award-winning author, environmental activist, and entrepreneur. Much of her writing explores the borderland between nature and culture: she believes in the power of stories to bring about transformation—in an individual, a community, or a nation. Ray has gained a following of earth-conscious folks who appreciate her heart-centered approach to life, her courage, and her well-crafted stories.

Ecology of a Cracker Childhood, Ray's bestselling first book, was a *New York Times* Notable. This environmental memoir about growing up in the disappearing longleaf pinelands brought attention to a critically endangered ecosystem and set fire to a movement to restore this iconic landscape. Eleven other books followed, including a novel, *The Woods of Fannin County*, and two volumes of eco-poetry. Ray has won an American Book Award, Pushcart Prize, Southern Booksellers Award, Southern Environmental Law Center Writing Award, Nautilus Award, and Eisenberg Award, among many others. Her essay collection *Wild Spectacle* received the Donald L. Jordan Prize for Literary Excellence, which carries a $10,000 prize. Her books have been translated into Turkish, French, and Italian.

Ray earned an MFA from the University of Montana and accepted two honorary doctorates. She serves on the editorial board of terrain.org, is an honorary member of the Association for the Study of Literature and the Environment, and has been writer-in-residence on many university campuses. She leads writing workshops on magical craft, where she teaches not only writing technique but how to access the duende, or spirits, that make writing sizzle. She is the creator of *The Wild Spectacle Podcast*.

Ray lives on an organic farm inland from Savannah, Georgia. She loves dark chocolate, the blues, and anything in flower. Find out more at her website, janisseray .com, or via her Substack newsletter, *Trackless Wild*.

WENDY REED is an Emmy-winning writer and producer whose work includes documentaries and the long-running Alabama Public TV series *Bookmark* and *Discovering Alabama*. The author of *An Accidental Memoir: How I Killed Someone and Other Stories* and coeditor of *All Out of Faith* and *Circling Faith*, Reed has

taught in the Honors Colleges at UAB and the University of Alabama, where she completed her PhD. She is passionate about compelling science-writing, critical thinking, combatting disinformation, and books. An Alabama State Council on the Arts fiction fellow, she has been recognized by Oregon State University, the Lillian E. Smith Center, the Seaside Institute, and Lincoln University for her work. During the pandemic she was a census enumerator and mass vaccine site registrar, which convinced her to complete a master's in public health. Currently she works in the Alabama BRAIN Lab. She and her husband have a combined family of six children, two grandchildren, and one chihuahua named Pablo.

CECILIA RODRÍGUEZ MILANÉS was born in New Jersey to Cuban parents and educated in Miami and New York. Her fiction, nonfiction, and poetry appear in numerous journals and anthologies, including *South Writ Large, Acentos Review, Azahares,* the *Antonym, Kweli Journal, Guernica, Letras Femeninas, Southern Humanities Review,* and *The Norton Anthology of Latino Literature.* Her short story collections *Oye What I'm Gonna Tell You* and *Marielitos, Balseros, and Other Exiles* were #4 and #5 on the *Guardian's* list of ten of the best books to help understand Cuba. *Everyday Chica,* winner of the 2010 Longleaf Press Poetry Prize, was followed by *Everyday Chica, Music and More,* a poetry CD set to Caribbean folk music released in 2011. Her most recent publication is "Dancing Danny"—a video essay found at https://constell8cr.com/articles/dancing-danny/. She is professor of English at the University of Central Florida, where she teaches literature by women of color and creative writing. She lives in Orlando with her family including three re-homed dogs and is abuela (Yeya) to three grandbabies.

ANNE STRAND, artist, has traveled a rich and complex journey. This teacher, Episcopal chaplain, published author, wife, mother, and retired licensed psychotherapist of thirty-one years has signed her work with a stamp meaning "Grand-Mother-Wise-Woman" given to her by her son at the birth of her first grandchild.

Mentored in Paris by the painter Elaine de Kooning, whose work hangs in the Metropolitan Museum and the Museum of Modern Art in New York City, Strand studied art with the New York Studio School and earned academic degrees in art, theology, and psychology. Her work forms an amalgam of these three disciplines. Both as writer and as artist, she interprets her subject matter through a mystical lens—grounded in spiritual literature, contemporary quantum theory, and current scientific thought.

Strand is a veteran of numerous museum and gallery one-woman and group exhibitions, and her work is to be found in homes, businesses, and institutions throughout the eastern United States.

JEANIE THOMPSON, a native of Decatur, Alabama, is founding director of the Alabama Writers' Forum (Montgomery), a statewide literary arts service organization (www.writersforum.org). She is also a poetry faculty member with the

low-res MFA Writing Program at Spalding University in Louisville and a literary arts education advocate.

Thompson began writing poetry in high school and attended the University of Alabama, where she received her MFA in creative writing and was founding editor of the *Black Warrior Review* literary journal. She has published five collections of poems and three chapbooks and has edited a collection of memoirs by Alabama authors, *The Remembered Gate*, with Jay Lamar. Her latest work, *The Myth of Water: Poems from the Life of Helen Keller*, was a finalist for the 2016 Foreword Indie Poetry Book Awards. Her literary arts awards include two literature fellowships from the Alabama State Council on the Arts, one from the Louisiana Arts Council, and the Alumni Artist of the Year Award (2003) from the University of Alabama's College of Arts and Sciences. Her current project is a collection of essays about collaborating with visual artists in Alabama.

Thompson's work with the staff of the Alabama Writers' Forum to develop Writing Our Stories, a creative writing program for at-risk youth, has been recognized by the Auburn University at Montgomery Center for Government as a public/private partnership and by the Alabama Arts Alliance for curriculum innovation in arts education. In 2022 Thompson and her staff published *The Language of Objects: A Creative Writing Handbook*, based on twenty-five years of Writing Our Stories classes. Find more about her work at www.jeaniethompson.net.

JACQUELINE ALLEN TRIMBLE lives and writes in Montgomery, Alabama, where she is a professor of English and chair of Languages and Literatures at Alabama State University. She holds three degrees in English: a BA from Huntingdon College and an MA and PhD from the University of Alabama. She serves on the board of the Alabama Writers' Forum. Trimble has won several teaching and writing awards, including the Exemplary Teacher Award (for junior faculty), the Todd Award for Outstanding Teaching (for senior faculty), the Julia Lightfoot Sellers Award (given by the Huntingdon College junior and senior class to the faculty member who has most inspired them to learning), and the University of Alabama's Outstanding Dissertation of the Year Award, for "Race, Gender, Culture in *Adrienne Kennedy in One Act*," an analysis of the playwright Adrienne Kennedy's absurdist dramas through the lens of feminist/womanist theory.

Trimble's research interests include twentieth-century Black women writers, feminist theory, and representations of race and gender in popular culture. She is also a poet. Her work has appeared in *The Offing, Blue Lake Review*, the *Louisville Review*, and *The Griot. American Happiness*, her first collection, was published in 2016, and *How to Survive the Apocalypse* followed in 2022. A 2021 NEA Creative Writing Fellowship in Poetry recipient, Trimble has also been awarded a Key West Literary Seminar scholarship, is a Cave Canem fellow, and was the recipient of a 2017 literary arts fellowship from the Alabama State Council on the Arts. *American*

Happiness won the 2016 Balcones Poetry Prize and was named best book of 2016 by the new Seven Sisters Book Awards.

LILA QUINTERO WEAVER is the writer and illustrator of a graphic memoir, *Darkroom: A Memoir in Black and White*, and later served as cotranslator of its Spanish edition. As a graphic novelist and documentarian of the immigrant experience in the American South, Weaver has lectured at college campuses across the United States. Original artwork from *Darkroom* has been exhibited in numerous galleries, including Whitman College, the Rosa Parks Museum, the Levine Museum of the New South, the Jule Collins Smith Museum, and CentroCentro, in Madrid, Spain. Weaver received the 2013 Druid Arts Award from the Arts Council of Tuscaloosa, and that same year *Darkroom* was named one of the Notable Books for a Global Society by the International Reading Association.

In 2018 Weaver published a children's novel, *My Year in the Middle*. As a children's writer, she has twice cotaught at Highlights Foundation Workshops & Retreats, in Pennsylvania. She is also a contributor to *Tales from La Vida: A Latinx Comics Anthology*.

YVONNE WELLS is an internationally renowned quilter who lives in her hometown of Tuscaloosa, Alabama. In 1985 she made her first appearance at the Kentuck Festival of the Arts in Northport, Alabama, where she won her first of six Best in Show awards. Wells's work has been exhibited in Japan, France, and Italy, as well as displayed in the prestigious Smithsonian Museum of African American History and Culture in Washington, D.C., and the American Museum of Folk Art in New York City. Six of her quilts are held in the permanent collection of the International Quilt Study Center and Museum in Nebraska, and she has garnered numerous awards, including the Alabama Arts Award from the University of Alabama Society for the Fine Arts, the Druid Arts Award for Visual Craftsmanship from the Arts and Humanities Council of Tuscaloosa, and a Governor's Arts Award from the Alabama State Council on the Arts.

The University of Alabama Press Faculty Editorial Board awarded Wells and Professor Stacy Morgan the 2021 Anne B. and James B. McMillan Prize, given for a work "Most Deserving in Alabama or Southern History or Culture," for their forthcoming book *The Story Quilts of Yvonne Wells*.